# MASTERING THE ART OF
# WATERCOLOUR

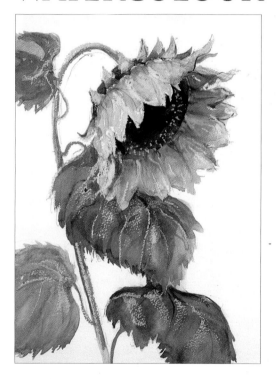

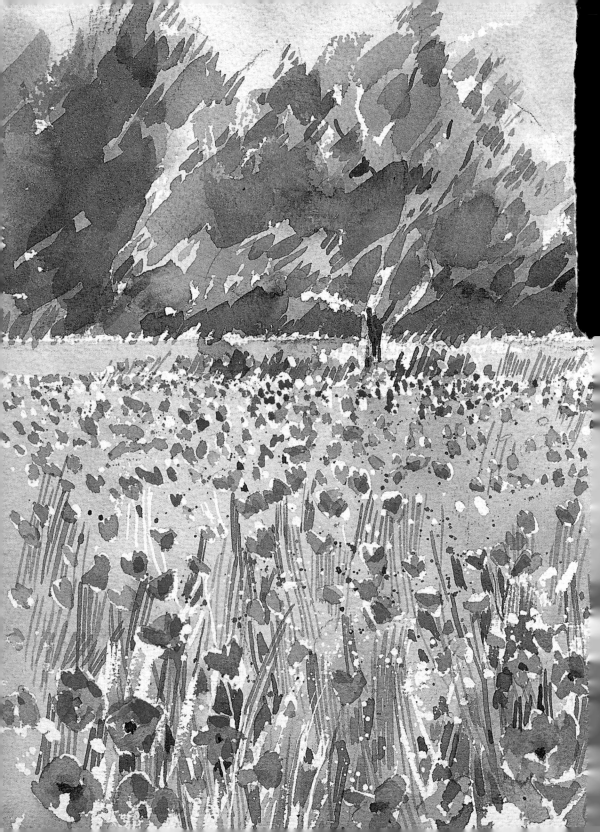

# MASTERING THE ART OF
# WATERCOLOUR

mixing paint • brush strokes • gouache • masking out • glazing • wet into wet
drybrush painting • washes • using resists • sponging • light to dark • sgraffito

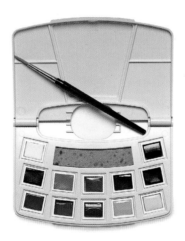

## WENDY JELBERT & IAN SIDAWAY

HH
HERMES
HOUSE

This edition is published by Hermes House,
an imprint of Anness Publishing Ltd,
108 Great Russell Street,
London WC1B 3NA;
info@anness.com

www.hermeshouse.com; www.annesspublishing.com; twitter: @Anness_Books

If you like the images in this book and would like to investigate using them for publishing, promotions
or advertising, please visit our website www.practicalpictures.com for more information.

A CIP catalogue record for this book is available from the British Library.

Publisher: Joanna Lorenz
Senior Editor: Sarah Ainley
Consultant Editor: Sarah Hoggett
Photographers: George Taylor and Nigel Cheffers-Heard
Designer: Nigel Partridge
Illustrator: Ian Sidaway
Project contributors: Ray Balkwill, Diana Constance, Joe Francis Dowden, Paul Dyson, Abigail Edgar,
Wendy Jelbert, Melvyn Petterson, Paul Robinson, Ian Sidaway, Albany Wiseman
Production Controller: Rosanna Anness

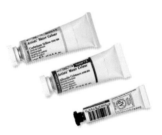

PUBLISHER'S NOTE
Although the advice and information in this book are believed to be accurate and true at the
time of going to press, neither the authors nor the publisher can accept any legal responsibility
or liability for any errors or omissions that may have been made nor for any inaccuracies nor for
any loss, harm or injury that comes about from following instructions or advice in this book.

# Contents

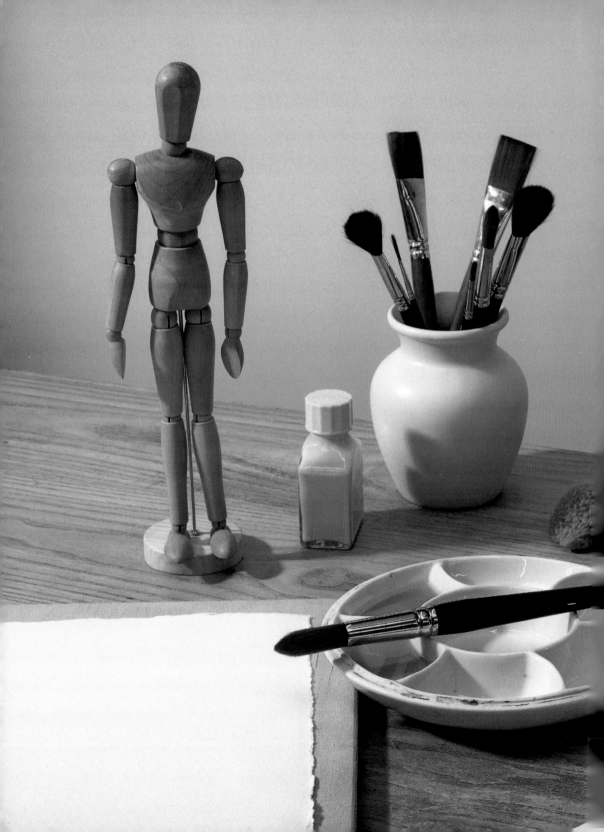

# Getting Started in Watercolour

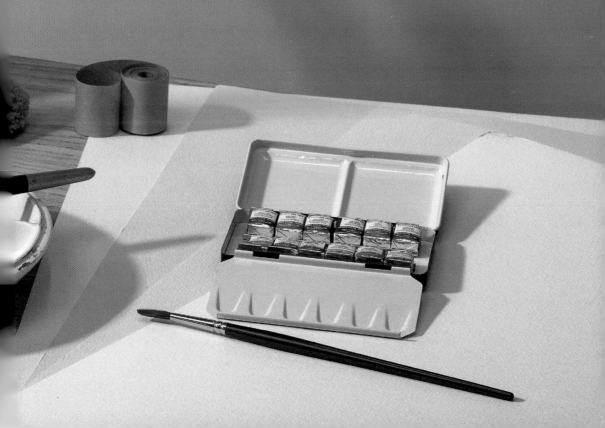

# Paints

Watercolour paints are available in two main forms: pans, which are compressed blocks of colour that need to be brushed with water in order to release the colour, and tubes of moist paint. The same finely powdered pigments bound with gum-arabic solution are used to make both types. The pigments provide the colour, while the gum arabic allows the paint to adhere to the paper surface, even when highly diluted with water.

Both pans and tubes can be bought in sets or singly. Pans are available as full pans and half pans, the only difference is size. If there are certain colours that you use only infrequently, buy half pans. Tubes range in size from 5–20ml (0.17–0.66 fl oz).

It is a matter of personal preference whether you use pans or tubes. The advantage of pans is that they can be slotted into a paintbox, making them easily portable, and this is something to consider if you often paint on location. Tubes, on the other hand, are often better if you need to make a large amount of colour for a wash, although it is easy to squeeze out more paint than you need, which is wasteful. You also need to remember to replace the caps of tube colours immediately, otherwise the paint will harden and become unuseable.

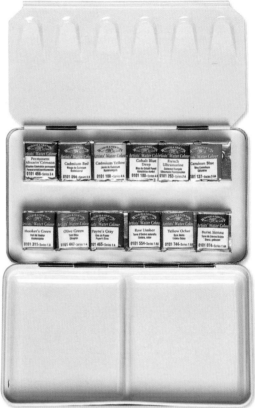

**◄ Paintbox**
You can buy paintboxes that are already filled with a selection of colours, or empty boxes that you then fill with colours of your own choice. The model shown here is for pans of paint, but you can also buy ones with spaces for tube colours.

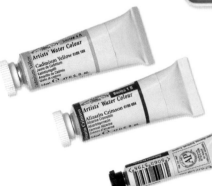

**Tubes ▲**
Tubes of watercolour paint are available in different sizes. It is worth buying the larger sizes for colours that you think you will use frequently.

**Gouache paint ▲**
This is a kind of water-based paint. Unlike pure watercolour, it is opaque, although the techniques and equipment used for gouache are similar to those used for watercolour. White gouache, in particular, is often used in conjunction with pure watercolour, both to add small highlights and to mix with watercolour to make pale, opaque colours.

# Palettes

Even if you usually mix colours in the lid of your paintbox, it is useful to have one or two separate palettes as well, particularly when you want to mix a large quantity of a wash. There are several shapes and sizes available, but two of the most common are the segmented round palette and the slanted-well tile.

Palettes are made from white ceramic or plastic. Although plastic is lightweight, which is an advantage when you need to carry your materials for painting on location, it is also slightly porous and will become stained over time.

For an inexpensive alternative, look out for white china saucers and plates in charity shops or jumble (rummage) sales. They must be white, as you would be able to see any other colour through the transparent paint, which would make it difficult to judge the colour or tone being mixed. Old teacups and bowls are good if you need to mix large quantities.

Pigment does settle, so remember to stir the wash in your palette from time to time to ensure that it is evenly dispersed. Always wash your palette thoroughly after use to prevent dried paint residue from muddying subsequent mixes.

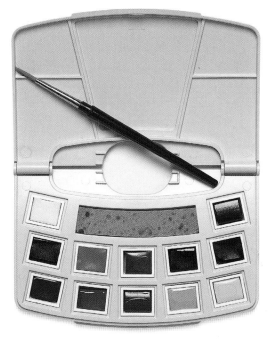

**Field box** ▲
Most of the major manufacturers sell field boxes specifically for use on location, which include a small brush and perhaps a sponge as well as a selection of paints.

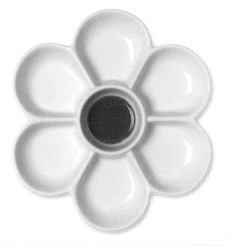

◄ **Segmented round palette**
This kind of palette, which is sometimes referred to as a chrysanthemum palette because of its flower-like shape, has deep wells that are perfect for mixing large washes.

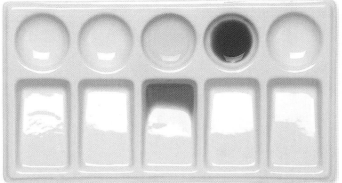

◄ **Slanted-well tile palette**
This type of palette is useful for mixing two or more colours together: place each colour in one of the round wells at one end of the palette and transfer a little on your brush to one of the flat, slightly sloping sections.

## Grades of paint

There are two grades of watercolour paint: artists' and students' quality. Artists' quality paints are the more expensive, because they contain a high proportion of good-quality pigments. Students' quality paints contain less pure pigment and more fillers, and are usually available in a smaller range of colours than artists' quality paints.

If you come across the word "hue" in a paint name, it indicates that the paint contains cheaper alternatives to the real pigment. Generally speaking, you get what you pay for: artists' quality paints tend to produce more subtle mixtures of colours.

The other thing that you need to think about when buying paints is their permanence. The label or the manufacturer's catalogue should give you the permanency rating. In the United Kingdom, the permanency ratings are class AA (extremely permanent), class A (durable), class B (moderate) and class C (fugitive). The ASTM (American Society for Testing and Materials) codes for lightfastness are ASTM I (excellent), ASTM II (very good), and ASTM III (not sufficiently lightfast).

Some pigments, such as alizarin crimson and viridian, stain more than others: they penetrate the fibres of the paper and cannot be removed.

Finally, although we always think of watercolour as being transparent, you should be aware that some pigments are actually slightly opaque and will impart a degree of opacity to any colours with which they are mixed. These so-called opaque pigments include all the cadmium colours and cerulean blue.

### Characteristics of paint ▼
Different pigments have different characteristics. The only way to learn about them is to use them and see how they behave, both singly and in combination with other colours. The chart below shows the characteristics of some of the most popular watercolour paints.

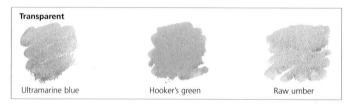

**Transparent**

| Ultramarine blue | Hooker's green | Raw umber |

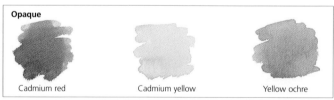

**Opaque**

| Cadmium red | Cadmium yellow | Yellow ochre |

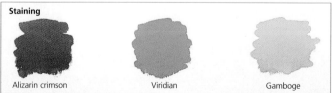

**Staining**

| Alizarin crimson | Viridian | Gamboge |

## Judging colours

It is not always possible to judge the colour of paints simply by looking at the pans in your palette, as they often look dark. In fact, it is very easy to dip your brush into the wrong pan by mistake, so always check before you apply the brush to the paper.

Even when you have mixed a wash in your palette, appearances can be deceptive, as watercolour paint always looks lighter when it is dry. The only way to be sure what colour or tone you have mixed is to apply it to paper and let it dry. It is always best to build up tones gradually until you get the effect you want. The more you practise, the better you will get at anticipating results.

### Appearances can be deceptive ▼
These two pans look very dark, almost black. In fact, one is Payne's grey and the other a bright ultramarine blue.

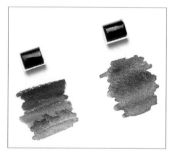

### Test your colours ▼
Keep a piece of scrap paper next to you as you work so that you can test your colour mixes before you apply them to your painting.

## What colours to choose?

With so many colours to choose from (some manufacturers offer as many as 100 artists' quality paints and up to 50 students' quality), how do you decide which ones to buy?

Although art supply stores and catalogues contain rainbow-like selections of every colour imaginable, the most important thing to realize is that you don't need to buy a huge range. You might choose to produce a painting entirely from ready-made colours, but learning how to mix your own will give you far more scope and is far more economical.

Some artists choose to work with a very limited palette of as few as five or six colours, creating astonishingly subtle variations in hue and tone in the process. Start with a few colours and learn as much as you can about them before you add to your range. In practice, most people find that a

range of 12–20 colours enables them to mix pretty much anything that they could wish for.

As you gain more experience, you will probably find that you discard certain colours in favour of others: this is all part of the learning process. Set aside some time to experiment and see how many colours and tones you can create by mixing two, or even three, colours together.

Above all, keep a note of any mixes that you particularly like, or find useful for certain subjects (such as trees, skies or water) so that you can recreate them in the future. Remember, however, that the more colours you combine, the more risk there is that the resultant mixes will look muddy and dull: one of the received wisdoms in pure watercolour painting is that you should not mix more than three colours together at any one time.

As always, your exact choice of colours is largely a matter of personal preference, but a good "starter palette" should contain at least one of each of the three primary colours (red, yellow and blue); in fact, it's helpful to have one blue with a warm bias, such as ultramarine blue, and one that is slightly cooler, such as cerulean. Earth pigments such as raw and burnt umber and raw and burnt sienna are useful for mixing neutral browns and greys. Although you can mix your own greens, versatile ready-mixed greens include viridian, Hooker's green and sap green. Payne's grey is a good colour to mix with other colours for cast shadows.

**Suggested starter palette ▼**
The palette shown below is a versatile selection of colours that will enable you to create a wide range of mixes.

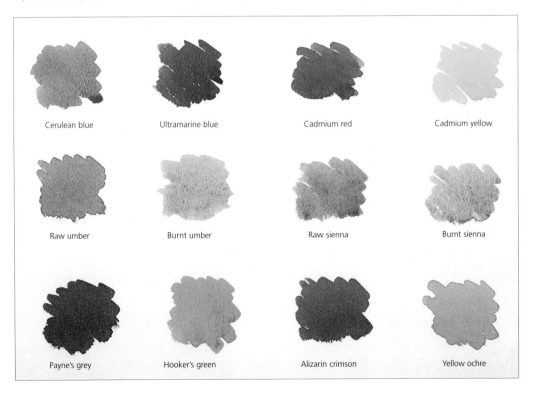

Cerulean blue     Ultramarine blue     Cadmium red     Cadmium yellow

Raw umber     Burnt umber     Raw sienna     Burnt sienna

Payne's grey     Hooker's green     Alizarin crimson     Yellow ochre

# Papers

There are three main types of watercolour paper: hot-pressed (HP), NOT, and rough. Hot-pressed paper is best for drawing and detailed work; it is very smooth to the touch. NOT surface, meaning not hot-pressed (cold-pressed), has a slight texture. Rough paper has a prominent "tooth"; when a wash is laid over it, some of the deep cavities are left unfilled, giving a sparkle to the painting. The best papers are handmade from pure linen rag and the quality is reflected in the price.

Good-quality paper has a right and a wrong side. The right side is coated with size, which is receptive to watercolour applications. To find out which side to use, hold the paper up to the light and look for the water mark on the right side.

Watercolour paper is available in rolls, sheets, and pads and blocks of various sizes. Pads are either spiral bound or glued; blocks are glued on all sides to keep the paper flat until you need to remove a sheet. Pads and blocks are more practical for location work and quick sketches.

### Types of paper ▼
From left to right: hot-pressed (HP), NOT and rough watercolour papers. Hot-pressed paper has a very smooth surface, while the other two are progressively more textured.

### Tinted papers ▼
Tinted papers are sometimes frowned upon by purists, but there are times when you want to establish an overall colour key; these ready-made tinted papers are a good alternative to laying an initial flat wash.

Duck-egg blue

Eggshell

Cream

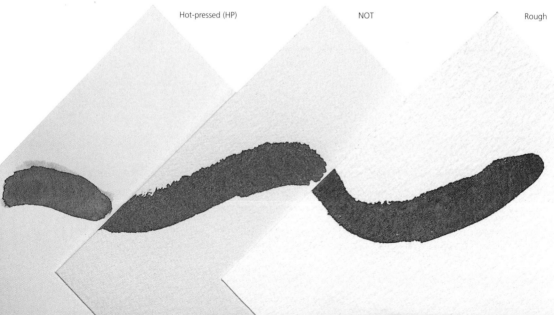

Hot-pressed (HP)

NOT

Rough

## Stretching paper

Papers come in different weights. The weight refers to the weight of a ream (500 sheets) and can vary from 90lb (185 grams per square metre or gsm) for lightweight papers to 300lb (640gsm) or more. The heavier the paper, the more readily it will take the water. Papers that are less than 140lb (300gsm) in weight need to be stretched before use, otherwise they will cockle when water is applied. First, the paper is soaked in water so that it expands; it is then taped or stapled to a board. As it dries it contracts, giving a taut surface that will not buckle when subsequent washes are applied.

**1** Dip a sponge in clean water and wipe it over the paper, making sure you leave no part untouched.

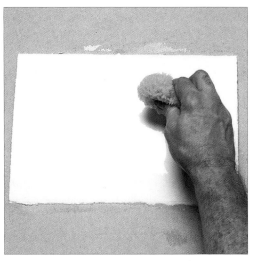

**2** Make sure a generous amount of water has been applied over the whole surface and that the paper is perfectly flat.

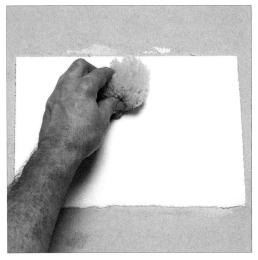

**3** Moisten four lengths of gum strip and place one along each long side of the paper. (Only gummed brown-paper tape is suitable; masking tape will not adhere to damp paper.)

**4** Repeat for the short edge of the paper. Leave to dry. (In order to be certain that the paper will not lift, some artists also staple it to the board.)

# Brushes

A quick glance through any art supplier's catalogue will reveal a bewildering range of brushes, from outrageously expensive sable brushes to budget-range synthetics. Although you might be tempted to invest heavily and stock up on a vast selection, in all shapes and sizes, in practice you can get away with a small number: a large brush for laying a wash, a medium-sized brush for moderate washes and larger details, and a smaller brush for fine detail should be enough to begin with.

The two main shapes of brush are flat and round. Round brushes are perhaps the most useful general-purpose brushes. They hold a lot of paint, allowing you to lay down broad strokes of colour and washes, but they also come to a fine point for more precise marks. Flat brushes have a square, chisel-shaped end. These, too, can be used for broad washes, while the flat end is used for making clean-edged, linear marks.

Many artists use Chinese-style brushes similar to those used by calligraphers: like good-quality round brushes, they hold a lot of paint but also come to a fine point. You may also come across rigger brushes (round brushes with long hairs and a fine point), which are useful for fine lines and details, and spotter brushes (less common, with very short hairs), which tend to be used by miniaturists and other artists whose work involves painting fine, very precise details.

Brushes can be made from natural hair. Sable, which is obtained from the tail of the sable marten, a relative of the mink, is the best, and the best sables come from the Kolinsky region of northern Siberia. Camel, ox and squirrel hair are common, as are synthetic materials. Buy the best quality you can afford. Cheaper brushes may shed hairs or wear out more quickly, and they may not hold as much colour or come to a point. Look for seamless, corrosion-resistant ferrules: they hold the hairs tightly and will not tarnish. Also check whether they hold their shape well. Unfortunately, you can't always tell this when you buy brushes as they are often "dressed" with some kind of adhesive, which needs to be washed out before you use them, so that they hold their points.

## Round brushes ▼

Most art stores stock round brushes ranging in size from the ultra-fine 000 right up to the rather fat size 12, although you will also find brushes that lie outside this range. To begin with, however, three brushes – one small, one medium and one large – will provide you with a versatile selection that should cover most eventualities. It is good practice to use the largest brush that you can for any given painting situation, so that you get into the habit of making broad, sweeping marks rather than tight, fussy ones.

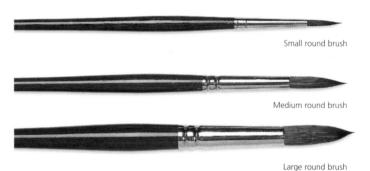

Small round brush

Medium round brush

Large round brush

## Large brushes ▼

Both flat brushes and mop brushes can be used to lay a wash over the paper ground. Flat brushes are wide and straight-edged, while mop brushes have large, round heads.

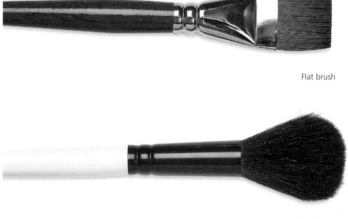

Flat brush

Mop brush

**Other types of brush** ►
Your choice of brush is very much a matter of personal taste, so experiment to find out which ones you enjoy using. You will find that some suit your style of painting better than others. Shown here are some of the other types of brush that you might come across.

A rigger brush has long hairs and a very fine point, and is good for painting fine lines and details. A Chinese-style brush is good for flowing, calligraphic marks; it holds a lot of paint and keeps its shape well, making it a versatile brush. The flat edge of a chisel brush makes it a good choice for painting straight-edged shapes – when painting up to the edge of a building, for example. In a fan brush, the bristles are splayed out, and this makes it useful for drybrush work.

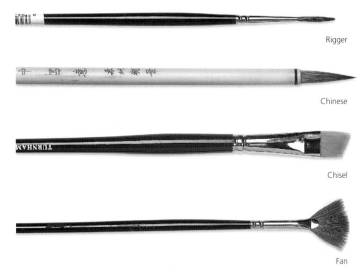

Rigger

Chinese

Chisel

Fan

## Caring for brushes

Given the cost of good-quality brushes, it is worth taking the time and trouble to look after them properly in order to prolong their life.

You should always clean your brushes immediately after use. Gently rub a little liquid detergent into the hairs, working it in with your fingertips and working right up to the ferrule. Rinse in clean running water until all the paint has been removed.

**Cleaning brushes** ▼
No matter how carefully you rinse your brushes, liquid detergent is the only way to be sure that you have got rid of all paint residue.

**Storing brushes** ►
After cleaning your brushes, squeeze the hairs to remove any excess water and then gently reshape the brush with your fingertips. Leave to dry. Store brushes upright in a jar to prevent the hairs from becoming bent as they dry.

**Tips**: • When you are painting, try not to leave brushes standing in water as this can ruin both the hairs and the wooden handles.
• When cleaning brushes, keep rinsing the brush under running water until the water runs clear. Make sure that any paint near the metal ferrule has been completely removed.
• Do not be tempted to store newly cleaned and still-wet brushes in an airtight container as mildew can develop.
• Moths are very keen on sable brushes, so if you need to store your brushes for any length of time, it is a good idea to use mothballs to act as a deterrent.

# Pencils and pens

While there is no need to have more than a small selection, pencils and pens are valuable accessories in the artist's tool kit.

## Pencils

The most common use of pencils in watercolour paintings is to make an initial underdrawing to map out the composition and put in the main lines of your subject as a guideline for when you come to apply the paint. It is very useful to keep a small selection of pencils to hand for this purpose.

Although graphite pencils range from 9B (very soft) to 9H (very hard), the more extreme choices are actually less useful: very soft pencils can smear while very hard ones make light, unimpressive marks. A more average HB and a 2B or 4B should be adequate for most underdrawings, depending on how strong you want the marks to be. It is also worth having a few very soft pencils in your collection to make quick tonal studies. Charcoal pencils and sticks are ideal.

Coloured pencils, too, are useful, and are particularly good for making colour notes when you are sketching on location. They are available in many colours but, unlike graphite pencils, only one degree of hardness.

You can also buy water-soluble pencils and crayons, both of which allow you to combine linear marks with the fluidity of watercolour washes. Easily portable, they are useful for location work. The range of colours is extensive, but many artists feel that they lack the subtlety of watercolour paints. Some brands seem to blend better than others, so experiment to find out which kinds you enjoy using.

> **Tip**: If you wish to use water-soluble pencils on location but do not want to carry the pencils, make heavy scribbles on paper in a range of colours: when you brush the scribbles with clean water you can pick up enough colour on the brush to use them as watercolour paints.

**Pencils ▼**
It is useful to keep a small range of pencils to hand for making tonal studies and underdrawings. For general usage, choose a medium hard pencil such as HB or 2B.

Charcoal pencil

HB graphite pencil

2B graphite pencil

**Water-soluble pencils ▼**
Water-soluble pencils can be used dry, to make clearly defined marks, or wet to create soft blends and colour mixes. To use a water-soluble pencil wet, either dip the tip in clean water or apply the pencil to the paper in the normal way and brush over the marks with a wet brush.

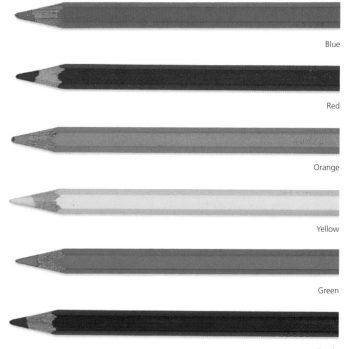

Blue

Red

Orange

Yellow

Green

Purple

◄ **Crayons**
These colour sticks are similar in consistency to hard pastels. Crayons are capable of much bolder effects than pencil, and are excellent for crisp, decisive lines and for areas of solid dark tone, as they can be sharpened to a point or broken into short lengths and used sideways. Bear in mind that crayons cannot be erased easily.

## Pens

Pens are most frequently used in watercolour in the line-and-wash technique, in which linear detail is put in in ink on top of (or under) loose watercolour washes.

There are various kinds of pen suitable for this technique. Fountain pens have the advantage of having a reservoir to hold the ink (or are loaded with a cartridge of ink), which means that you don't have to keep stopping to reload, but many artists prefer the spontaneity and rougher lines of dip pens. Both have interchangeable nibs, allowing you to vary the width and character of the lines you make. You can also create different widths of line by turning the pen over and using the back of the nib. Technical drawing pens of the type used by architects and graphic designers deliver a line of uniform width. These are available in a range of sizes.

As far as inks are concerned, your choice is between waterproof and water-soluble. Once dry, waterproof ink marks will remain permanent even when watercolour paint is applied over the top. Water-soluble inks, on the other hand, will blur and spread.

Inks can be used at full strength or diluted with water to create different tones; you may want to use several dilutions of ink in the same painting. Black is the colour traditionally used in line and wash, but there are many other colours available; they do not, however, possess the lightfastness of watercolour pigments.

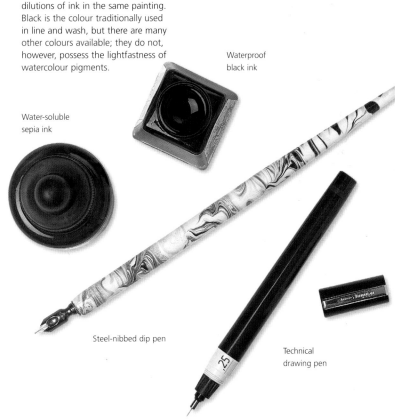

Waterproof
black ink

Water-soluble
sepia ink

Steel-nibbed dip pen

Technical
drawing pen

# Additional equipment

There are a few other pieces of equipment that you will probably find useful in your watercolour painting, ranging from things to secure your work to the drawing board and easels to support your painting to aids to specific painting techniques.

The most important thing is that the surface on which you are working must be completely flat and unable to wobble around as you work. If you use blocks of watercolour paper, then the block itself will provide enough support; you can simply rest it on a table or your knee. If you use sheets of watercolour paper, then they need to be firmly secured to a board. Buy firm boards that will not warp and buckle (45 x 60cm/18 x 24in is a useful size), and attach the paper to the board by means of gum strip or staples.

It is entirely a matter of personal preference as to whether or not you use an easel. There are several types on the market, but remember that watercolour paint is a very fluid liquid and can easily flow down the paper into areas that you don't want it to touch. Choose an easel that can be used flat and propped at only a slight angle. The upright easels used by oil painters are not really suitable for watercolour painting.

Other useful pieces of equipment include a scalpel or craft (utility) knife: the fine tip allows you to prise up pieces of masking tape that have become stuck down too firmly without damaging the paper. You can also use a scalpel to scratch off fine lines of paint – a technique known as sgrafitto. Absorbent kitchen paper is invaluable for cleaning out paint palettes and lifting off or softening the colour before it dries.

As you develop your painting style and techniques, you may want to add other equipment to the basic items shown here. You will probably assemble a selection of props, from bowls, vases and other objects for still lifes, to pieces of fabric and papers to use as backgrounds. Similarly, you may want to set aside pictures or photographs that appeal to you for use as reference material. The only real limit to what you can use is your imagination.

### Box easel ▼

This easel includes a handy side drawer in which you can store brushes and other paraphernalia, as well as adjustable bars so that it can hold various sizes of drawing board firmly in place. Some easels can only be set at very steep angles, which is unsuitable for watercolour, so do check before you buy.

### Table easel ▼

This inexpensive table easel is more than adequate for most watercolourists' needs. Like the box easel it can be adjusted to a number of different angles, allowing you to alter the angle to suit the technique you are using. It can also be folded flat so that it can be stored neatly when it is not in use.

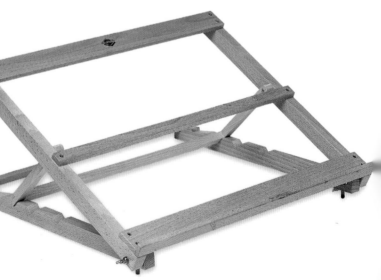

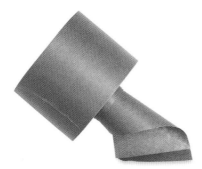

**Gum strip** ▲
Gummed brown-paper strip is essential for taping stretched lightweight watercolour paper to a board, to ensure that it does not buckle when the water is applied. Leave the paper stretched on the drawing board until you have finished your painting and the paint has dried, then simply cut it off, using a scalpel or craft (utility) knife and a metal ruler, and discard. Masking tape cannot be used in place of gum strip for the purpose of taping stretched watercolour paper.

**Gum arabic** ▲
Adding gum arabic to watercolour paint increases the viscosity of the paint and slows down the drying time. This gives you longer to work, which is often what you need when painting detail or referring to a reference photo while you are painting. Add a few drops of the gum arabic to your paint and stir to blend. Gum arabic also imparts a slight sheen on the paper, which can be useful for certain subjects, and it increases the intensity of the paint colour.

**Sponge** ▲
Natural or synthetic sponges are useful for mopping up excess water. Small pieces of sponge can be used to lift off colour from wet paint. Sponges are also commonly used to apply paint, with the pitted surface of the sponge creating interesting textures on the paper.

**Masking fluid and masking tape** ▲
Masking is one of the most basic techniques in watercolour. It is used to protect white areas of the paper so that they do not get splashed with paint, or when you want the white of the paper to represent the lighter areas of your subject. Depending on the size and shape of the area you want to protect, masking fluid and masking tape are the most commonly used materials. Masking tape can also be used to secure heavy watercolour paper, which doesn't need to be stretched, to the drawing board.

**Eraser** ▲
A kneaded eraser is useful for correcting the pencil lines of your underdrawing, and for removing the lines so that they do not show through the paint on the finished painting.

**Tips:** • Store small painting accessories such as sponges and rolls of tape in lidded boxes to keep things neat and tidy; plastic food storage boxes are ideal.
• Store bottles upright and always put the lids back on immediately after use to prevent spillage.
• Wash sponges immediately after use.

# From light to dark

One of the things that attracts people to watercolour painting, and the one characteristic for which watercolour is most renowned, is its translucency. Good watercolours glow with a light that seems to come from within the painting itself. The reason for this is that pure watercolour paints are transparent: when a wash of watercolour paint is applied to paper, the white of the paper shines through. This is what makes watercolour the perfect choice for capturing subtle nuances of light and shade and creating a feeling of airiness that is unrivalled by any other painting medium.

However, the transparency of the paint imposes a technical constraint that you need to be aware of. When one colour is laid on top of another, particles of the first colour will still show through.

In opaque media such as oils, you can obliterate a dark colour by placing a light one on top of it. In pure watercolour, however, if you try to paint a pale yellow on top of a dark blue, some of the blue will remain visible – so instead of yellow, the two colours will appear to merge to form a green.

In practical terms, this means that you have to work from light to dark, putting down the lightest tones first and working around them as you develop the painting. You have plan ahead and work out where the light tones and colours are going to be before you pick up a brush and begin the actual painting.

One other important consideration is that in pure (transparent) watercolour there is no such thing as white paint. If you want certain areas of your painting

to be white, the only white available to you is the white of the paper, and so you leave those areas free of paint, protecting them if necessary by applying some kind of mask. Alternatively, you can use white gouache, but gouache is opaque, and so you have to be very careful not to lose the feeling of luminosity.

**Osprey ▼**

The artist has combined watercolour with white gouache to great effect. The billowing clouds were created by leaving areas of the sky free of paint and by blotting off paint with a paper towel to soften the colour around the edges of the clouds. The ripples and spray in the water were painted using very dilute white gouache so as not to lose the wonderful feeling of light.

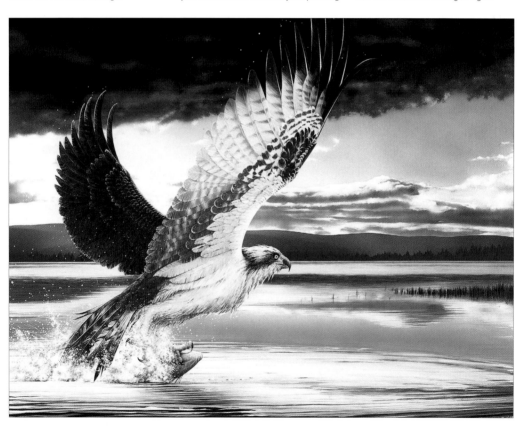

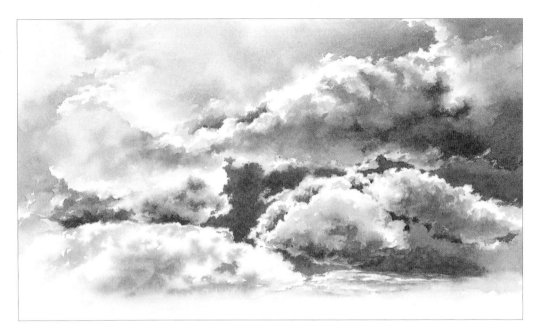

**Stormy sky** ▲

The artist began this study of a stormy sky by dampening the paper with clean water and dropping in a very pale grey colour, allowing it to spread of its own accord. She then blotted off paint in some areas with a paper towel to reveal the white of the paper before adding the mid- and dark greys and the deep blue of the sky, wet into wet.

**Poppies** ▶

Watercolour is a wonderful medium for painting translucent subjects such as flower petals. Following the light to dark rule, the artist began by putting down the very pale yellowy green colour that is visible in the background and around the edges of the flowers. She then gradually applied more layers of colour to build up the density of tone on the petals and make the flowers look three-dimensional, taking care to allow some of the first very pale washes to show through in places. Note how paint has been scraped off to create the striations in the petals and delineate the petal edges: using the white of the paper in this way adds "sparkle" to the image. Tiny touches of opaque yellow gouache give the flower centres and stems solidity, without destroying the translucency of the painting as a whole or the balance between the two media. Careful planning and observation of the light and dark tones have resulted in a fresh and spontaneous-looking study of a perennially popular subject.

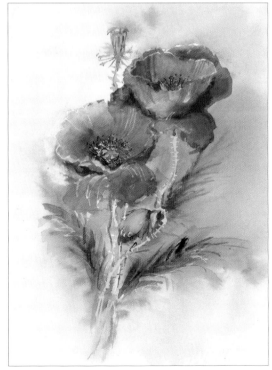

# Making marks

Although artists are, by definition, inventive and apply watercolour paint with a variety of tools in order to create as wide a range of marks as possible, a brush is still the most basic and the best tool for the job. There are so many different brushes on the market that it seems as if there is a shape and a size to cover every eventuality, and it is easy to get carried away and buy a lot of brushes that you will rarely, if ever, use. With a little practice, however, you will find that you can get a remarkable range and variety of marks from a single, carefully chosen brush simply by altering the way you hold it and apply it to the paper.

A good first brush is a round, soft-haired (preferably sable) watercolour brush. This is probably the most widely used and versatile type. A medium round brush (say, no.8 or no.10) is a good, general-purpose brush, as it holds sufficient paint to make washes but also comes to a good point for fine detail work.

The conventional, and perhaps the most obvious, way to hold a brush is to hold it in the same way as you would a pen or a pencil, but that is by no means the only option.

Holding the brush with four fingers on one side of the barrel and your thumb on the other and pushing or pulling it quickly sideways will leave a broken smear of paint that is perfect for depicting texture and is totally unlike the mark made when using the point of the brush. These marks can be long or short; the density and spread of paint depends on the speed of the stroke.

Holding the brush vertically allows you to make a stabbing action, which results in a series of individual marks. You can vary the size of the marks by altering the amount of pressure you apply and the speed at which you apply it. The amount of pressure that you apply also has a marked effect. Increasing the amount of pressure that you apply, so that more of the sable hair comes into contact with the support, increases the width of the stroke.

A flat or a mop-shaped brush will result in a completely different range of marks. Experiment with different brushes to find out what you can achieve.

**Strokes of an even width**
To create strokes of an even width, use the tip of the brush and apply a steady pressure. Apply more pressure to increase the width of the line. For short strokes, you may find it helpful to rest your little finger on the paper surface as a balance, but take care not to smudge any wet paint if you do this.

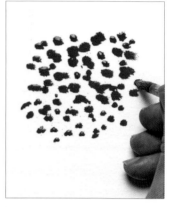

**Dots**
A stabbing or stippling creates a series of dots or blob-shaped marks. Holding the brush in an upright position helps to speed up the process and make it more controllable.

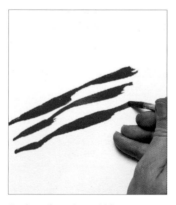

**Strokes of varying widths**
Varying the amount of pressure you apply also varies the width of the brushstroke, resulting in expressive calligraphic marks.

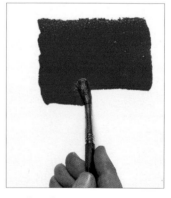

**Broad washes**
To make a wash that covers a wide area, use the side of the brush, rather than the point, and apply even pressure as you make the stroke.

**Tip**: Load your brush with plenty of paint. Using too little paint will mean that you run out quickly, often in mid mark. The amount of paint delivered to the support should come as much from the pressure applied as from the amount of liquid held within the brush fibres.

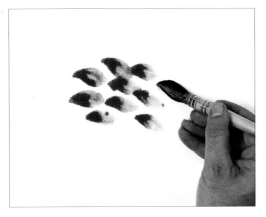

**Brush shape**
Pressing the brush to the paper surface without moving
it results in marks that reflect the shapes of the brush.

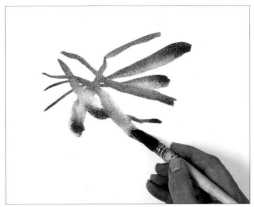

**Thick and thin**
Provided your brush holds a point well, you can create marks
that vary greatly in thickness by applying more or less pressure.

**Quick washes**
A Japanese-style hake brush holds a large amount of paint,
and this makes it easy to lay flat washes. This is a good choice
of brush if you need to cover a large area with paint.

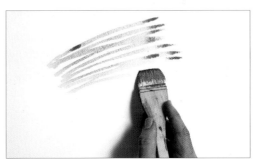

**Thin lines**
Used on its edge and with a light touch, even a large flat
brush can be made to make delicate brush marks. Practise
until you get a feel for the amount of pressure needed.

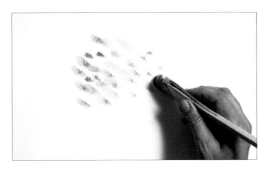

**Uniform pattern**
Using even pressure and the corner of the brush to dab
or stipple paint on to the support will result in a series of
uniformly shaped marks.

**Varying the texture**
Using a similar stippling action while varying the pressure
and the angle at which the brush is held will create a loosely
textured area, made up of marks of different shapes.

# Washes

A wash is the term used to describe the process of applying watercolour paint in a single layer. There are three kinds of washes – flat, gradated and variegated (which is really a variation on a gradated wash). Although the technique is broadly the same way in all three cases, the results look very different.

Washes are among the most fundamental of all watercolour techniques. Sometimes washes are applied over the whole of the paper, and sometimes they are used over only selected areas. It is very rare for a painting to be composed entirely of washes, but as a wash of one kind or another is very often the first stage in producing a watercolour, it is well worth taking the time and trouble to master the technique. It will stand you in good stead for all your subsequent work and is an essential first step in getting used to manipulating paint on paper.

A flat wash is, as the name implies, a wash that is completely even in tone. All pictures need some blank and uncluttered areas, so flat washes are necessary on occasions, either to provide a base for the rest of the painting or as "breathing spaces" that allow the viewer's eye to rest. Flat washes can be particularly useful in abstract, or semi-abstract, work. In representational work, however, too many flat washes will lead to a dull and uninteresting painting. A flat wash contrasts well with many of the techniques used to introduce texture into watercolour paintings, such as spattering and stippling, as well as with other media, such as pastels, inks and coloured pencils.

Gradated and variegated washes are both designed to give some variety of tone. Like the flat wash, both are normally used in conjunction with other techniques. Both gradated and variegated washes are particularly useful in landscape painting.

> **Tip**: It is difficult to mix two washes that are identical in tone, so always mix more wash than you think you will need, so that you don't have to stop halfway through a painting to mix more, then find that you cannot match the tone.

## Flat wash

A well laid flat wash should show no variation in tone. Having said that, however, the kind of paper you use does have an effect and it is worth experimenting so that you know what results you can expect.

Work smoothly and confidently, without hesitation. Never go back over an area that you have already painted or the tones will be uneven. Work with your drawing board flat, or angle it slightly to help the paint flow down the paper. Use a large round-headed brush that holds a lot of paint, so that you can work quickly without having to re-load the brush.

1 Using a large wash brush, mix a generous amount of wash (here, sap green was used). Working from left to right, lay a smooth stroke of colour across the paper.

2 Quickly re-load your brush with more paint. Pick up the pool of paint at the base of the first stroke with your brush and continue across the paper, again working from left to right.

3 If you find you've got too much paint at the base of the wash, dry your brush on tissue paper and run it along the base of the wash to pick up the uneven streaks.

**The finished flat wash**
The wash has dried to a flat, even tone with no variation or visible brushstrokes.

The fewer strokes you use, the flatter the wash will be – so use a large brush if you want to cover the whole paper.

# Gradated wash

A gradated wash is painted in a similar way to a flat wash, using a large brush and brushstrokes that dry evenly without leaving any streaks, but it shows a variation in tone. More water is added to the wash as you work down the paper so that the colour gradually gets lighter. Alternatively, you can add more pigment to the wash so that it gradually becomes darker in tone.

A gradated wash is often used to paint skies which, because of the effects of aerial perspective, are usually darkest at the top of the painting and paler towards the horizon.

You can also use a gradated wash to make one side of your subject darker in tone than another; the dark side looks as if it is in shadow, and this helps to make your subject look three-dimensional. Transitional gradations such as this are excellent for painting curved surfaces, such as glass bottles, oranges and domed roofs.

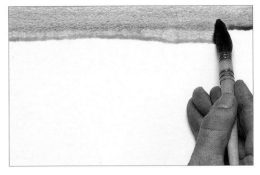

1 Lay the first stroke of colour as for a flat wash, working from left to right with smooth, even strokes.

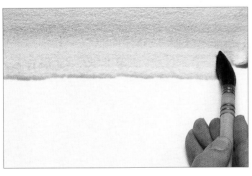

2 Add more water to the wash to make a paler tone and continue to work across the page from left to right.

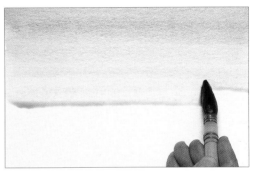

3 Continue as before, adding more water to the wash with each stroke so that it gets lighter as you move down.

4 As more water is added to the paint mixture, the colour virtually disappears.

**The finished gradated wash**
In the final wash, the colour has paled from a strong tone at the top to almost nothing at the base.

## Practice exercise: **Landscape using flat and gradated washes**

Although washes are among the most fundamental of watercolour techniques, they can be used as the basis for simple little studies that you can be proud to hang on your wall.

This exercise is based around using flat and gradated washes to establish the planes of an imaginary landscape scene. The simple detailing that is added on top of the washes – the trees and the distant farmhouse – create texture and add visual interest to the painting.

You could easily adapt this exercise to create an imaginary landscape of your own. Choose colours for the underlying washes that are appropriate to the main subject of the painting – perhaps warm yellows and greens for a woodland scene, or blues for a seascape.

### Materials
- *2B pencil*
- *140lb (300gsm) rough watercolour paper, pre-stretched*
- *Watercolour paints: cerulean blue, yellow ochre, cadmium lemon, cobalt blue, viridian, raw sienna, Payne's grey, ultramarine violet, neutral tint, light red, cadmium red, burnt umber*
- *Brushes: large mop, medium round, fine round*

### Reference sketch
A quick sketch made in situ outdoors, when standing in front of your chosen scene, is a useful way of trying out compositions and colour combinations to see what works best. Use it as reference material to produce a more detailed painting when you get home.

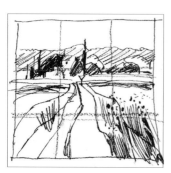

1 Using a 2B pencil, sketch the main shapes of the subject – in this case, the foreground path, the house and trees in the middle distance, and the tree-covered hills in the background.

3 At the bottom of the gradated wash, where the colour has paled to almost nothing, put down a broad stroke of very pale yellow ochre. You may need to tilt the drawing board backwards slightly to prevent paint from flowing into the dry part of the paper, below the sky area.

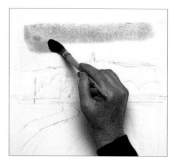

2 Using a large mop brush, dampen the whole of the sky area with clean water. As soon as you have finished, lay a gradated wash of cerulean blue across the top of the sky.

4 While the first wash is still damp, lay a stroke of cerulean blue across the top of the sky to intensify the colour. Leave to dry. Mix a pale green from cadmium lemon and cerulean blue and wash it over the foreground grass on either side of the road and the trees in the middle distance. Leave to dry.

5 Mix a bluish green from cobalt blue and a little viridian. Using a large mop brush, wash the paint over the tree-covered hill in the distance, taking care to leave the house untouched. You may need to use a finer brush to go around the outline of the house. Dot in the shapes of trees along the horizon and leave to dry.

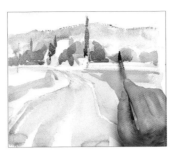

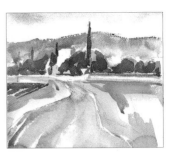

6 Mix an olive green from raw sienna, cobalt blue and a little cadmium lemon. Brush the mixture over the trees and the foreground. Mix a pale mauve from Payne's grey and ultramarine violet and paint the road. Leave to dry.

7 Mix a dark green from neutral tint and viridian. Using a medium round brush, paint in the dark shapes of the trees. Don't worry too much about making the shapes accurate, just go for the overall effect. Leave to dry.

8 Mix a strong wash of ultramarine violet and paint a broad stroke of colour below the trees, to the right of the farmhouse. Paint another to the left of the road to indicate the brightly coloured fields of lavender.

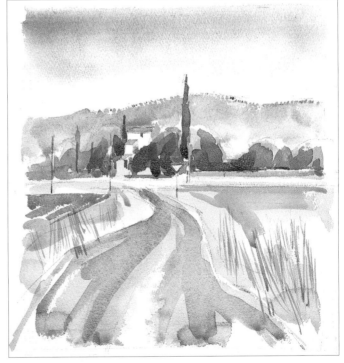

9 Paint the roofs in light red and the outline of the road sign in cadmium red. Note how these small touches of hot colour stand out against the cool blues and greens used elsewhere in the painting. Mix a wash of ultramarine violet and burnt umber, and paint over the foreground road.

10 Mix a warm brown from cadmium lemon, raw sienna and a little cobalt blue. Paint in the fine foreground grasses, using a fine round brush.

**The finished painting**
This painting effectively combines flat and gradated washes in a charming landscape that is full of character. Flat washes of colour on the hillside and winding foreground road, and a gradated wash of cerulean blue on the sky, establish the basis of the scene, while a few simple details – the broad strokes of colour for the trees in the distance, the sharp lines of the foreground grasses and the small touches of red on the roof in the middle distance – help to bring the scene to life.

## Variegated wash on damp paper

A variegated wash is a variation on the gradated wash, but instead of adding more water, you gradually introduce another colour. When properly done, the transition from one colour to the next should be almost imperceptible.

Some artists find it easier to dampen the paper first, using either a sponge or a lmop brush dipped in clean water. This allows the colours to blend and merge in a much more subtle way, without any risk of hard lines appearing between one colour and the next. You may need to allow the paper to dry slightly before you apply any paint: this is something you will learn with practice. However, if you prefer, you can work on dry paper.

**1** Dampen the paper with a sponge dipped in clean water. Use plenty of water: you can let the paper dry a little before applying the paint, if necessary.

**2** Using a large wash brush, lay a stroke of colour over the paper, working from left to right. The paint spreads more evenly on damp paper.

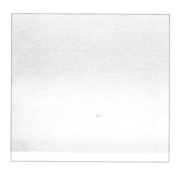

**Variegated wash on dry paper**
Here, the division between the two colours is slightly more obvious.

**3** Clean your brush thoroughly and load it with a second colour. Start laying this colour over the first. Continue until the wash is complete.

**Variegated wash on damp paper**
In the finished wash, the colours merge together almost imperceptibly, with no obvious division between the two.

## Practice exercise: **Sunset using a variegated wash**

A variegated wash is one of the most useful techniques for painting a sunset in watercolour. This simple exercise also shows you how to create a silhouette to turn the variegated wash into an attractive landscape painting.

**Materials**
- *2B pencil*
- *140lb (300gsm) rough watercolour paper, pre-stretched*
- *Watercolour paints: ultramarine blue, cadmium orange, cadmium red, ultramarine violet, alizarin crimson, sepia*
- *Brushes: large round, small round*

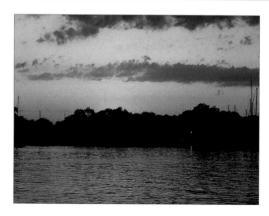

**The original scene**
Striking colours, shimmering reflections and a bold silhouette – all the ingredients for a sunset with impact.

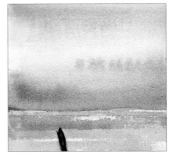

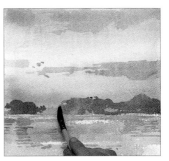

1 Using a 2B pencil, lightly sketch the outline of the silhouetted trees on the skyline. Using a large round brush, dampen the paper with clean water. Mix a wash of ultramarine blue and, again using the large round brush, lay a gradated wash over the top half of the paper, adding more water with each brushstroke so that the blue colour pales to almost nothing just above the horizon.

2 Mix an orangey red from cadmium orange and cadmium red. While the paper is still damp lay this colour over the lower half of the paper, allowing it to merge wet into wet into the very pale blue around the horizon line. Leave to dry. Dampen the paper again very slightly. Brush a broad stroke of the same orangey red mix across the middle of the painting (this will form the basis of the silhouetted land area) and dot it into the sky. Leave to dry.

3 Mix a warm purple from ultramarine violet and a little alizarin crimson. Using a large round brush, brush this mixture on to the sky to represent the dark cloud shapes. Add a little more pigment to the mixture to make a darker tone and paint the outline of the silhouetted trees. Using the same mixture, paint a few broken brushstrokes on the water for the dark reflections of both the trees and the land area.

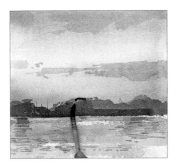

4 Mix a dark violet from ultramarine violet and sepia and darken the silhouetted area, adding a few fine vertical lines for the boat masts that stick up into the sky.

**The finished painting**
A two-colour variegated wash forms the basis of this colourful sunset, while a bold silhouette gives the viewer a strong shape on which to focus. Although the painting itself is very simple, the choice of rich colours and the careful placing of both the silhouetted land form and the reflections in the water combine to make an atmospheric little study.

The initial blue wash merges almost imperceptibly with the rich, warm colours of the sunset.

The white of the paper shows through in places – a simple but effective way of implying water sparkling in the last rays of the setting sun.

# Understanding tone

"Tone" is a word that you will often come across in art books: it simply means the relative lightness or darkness of a colour. The exact tone depends on the degree and quality of light falling on a particular object: if one side of an object is in shadow, it will be darker in tone than a side that is in direct sunlight. You can often see this clearly by looking at two adjacent sides of a building, where the front of the building is illuminated by the sun and the other forms one side of a narrow, shaded alleyway. Both sides of the building are made from the same materials, and we know they are the same colour, but the side that is in shade looks considerably darker.

But why is tone important in painting? The answer is that it enables you to create a convincing impression of light and shade, and this is one of the things that helps to make your subjects look three-dimensional.

This means that you have to analyse your subject and decide at the outset where the lightest areas of your painting are going to be. Because watercolour paint is transparent and you cannot lay a light colour on top of a dark one without the underlying colour showing through, you usually start with the lightest tones and build up to the darkest. Before you begin painting, therefore, it is often helpful to make a quick tonal sketch to work out where the light, medium and dark tones should be placed. Get the tonal structure right and much of the rest of your work will fall into place.

### Single-colour subject ▼

Even a single-colour subject, such as this strongly lit orange, consists of hundreds of slightly different tones. The human eye, however, can only make out the difference between a fraction of this number.

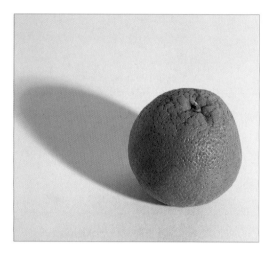

### Tonal sketch ▼

When you sketch a single-colour subject, you need to show some differences in tone in order for it to look convincing. However, most images will still read convincingly when broken into only a handful of tones, as here. The side of the orange

that faces away from the light, looks dark. The side that is directly illuminated by the light is a much lighter tone. In very strong light, the best way to convey this may be to leave highlight areas completely white and untouched by paint.

## Translating colours to tones

But just how do you analyse the tones in your subject? We're used to describing things by their colour – red, blue, green and so on – but assessing tones is a different matter. One of the best ways to grasp the concept is try to imagine what a black-and-white photograph of your subject would look like.

Confusingly, colours that look very different (say, red and green) may turn out to be very similar in tone, while colours that you might expect to be light in tone (such as yellow) may actually be fairly dark, depending on how the light hits them. In addition, of course, you will find infinitely subtle gradations of tone across an object.

To make it simple, break down what you see into a few tones only – say, four or five – varying from white to black in stages. To get yourself more attuned to tones, set up some contrasting objects and, using numbers, place them in the correct order from light to dark. Time yourself. You will gradually train yourself to recognize tones more quickly. Start with objects that are strongly lit from one side, as this makes it easier to discern different tones, and gradually move on to more evenly lit objects as you develop your ability to assess tonal values. Another useful exercise is to make black-and-white photocopies of colour photographs.

**Multi-coloured subject** ▲
When you're dealing with a subject that contains many colours, it can be difficult to work out which tones are light and which ones are dark. Try to imagine your subject as if it was a black-and-white photograph.

**Colour converted to tone** ▲
Note that different colours – for example, the oranges and the foreground lemon – are very similar in tone. The shaded sides of the bananas, which we know to be a lighter yellow than the lemon, look darker than one might expect.

## Mixing tones

Once you've trained yourself to analyse tones, you need to apply this knowledge in your paintings. In pure watercolour, you make tones darker by adding more pigment (or black) and

lighter by adding more water. Practise doing this with a range of different colours so that you get better at judging how much more pigment or water to add.

**Tonal strip** ▼
Here, alizarin crimson watercolour paint (shown in the centre of the strip) has been progressively darkened by adding black and lightened by adding water.

▶

## Practice exercise: **Tonal study in monochrome**

This exercise trains you to assess tone by using five tones of the same colour to create a three-dimensional impression of blue and green children's play bricks. The image is painted in layers, working from light to dark, with each layer being allowed to dry before the next one is applied.

Note that the tone of the mixed washes always looks darker when it is wet than it does when it is dry. With practice you will learn to compensate for this by mixing your tones so that, when you first apply them, they appear to be a little darker or more intense than necessary.

Once you have done this exercise, try your own versions of it using other objects that you might have lying around the home. Books and plastic food containers are good choices as they are straight sided, so you can concentrate on the tones without having to worry too much about getting the shapes right.

### Materials
- *200lb (425gsm) NOT watercolour paper, pre-stretched*
- *2B pencil*
- *Watercolour pigment: burnt umber*
- *Brush: medium round*

### The set-up
Set up your subject on a plain white background (a large sheet of paper will do), with a table lamp in front and slightly to the left of it. Spend some time looking at it in order to decide which tone each area is going to be. If it helps, make a quick pencil sketch and number each area from one to five, with one being the lightest tone and five the darkest.

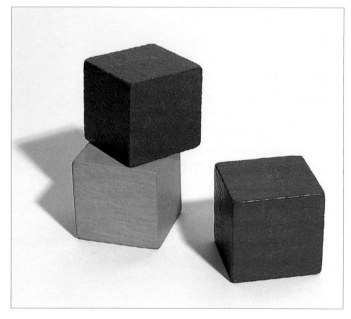

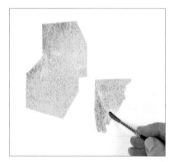

1 Using a 2B pencil, lightly sketch the bricks, taking careful note of where they overlap. Mix a thin wash of burnt umber (tone 1) and, using a medium round brush, paint all the brick shapes in this tone. This is the lightest tone.

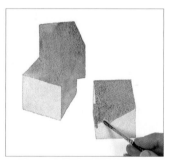

2 Strengthen the wash slightly by adding a little more burnt umber pigment (tone 2). Leaving the lightest area (the side of the green brick) untouched, apply tone 2 over all the remaining areas. Even though only two tones have been used so far, the image instantly begins to have form.

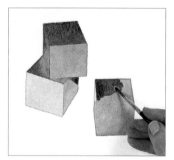

3 Add a little more pigment to the wash to darken it further and brush it over those areas that are in deeper shadow (tone 3). The shape of the three bricks is becoming ever more apparent. The tone is deepened both by adding more pigment and by overlaying successive layers of colour.

**4** Now mix up tone 4. As before, do not by make a new mix, but instead, add more burnt umber pigment to the previous one to make it darker. Carefully apply this tone along the lower edge of, and below, the topmost blue brick, where a small shadow is cast across the green brick.

**5** Tone 5, the darkest tone (created by the deep shadow reflected in the slightly shiny surface), is evident on the left-hand side of the topmost brick. A similar dark tone can be seen on the right-hand side of the brick below. This is created by the reflection of the shadow from the right-hand brick.

**6** Put the finishing touches to the study by adding the cast shadow of all three bricks. Leave to dry.

**The finished painting**

Although this is nothing more than a technical exercise, the bricks look convincingly three-dimensional. This is entirely due to the fact that the artist paid very careful attention to the relative tones and built up the density by overlaying several layers where necessary, even though he used only five tones of the same colour to make the painting.

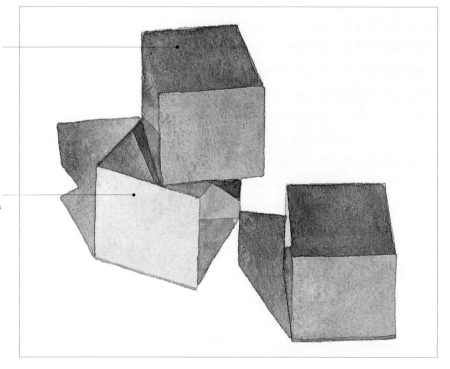

The darker tones are created by adding more pigment to the wash and also by applying several layers so that the tone is darkened gradually.

The lightest tone is created by means of a single wash of tone 1.

# Understanding colour

Colour is an important element in most artistic endeavours, but in order to capture the subtle and elusive qualities of light seen in the best watercolours, a basic knowledge of colour theory is especially valuable. It will help you to understand why some colour mixes work better than others, and how to use the emotional effect of colours in your paintings.

## Primary, secondary and tertiary colours

It was the Englishman Isaac Newton who first proved that white light is made by the mixing together of the seven spectrum colours of red, orange, yellow, green, blue, indigo (or blue/violet), and violet. This is known as additive colour mixing, because the "adding" together of the seven spectrum colours results in white light.

Pigment colours, however, behave in a different way. Mix together a similar range of pigment colours and the result is an almost black, mud-coloured mess. This is because every time you mix one pigment colour with another, the resulting colour is always duller and less pure than the parent colours. The more colours that are mixed together, the less pure the resulting colour will be, and the darker the resulting mix. If the three primary colours are mixed together, all the light waves are absorbed from white light, ultimately resulting in black. In other words, you subtract light and so this is known as subtractive colour mixing.

The classic diagram for explaining colour theory is the colour wheel, which illustrates the relationships between the different colours. Red, yellow and blue are the three primary pigment colours. These can only be manufactured: they cannot be mixed by combining any other colours. They are also sometimes known as the "first" or "principal" colours.

Mixing equal amounts of red with yellow creates a mid-orange; mixing yellow with blue creates a mid-green; and mixing blue with red creates a mid-violet. These are known as the secondary colours.

Mixing a primary colour with an equal amount of the secondary colour next to it results in six more colours, which are known as tertiary colours. These are red-orange, orange-yellow, yellow-green, green-blue, blue-violet, and violet-red. The quality and intensity of these tertiary colours can be extended almost indefinitely, not only by varying the proportion of the primary and secondary colours used in the mix, but also by varying the amount of water added to lighten them.

However, it is important to remember that there are many different versions of the three primary colours, and your choice of primaries therefore dictates the kind of secondary and tertiary colours that you can mix.

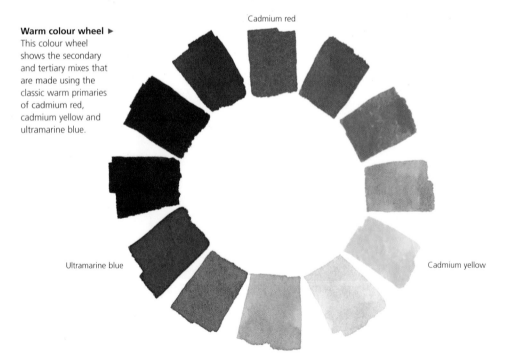

Cadmium red

**Warm colour wheel ▶**
This colour wheel shows the secondary and tertiary mixes that are made using the classic warm primaries of cadmium red, cadmium yellow and ultramarine blue.

Ultramarine blue

Cadmium yellow

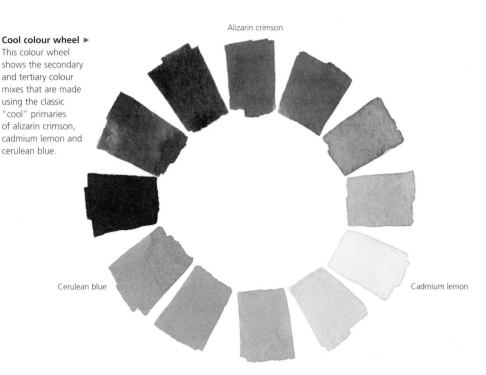

**Cool colour wheel ▶**
This colour wheel shows the secondary and tertiary colour mixes that are made using the classic "cool" primaries of alizarin crimson, cadmium lemon and cerulean blue.

Alizarin crimson

Cadmium lemon

Cerulean blue

## The language of colour

There are several terms relating to colour that you may come across in art books and magazines. It is important to be clear about the meaning of each.

A hue is simply another name for a colour. Red, purple and yellow are all hues. Two different reds might be described as being close in hue, while yellow and blue are different hues. There are many different versions (or hues) of the primary reds, yellows and blues, and the quality of the secondary and tertiary colour mixes depends very much on which of the primary versions you use.

A tint is made when white is added to a colour, or, in the case of pure watercolour, clean water. The opposite of a tint is a shade. This is made by making the colour darker, either by adding black or a little of its complementary colour. When you make a shade, the colour should not change dramatically in hue.

**Mixing from different primaries ▶**
The primary phthalocyanine blue is mixed with two versions of primary red, cadmium red (left) and alizarin crimson (right), to create two different violets.

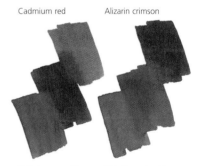

Cadmium red    Alizarin crimson

Phthalocyanine blue    Phthalocyanine blue

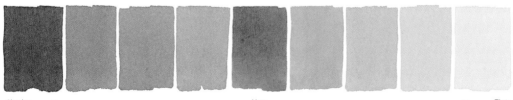

Shades ◀——————————————— Hue ———————————————▶ Tints

## Colour temperature

All colours are described as being either warm or cool. We think of red, orange and yellow as being warm colours; these are found on one side of the colour wheel, opposite the so-called cool colours of violet, blue and green. However all colours, regardless of their position on the colour wheel, have either a warm or a cool bias. For example, blue is a cool colour and red is a warm colour, but you can have a warm blue or a cool red. If a red has a blue bias, it is described as cool; if a red has a yellow bias, it is described as warm.

In order to be able to mix a full range of colours, you need to include both warm and cool variants of at least the three primaries in your chosen palette.

**Warm and cool primaries ▶**
This illustration shows the classic warm primaries (top row) and the classic cool primaries (bottom row).

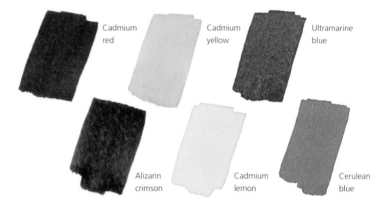

Cadmium red

Cadmium yellow

Ultramarine blue

Alizarin crimson

Cadmium lemon

Cerulean blue

Modern paint technology, however, has meant that paint manufacturers now have primary reds, blues, and yellows that display very little or no warm or cool bias. These are the perfect primaries which, in theory, make it possible to mix a full range of colours from just three.

Colour temperature is an important part of colour mixing. Those primary colours that have a bias towards one another on the colour wheel invariably make more intense secondaries when mixed. Primaries that lean away from each other result in muted secondaries.

Colour temperature is especially important when you are trying to create the illusion of depth. Warm colours are perceived to advance while cool ones recede, so objects painted in a warm colour seem to be closer to the viewer.

**Intense and subdued secondary mixes ▶**
Secondary and tertiary mixes are either intense or subdued, depending on the primary hues used to create them.

Here, ultramarine blue, which has a red bias, is mixed with cadmium yellow, which also has a red bias. This places them further apart on the colour wheel and results in a subdued secondary.

Phthalocyanine blue, on the other hand, has a yellow bias, and this results in an intense secondary when mixed with cadmium lemon.

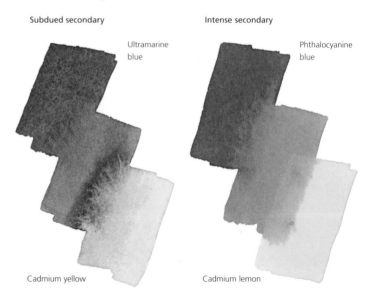

Subdued secondary

Ultramarine blue

Cadmium yellow

Intense secondary

Phthalocyanine blue

Cadmium lemon

## Colour contrast

Colours that fall opposite each other across the colour wheel – such as orange/blue, yellow/violet and red/green – have a special relationship and are known as complementary pairs. When they are placed next to each other in a painting, complementary colours create vibrant colour contrasts and have the effect of making each other appear more intense than they really are.

This is due to an effect known as "simultaneous contrast". If you stare at an area of green and then look away to a white surface, you will see a red after-image – red being the complementary of green. If red is placed next to a green area, it will be visually intensified by this red after-image. Likewise, the green would be intensified by the green after-image from the red. This effect can be used to add intensity to your work.

**Complementary pairs ▶**
These special colour pairings seem more intense when placed next to each other, but they neutralize each other when the paints are physically mixed together.

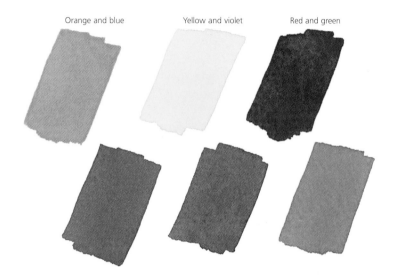

Orange and blue     Yellow and violet     Red and green

## Mixing complementaries

If a little of one complementary colour is added to another, it subdues the recipient colour, knocking it back but without dulling it in the way that adding black would. If more of the colour's complementary is added, the result (depending on which complementaries are used) is a range of browns and greys, known as neutral colours. The advantage of mixing neutral colours in this way, rather than by adding black, is that the mixes look much fresher.

If you look at a colour wheel, you will see that regardless of their position all complementary pairs are, to a greater or lesser extent, composed of all three primary colours. When you mix equal amounts of all three primaries together, the result is a dark grey – almost black. However, by carefully managing the relative amounts of the three primaries that enter the mix, you can create a wonderful range of subtle, neutral mixes that echo those found in the natural world.

**Mixing neutral greys ▼**
Neutral greys and browns are made by mixing together two complementary colours. Here, progressively larger amounts of viridian green are added to alizarin crimson, resulting in a dark grey. A range of grey tints is then made by adding increasing amounts of water.

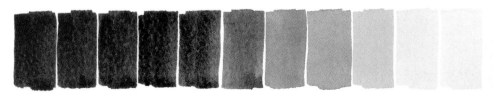

## Colour harmony

Using harmonious colours that work well together creates a distinct feel or mood, and this adds immeasurably to the success of a work. This is especially true if you are trying to depict a specific season of the year or time of day, or if you are trying to show how a subject has been lit, for example, a still life bathed in candlelight or a figure lit with harsh mid-day light.

As the colour wheel below shows, there are many different ways of achieving colour harmony. With practice you will find that your instinct is the best guide: if something looks right, then it is right. However, a little basic theory about colour harmony will set you on the right path.

**Different types of colour harmony ▼**
Complementary harmony is created by using those colours that fall opposite each other on the colour wheel. Triad harmony is achieved by using the colours found at the angles of an equilateral triangle, superimposed at any position over the colour wheel. Using an isosceles triangle will point to the colours to form a split complementary, while using a square or a rectangle will produce tetrad harmonies. Alternatively, you can create harmony by using those colours that have one primary in common or are close to each other on the colour wheel. These are known as analogous colours.

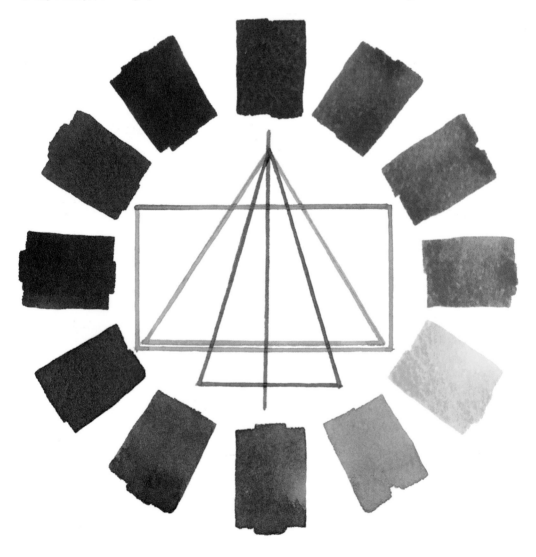

# Tone and optical mixing

Traditional watercolour technique relies on one transparent wash being laid over another in such a way as to modify or consolidate the initial wash without necessarily obliterating it. It is, however, easy to overdo these wash layers so that the image and the colours look dull, lacking the sparkle and elusive inner light for which good watercolour is renowned.

Try to think ahead when planning your work, and aim to use no more than three layers of wash at the most. Working on the light to dark principle, the first washes would include the lightest tones and colours, the second layer the mid-tones and colours, and the final layer the darkest ones. As with all best laid plans, of course, this is not always possible, but it is a useful discipline to keep in mind. This is one of the reasons why the ability to assess tonal values is such an important part of watercolour painting.

**Building up colour density ▼**
Colour density can be built up by overlaying washes. This illustration shows three layers of the same colour, though the same principle holds true when you apply different colours on top of each other.

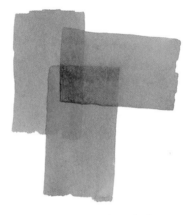

This layering technique can also create colour mixes that are impossible when certain colours are mixed together physically. Physically mixing any two complementary colours together will result in the chosen colours being neutralized and, depending on the amounts used, being turned into a brown or a grey. However, you can mix these colours optically by applying a transparent wash of one colour over a dry wash of the other. This retains the integrity of both washes; a certain amount of the lower wash colour will show through the upper wash, modifying it. Another name for this type of colour application is broken colour. It can provide both texture and interest to those areas of a work where the colour is intrinsically flat and featureless, as well as being used to depict difficult subjects consisting of complex colour variations, such as foliage, water or extreme weather conditions.

**Optical mixes ▼**
When one wash is applied over another, wet on dry, the two colours mix optically to produce a third colour. These optical mixes look crisp and clean, as the colours retain their integrity.

**Physical mixes ▼**
When colours are mixed physically, the resulting colours look duller than their optical counterparts. This is true regardless of whether the colours are mixed wet into wet (left) or wet on dry.

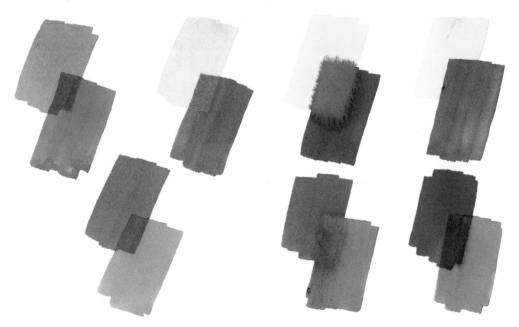

## Practice exercise: **Overlaying colours**

In this exercise, colours are overlaid both to build up density of tone and to optically "mix" colours on the paper. Because watercolour paint is transparent, some of the colour of your initial wash will show through any subsequent washes, modifying their appearance. The only way you can be sure of the effect is to practise on a piece of scrap paper in advance. Remember that watercolour always looks lighter when it is dry, so you must wait until your practice piece is completely dry before deciding whether you've got the colour you want.

**Materials**
- *140lb (300gsm) NOT watercolour paper, pre-stretched*
- *2B pencil*
- *Watercolour paints: cerulean blue, lemon yellow, yellow ochre, burnt umber, mauve, alizarin crimson, cadmium yellow*
- *Brushes: large round, fine round, mop*
- *Sponge*

**The set-up**
When setting up a still life, choose objects of different shapes and sizes. The elongated shape of the pear and the rounded swede (rutabaga) used here give interesting visual contrasts. In terms of their colour, the same underlying green occurs on both, giving unity to the still life, while the red coloration on the swede complements the green, making it more exciting.

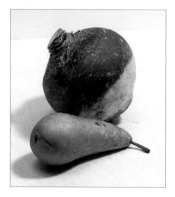

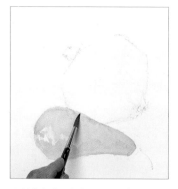

1 Lightly sketch the pear and swede. Mix a bright green from cerulean blue and lemon yellow, and brush over the pear, leaving highlights untouched. Dot paint on to give an uneven texture.

> **Tip**: When drawing fruit, work out the position of the stem and the base and draw a line between them to help get the angle of the fruit right.

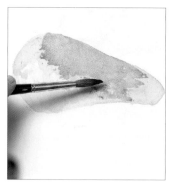

3 Mix a dark brown from yellow ochre, a little burnt umber and a touch of mauve. Using the side of the brush, brush this mixture unevenly over the pear, leaving gaps in places so that some of the first green wash is visible. The brown mixture is transparent, hence its appearance is modified by the underlying bright green. The two colours on top of each other look like a dull, mottled green.

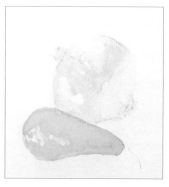

2 Add more cerulean blue to the mixture and more water to make it very dilute, and brush it unevenly over the top half of the swede, again leaving some gaps. You have now established the underlying colours of both the pear and the swede. These colours will be allowed to show through in parts of the finished painting, but they will also influence any colours that are laid down on top of them, creating mixes that could not be achieved in the palette.

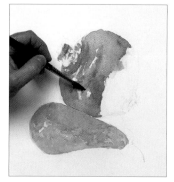

4 Mix a dull purple from mauve with a little burnt umber and brush it over the swede, making the top lighter than the bottom by adding more water. As on the pear, keep the texture and density of tone uneven by dotting more paint on in places. While the paint is still wet, build up the colour by touching more paint into selected areas so that it spreads wet into wet and you do not get any hard-edged shapes.

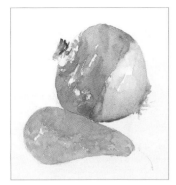

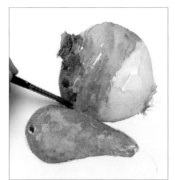

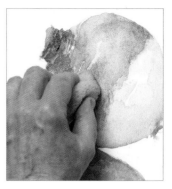

5 Mix a dilute wash of yellow ochre and brush it over the lower half of the swede, adding more pigment as you work down so that the base is darker. While the paint is still wet, brush a line of the green used in Step 1 between the two halves of the swede.

6 Using the same mixture as before, continue building up tone and depth on the purple half of the swede, applying the paint unevenly to create interesting textures. Using the same dark brown mixture as in Step 3, put a few spots and blemishes on the pear.

7 Mix up a very dilute wash of alizarin crimson. Using a small sponge, dab it on to the purple half of the swede. Crimson and green are complementary colours, so using the two together in the picture immediately gives it a lift. Leave to dry.

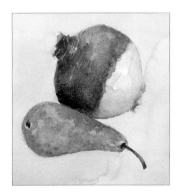

8 Mix a warm orange from alizarin crimson and cadmium yellow. Using a large mop brush, brush this mixture carefully on to the background; you may need to tilt the board to prevent paint from running over the pear or swede. Mix a dark brown from burnt umber and mauve and, using a fine round brush, paint the pear stem.

**The finished painting**
The initial green washes have modified the colour of subsequent layers, creating subtle optical mixes that are more effective than a single, solid wash could ever be. Applying several layers of the same colour (as on the swede) allows you to build up the tone gradually.

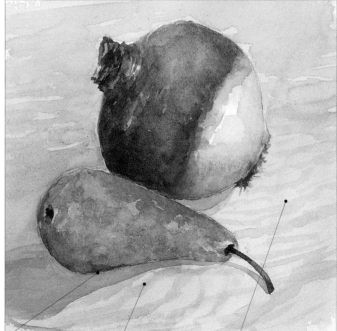

The shadows under the pear and swede anchor them to the surface and make the still life look more three-dimensional.

The "woodgrain" is painted using a more pigmented version of the background colour plus a little mauve.

The background colour harmonizes with the pear and swede but is sufficiently different to allow them to stand out.

# Wet into wet

Working wet into wet means exactly what it says – applying wet paint to wetted paper. When you do this, the paint spreads outwards in soft-edged blurs, and the wetter the paper, the further the paint spreads. You can apply paint either to paper that has been dampened with clean water or on top of a wash that has not yet dried, creating interesting colour mixes. Paint will not spread into any areas that are completely dry.

Dropping gorgeous, rich colours on to wetted paper is an exhilarating experience, as you can never predict exactly what

will happen or how far the paint will spread on the paper. For many people, that unpredictability is part of the charm of watercolour painting.

Colours that have been applied wet into wet always look lighter when they dry than they do when they are first put on. With experience you will learn to compensate for this by using stronger, more pigmented washes.

The wet-into-wet technique is excellent for cloudy skies, distant trees and woods, and atmospheric effects, such as fogs or storms. However, a picture painted entirely

wet into wet would look very blurred and indistinct. Try to keep a balance between wet-into-wet areas and sharper, more clearly defined sections. It is particularly important not to make the foreground too blurred. The soft-focus effect of wet into wet is normally best reserved for distant parts of a scene where you do not want a lot of sharp detail. When you apply paint on top of wet-into-wet washes that have dried, make sure you allow the underlying, diffuse effect of wet into wet to be seen in places, otherwise you will lose the character of the technique.

**On very damp paper ▲**
The paint spreads far beyond the line of the brushstroke.

**On moderately damp paper ▲**
The paint still blurs but it does not spread so far.

**On almost dry paper ▲**
The paint barely spreads beyond the brushstroke.

## Practice exercise: **Still life painted wet into wet**

With their wonderful markings and silvery undersides, mackerel are beautiful fish to paint. This exercise allows you to practise controlling the degree of wetness on the paper. On the background and undersides of the fish, paint is applied to very damp paper so that it spreads freely. For the markings, the paint is applied to paper that is only very slightly damp. The paint blurs a little but the markings remain distinct.

**Materials**
- 2B pencil
- 140lb (300gsm) rough watercolour paper, pre-stretched
- Watercolour paints: Payne's grey, Delft blue, alizarin crimson, aureolin, viridian, raw sienna, light red, sap green, cadmium lemon
- Brushes: large round

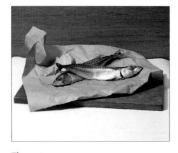

**The set-up**
Crumpled brown parcel paper provides a textured but simple background to this still life. Arrange the fish so that you can see both the markings and the silvery belly, and add a lemon for a touch of extra colour. Position a lamp to one side of your subject, so that it casts definite shadows.

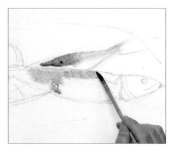

1 Using a 2B pencil, lightly sketch the still life. Using a large round brush, dampen the fish with clean water, leaving the highlights around the eyes and on the belly untouched and keeping within the outline of the fish. Mix a greyish blue from Payne's grey and Delft blue. Brush this mixture on to the damp areas so that it spreads.

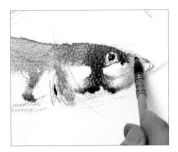

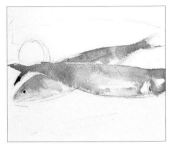

2 Add a little more Delft blue to the mixture and, using the tip of the brush, touch in the dark details around the head, again working carefully around the highlight areas.

3 While the first wash is still damp, brush alizarin crimson on to the belly of the foreground fish and the head of the background fish. It will merge with the underlying wash. Leave to dry.

4 Dampen the lemon and brush on a pale mix of aureolin. Mix a pale green and brush on to the shaded side of the lemon. Leave to dry. Dampen the background and brush on raw sienna.

5 While the background wash is still damp, add a little light red to the raw sienna and touch it into those areas of the background that you want to appear darkest in order to build up the tone and imply the creases in the paper. Leave to dry.

6 Mix a dark blue-grey from Delft blue, Payne's grey and a little alizarin crimson. Dampen the backs of the fish with clean water and brush the paint on to the darkest areas. Add more Delft blue to the mixture and, when the paper is nearly dry, paint the markings.

7 Dampen the darkest areas of the background and touch in more of the mixture used in Step 5. Paint the lemon segments in aureolin. Dampen the rest of the lemon and brush a mixture of sap green and cadmium lemon on to the right-hand side.

**The finished painting**
The subtle transitions of colour on the bellies of the fish and the background paper could only be achieved using the wet-into-wet technique. These areas contrast well with the dry applications of colour on the lemon and around the fish head.

Several layers of colour are applied to the background while the paper is still very damp. The paint spreads, creating soft-edged blocks of colour.

For the markings, the paint is applied to paper that is only slightly damp. It spreads enough to soften the markings, but not so far that they become blurred and indistinct.

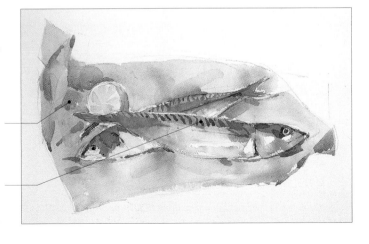

# Masking

Often in watercolour, you want the white of the paper to represent the lightest areas of your subject. Sometimes you will need to protect the white areas so that they don't get splashed with paint accidentally. Masking is the way to do this. The masking technique can also be applied over a coloured wash. When a

second wash is applied over the mask, the mask can then be removed to reveal the underlying base colour. This technique is used to give an aged and weathered look to paths, walls and painted timber.

There are many subjects that might benefit from masking, from whitewashed buildings and structural objects, such as

ladders, to water foam splashing against a rock, tiny flowers, and even the delicate tracery of lace and spiders' webs.

There are three methods of applying masking. The one you choose will depend largely on whether you need to mask straight lines, delicate lines or curved shapes, or larger areas.

## Masking tape

Masking tape is useful for masking straight-edged shapes, such as buildings, although it can also be cut or even torn to create more random effects. Make sure you use the low-tack

variety of masking tape, otherwise you may find that you damage the surface of your watercolour paper when you attempt to remove it.

1 Place the masking tape on the watercolour paper, smoothing it down at the edges so that no paint can get underneath.

2 Apply a wash over the top of the masking tape and then leave it to dry completely.

3 Carefully peel off the tape (you may need to use the tip of a scalpel or craft or utility knife to lift the edge). The area underneath remains white.

## Masking fluid

Masking fluid is useful when you want to mask out thin lines, such as grasses in the foreground of a landscape. You can also spatter it on to the paper for subjects such as white daisies in a meadow or the white foam of a waterfall. Always

wash the brush thoroughly with liquid detergent immediately after use, as it is almost impossible to remove the fluid from the bristles once it has dried; better still, keep old brushes specifically for use with masking fluid.

1 Using an old brush, paint masking fluid over the areas you want to protect. Leave it to dry completely.

2 Apply a wash over the paper and leave it to dry completely.

3 Using your fingertips, gently rub off the fluid. (You will find that it can be rubbed off quite easily.)

## Masking film

Masking film (frisket paper) is used by draughtsmen and is available from most good art supply stores. It works best with large, clearly defined areas that you can easily cut around, such as hills or a pale-coloured building.

You need to use a very smooth watercolour paper or board so that the film has a perfectly flat surface to adhere to, otherwise paint may seep under the edges and ruin the effect.

Alternatively, you could cut a paper mask and either hold it in position with one hand while you paint with the other, or fix it to your painting surface with low-tack masking tape. This is not advisable for fiddly, intricate details where you need the mask to be stuck down firmly, but if you need to protect, say, the sky area of a landscape while you spatter paint on to the land, then a paper mask is a good, low-cost option.

1 Cut a piece of masking film (frisket paper) to roughly the same size as your painting. Peel the film from its backing paper, position it on your underdrawing, and smooth it down with a soft cloth or piece of tissue paper to make sure it is stuck down firmly and smoothly.

2 Using a scalpel or craft (utility) knife, carefully cut around the outer line of your subject, taking care not to cut into the paper or board.

3 Slowly peel back the masking film from the area that you do not want to protect from paint (ie. the area that you want to paint with colour).

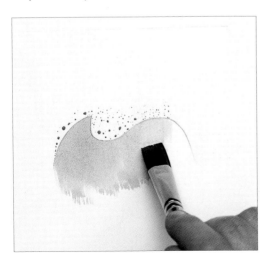

4 Apply a colour wash to the exposed paper, using a large round brush. Leave the wash to dry completely before you attempt to remove the masking film.

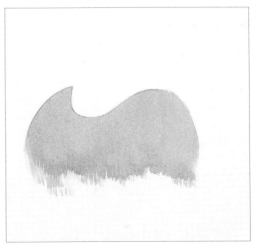

5 Check that the wash is dry, then slowly peel back the masking film from the unpainted area. Remove it in a smooth movement, so as not to tear the paper.

## Practice exercise: **Masking a white-patterned jar**

This short exercise allows you to experiment with using both masking fluid (to mask out the sweeping curved lines and fine detail of the decorative jar) and low-tack masking tape (to mask out the straight-edged rectangle of paper on which the jar is placed). Painting around the pattern on the jar in order to leave the paper white would be a painstakingly slow and laborious process, and it would be very difficult to create such fine lines. Protecting the pattern with masking fluid allows you to work in a much more free and spontaneous manner.

### Materials
- *2B pencil*
- *200lb (425gsm) NOT watercolour paper, pre-stretched*
- *Watercolour paints: cobalt blue, ultramarine blue, Payne's grey, raw umber, dioxazine purple*
- *Brushes: old brush for masking, medium round, fine round*
- *Masking fluid*
- *Low-tack masking tape*

### The set-up
Arrange your subject on a piece of coloured paper that harmonizes with it, and position a table lamp in front of and slightly to the right of the subject so that you get an interesting shadow.

1 Using a 2B pencil, lightly sketch the jar and its decorative pattern. Using an old brush and liquid rubber masking fluid, mask out any areas that you want to keep white and clear of paint. Rinse the brush thoroughly and allow the masking fluid to dry completely before moving on to the next stage.

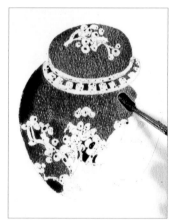

2 With the design protected by the masking fluid, there is no risk of accidentally painting over the white areas. Mix a vivid blue from cobalt blue, ultramarine blue and a little Payne's grey. Using a medium round brush, wash this mixture evenly over the jar. Leave to dry.

3 Using the same blue paint mixture, work over the jar once again to strengthen the tone. Add more Payne's grey to the mixture when you paint the right-hand side of the jar, which is slightly in shadow. This darker tone helps to make the jar look realistically three-dimensional. Leave to dry.

4 Using your fingertip, gently rub off the masking fluid. It should come off easily, but if any of the masking fluid is hard to remove, use a soft kneaded eraser. Blow or brush any bits of loose masking fluid off the paper before continuing.

5 Using the same blue mixture used in Step 2, carefully paint in the detailing on the pattern – the outline of the flowers, the flower centres, and tiny brushmarks to indicate the bark of the branches. Leave to dry. Mix a mid-toned Payne's grey and brush over those parts of the white patterns that are in shadow. This helps to integrate the stark design into the painting and reinforces the three-dimensional feel.

6 Using low-tack masking tape, mask out the square of dark grey paper on which the jar is standing. Mix a warm grey from Payne's grey and raw umber and, using a medium round brush, paint in the rectangular shape. Do not flood on too much paint, as there is always a risk that some may seep under the tape and ruin the clean edge. Leave to dry.

**The finished painting**

Once the tape has been removed, complete the painting by adding the dark shadow cast by the jar using a pale mauve mixed from Payne's grey and dioxazine purple. The result is an attractive little study that preserves the flowing lines and brilliant white pattern on the jar, without looking tight or laboured in its execution.

The brilliant white of the paper is preserved to the last.

The shadow anchors the jar on the surface.

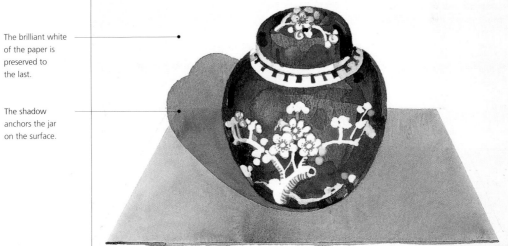

# Resists

Resist techniques are based on the principle that wax and water do not mix. Wax repels water, so if there is wax on your watercolour paper, any watercolour paint that is subsequently applied to those areas will not adhere to the surface.

Wax can be applied in several ways. You can use a clear wax candle, coloured wax crayons or oil pastels to draw on to the support. Interesting results can also be obtained by brushing on furniture wax using a stiff bristle brush. The technique is similar to using masking fluid but, unlike masking fluid, a resist cannot be removed.

Since the wax remains on the support and will continue to repel any subsequent washes, you need to plan where and at what point you introduce the resist. It does not have to be applied to the paper at the beginning of the work; you can introduce it at any point by working over existing dry washes.

The technique is difficult to use in confined, detailed areas and is more commonly used to create broader areas of texture. The success of the technique depends on how much pressure you apply and on the type of surface on which you are working. On a smooth, hot-pressed paper, the wax takes to the surface in a uniform way, resulting in a more subtle, flatter effect. On a rough paper, the wax is picked up only on the "peaks" of the paper surface, resulting in the wash lying in the "troughs", producing a highly textured, speckled effect.

An interesting variation can be made by combining it with frottage. Frottage allows you to incorporate textures other than that of the watercolour paper into your painting. Place smooth, lightweight paper on a textured surface, such as a plank of wood, and rub on the wax. The wax will pick up the texture of the underlying surface and, once a wash has been applied, the pattern will be revealed.

Resist techniques are ideal for light sea waves and for broken textural effects for sand and shingle. These patterns can be applied as a drawing or as a fragmented layer of light colour. Try drawing the white petals of a daisy with a wax resist and then covering them with deep blue – the contrasting tones are quite startling.

## Household candle

Using an uncoloured household candle as a resist is an effective and inexpensive way of creating large areas of texture on a painting. Be aware that you cannot remove the wax once it has been applied, so don't get too carried away!

1 Rub a household candle over the paper, presssing quite hard to ensure that enough wax is deposited on the surface of the paper.

2 Apply a watercolour wash. Note how the wax repels the water in the paint. Here a rough paper was used, creating a broken texture.

### On smooth, hot-pressed paper
On smooth, hot-pressed paper, the wax can be applied more smoothly. As a result, when the watercolour wash has been applied, the effect is much more subtle.

## Coloured wax crayon or oil pastel

With a coloured wax crayon or oil pastel, not only can you make finer, more linear marks which will remain visible in the finished painting, but it is also easier to see exactly where the wax has been applied. This makes it less likely that you will apply too much of the resist that cannot then be removed, and it is a useful way to practise the resist technique.

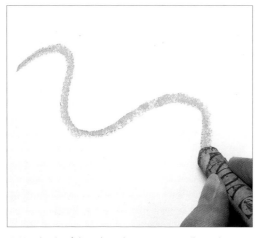

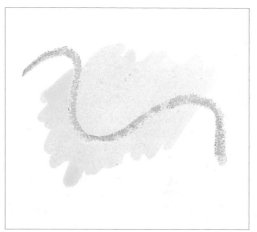

1 Use the tip of the coloured wax crayon or oil pastel to draw in the areas where you want to apply the resist. Work slowly and in one smooth, continuous movement.

2 Apply a watercolour wash over the top of the resist. The fine coloured lines of the wax remain visible, even though the wash was applied over the whole surface.

## Practice exercise: **Using resists to create texture**

In this exercise, a combination of oil pastels and watercolour is used to give tiny variations in tone across the surface of the fruits, revealing the dimpled texture. Resists are used both to add colour and to reserve the white of the paper. The colour of the oil pastels is rich and vibrant, and it shows through the lighter watercolour washes because the oil in the pastels acts as a resist and repels the watercolour paint. Candle wax is used to reserve the white of the paper for the brightest highlights.

### Materials
- *200lb (425gsm) NOT watercolour paper, pre-stretched*
- *2B pencil*
- *Watercolour paints: cadmium lemon, cadmium orange, burnt umber, sap green, Payne's grey, dioxazine purple*
- *Oil pastels: cadmium yellow, yellow ochre, deep orange*
- *Brushes: medium round*
- *Household candle*

### The set-up
Odd numbers of objects always seem to work better in a still-life composition than even numbers. Arrange the fruit to form a composition that is roughly triangular in shape, with the lemon angled to "point" towards the oranges.

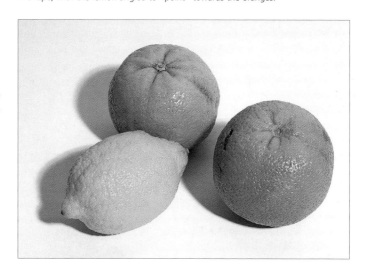

▶

1 Using a 2B pencil, lightly sketch the outline of the fruits, looking carefully at their positions in relation to one another and at where they overlap. Scribble in the lighter yellow areas using a cadmium yellow oil pastel. Take care not to press too heavily, or the pastel will build up in the tooth of the paper to such an extent that there will be nowhere for the watercolour wash to adhere to the paper.

2 Using a clear wax candle, draw the white highlight on each orange and on the lemon; the wax will repel the watercolour paint, with the result that these areas will remain white in the finished painting. Develop the colours on the oranges and lemon using yellow ochre and deep orange oil pastels. As before, keep the pastel marks light and open so that they help describe and follow the contours of the fruit.

3 Brush on the lightest washes – cadmium lemon on the lemon and cadmium orange on the oranges. The paint gathers and puddles on those areas of the paper that are free of oil pastel and candle wax. Leave to dry.

4 When dry, go back to the oil pastels to redraw areas and add colour and detail. Now that some paint has been applied, you can make this subsequent pastel work heavier, as it will not affect the washes that have been put down.

5 Using concentrated mixes of cadmium orange, cadmium lemon and burnt umber, paint the shaded sides of the fruits, and the areas where the stalks are attached, in order to make them look more rounded and three-dimensional. Allow the paint to puddle as before and leave to dry.

6 Mix a brownish green from sap green, cadmium orange and burnt umber and paint the point where the stalk is attached. Paint the shadow in Payne's grey and drop cadmium orange and dioxazine purple into the grey to hint at the colours reflected from the underside of the fruit.

**The finished painting**

This is a lively and spontaneous painting of a very simple still life. The oil pastel resists add both depth of colour and texture to the image, while the watercolour washes provide smoother, calmer areas that act as an effective contrast. Even the white highlight areas have gained some texture from the candlewax resist.

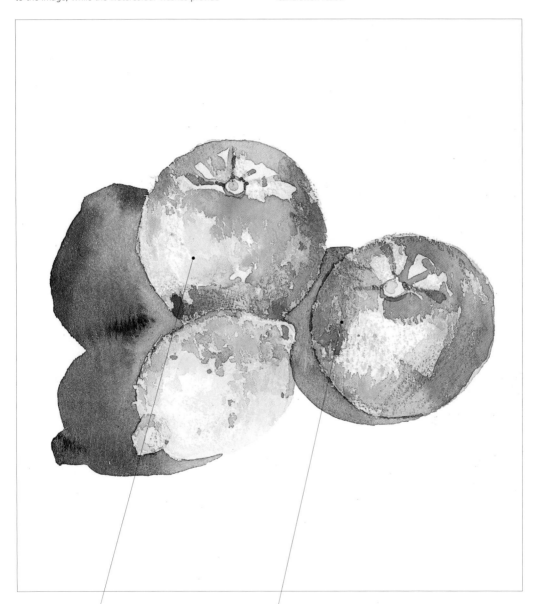

The bright highlighted areas of the fruits are reserved by using clear candle wax.

Yellow ochre and deep orange oil pastels convey the colours of the oranges and also repel the paint to create interesting textures.

# Spattering

Spattering is an effective technique for creating texture in paintings. It consists of flicking paint on to the paper to create a random series of dots or flecks. It is done either by tapping a brush loaded with paint, so that drops of paint fall on the paper beneath, or by pulling back the bristles of a loaded brush with your fingers, so that paint droplets fly off.

You can apply spatter to either dry or wet paper, or even combine the two approaches in a single painting. They give very different effects. On a dry ground, the spatter doesn't blur, so this is a good technique for subjects such as old stone walls and pebbly garden paths, where you want the dots and flecks of paint to be crisp and sharp. On a wet surface, the spatter blurs and spreads, which can be useful for snow or foam-crested waves lapping against the shore.

The amount of water in the paint mixture affects the size of the spatter marks: the wetter the mixture, the larger the marks. Distance also plays a part: the further away you hold the brush, the smaller the marks and the wider the area that will be covered. Practise on scrap paper to find out how much pressure you need to apply and how far away from the paper you need to hold the brush in order to create the effect you want.

**Pulling back the bristles**
Load a stiff-bristled brush with paint and gently pull the bristles back towards you.

**Tapping the brush**
Load the brush with paint, hold it horizontally over the area that you want to spatter, and gently tap the handle.

**Spatter on a damp wash**
Applied to a wet surface, the paint droplets blur and spread.

**Spatter on a dry wash**
Applied to a dry surface, the paint droplets remain crisp and well defined.

## Practice exercise: **Beach with spattered pebbles**

Spattering is the perfect technique for this pebbly beach scene. Make the foreground spatters slightly larger than those in the distance. The foreground pebbles appear larger because they are closer to the viewer, so this will help to create an impression of distance.

### Materials
- *2B pencil*
- *140lb (300gsm) rough watercolour paper, pre-stretched*
- *Watercolour paints: cobalt blue, raw sienna, light red, sepia, ultramarine violet, cadmium red, cadmium orange, Payne's grey*
- *Brushes: old brush for masking, large round, fine round*
- *Masking fluid*

**The original scene**
You can almost feel the hard, crunchy texture of this shingle beach. Spattering the paint on to dry paper will create crisp dots of texture.

1 Using a 2B pencil, lightly sketch the outline of the boat and flags and the planks of wood that lie in the foreground of the beach scene.

2 Hold a piece of scrap paper over the boat to protect it and, using an old brush, spatter masking fluid over the beach. Leave to dry.

3 Dampen everything except the boat with water. Brush pale cobalt blue over the sky. Brush a mixture of raw sienna and light red over the beach.

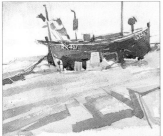

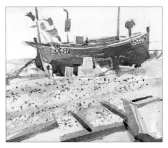

4 When the previous stage is dry, mix a dark brown from sepia, ultramarine violet and a little light red and paint the boat, adding more ultramarine violet for the stern. Use a pale version of the mixture for the planks and brush broad strokes of the same colour across the beach. Paint the flags in cobalt blue and the floats in a mixture of cadmium red and cadmium orange. Using a fine brush, paint around the lettering in Payne's grey.

5 Mix a warm brown from raw sienna and sepia. Hold a piece of scrap paper over the boat to protect it and, using a fine brush, spatter the paint mixture over the foreground.

6 Add ultramarine violet to the mixture to darken it and continue spattering as before. Using the same mixture, darken the ropes tethering the boat and the planks. Leave to dry.

**The finished painting**
Complete the picture by rubbing off the masking fluid. This is a delightful little scene of a beach at low tide. The spattering is subtle and does not detract from the painting of the boat, but it captures the texture of the hard, shingly beach very effectively.

These stripes of colour help to imply the ripples in the sand.

The spattering in the foreground contrasts well with the flat colour of the sky.

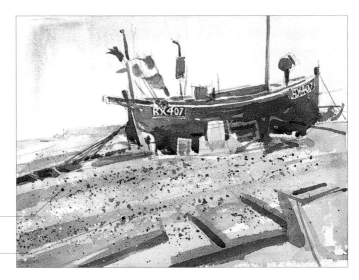

# Stippling

Stippling consists of placing dots or blobs of colour on the paper. The technique is often used to create texture in a painting, but it can also be used to optically mix colours on the paper, as it was by the French Pointillist School, whose most famous exponent was Georges Seurat (1859–91).

   The dots can be placed close together or further apart, depending on the effect you want to create. You can use either a specialist stippling brush, which is a short, stubby brush with hard bristles, or the tip of your normal painting brush. To create even stipples, dip an almost dry brush into a thick mix of watercolour paint. A wetter mix of paint will produce dots that are less sharply defined.

**The technique**
Load a stippling brush with paint and, holding the brush almost vertically, dab it on to the paper with short, sharp movements. Vary the amount of pressure to create dots of different weights.

**The effect**
A stippling brush creates areas of random texture that are perfect for subjects such as lichen-covered pebbles and stones.

## Practice exercise: **Fruits with stippled texture**

Stippling is a great way of painting fruits with dimpled surfaces, such as the citrus fruits and avocado shown here. Use a fine brush and stipple darker tones on to the base colours of the fruits to convey the pitted hollows in the skin.

**Materials**
• *2B pencil*
• *140lb (300gsm) rough watercolour paper, pre-stretched*
• *Watercolour paints: aureolin, yellow ochre, raw sienna, sap green, Payne's grey, ultramarine blue, burnt umber, ultramarine violet*
• *Brushes: fine-pointed old brush for masking, medium round, fine round*
• *Masking fluid*

**Tip**: As you make your initial drawing, turn it upside down every now and then to check that you've drawn the ellipses of the bowl and the fruits correctly. Looking at the drawing upside down makes it much easier for you to see what you've drawn as simple geometric shapes, without being distracted by the subject matter.

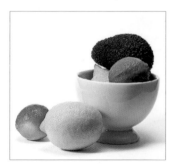

**The set-up**
When you set up a still-life exercise like this, position a table or anglepoise lamp to one side. The raking light will pick out the dimples on the fruit, making it easier for you to see where to apply the stippling, and will cast interesting shadows that make the subject look three-dimensional.

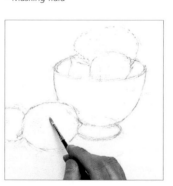

1 Using a 2B pencil, lightly sketch the outline of your subject. Using an old, fine brush, stipple masking fluid on any highlight areas on the left-hand side, where light hits the fruit. Leave to dry completely.

2 Mix two washes, one from aureolin with a little yellow ochre and the other from yellow ochre alone. Dampen the foreground lemon and bowl with clean water. Paint the lemon with the aureolin and yellow ochre mixture and the bowl in the plain yellow ochre.

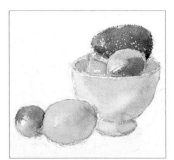

**3** Mix raw sienna with a little yellow ochre and, while the paper is still damp, touch this mixture on to the right-hand side of the bowl, which is in shadow. Add a little sap green to the mixture and brush it on to the shadowed side of the foreground lemon. Paint the lemon in the bowl with the aureolin and yellow ochre mixture used in Step 2. Leave to dry.

**4** Mix a pale green colour from sap green and aureolin. Wet the limes and the avocado with clean water. While the paper is still damp, using a medium round brush, brush this mixture over the limes, leaving some white areas untouched where the light hits the fruits. Add some Payne's grey to the mixture and stipple it over the avocado. Leave to dry.

**5** Mix a dark green from ultramarine blue and sap green. Using a fine round brush, stipple the mixture over the darker areas of the limes and leave to dry. Mix sap green with a little Payne's grey and wash this mixture over the right-hand side of the avocado and the shadowed underside of the lime in the bowl. Leave to dry.

**6** Strengthen the tone on the bowl by applying another wash of yellow ochre, leaving a white edge on the rim. Add a touch of burnt umber to the inside of the bowl. Leave to dry. Stipple a mixture of aureolin and yellow ochre on to the foreground lemon, adding burnt umber for the side that is in shadow. Stipple a mixture of sap green and Payne's grey on to the dark side of the avocado and the foreground lime. Leave to dry.

**The finished painting**
To complete the painting, rub off the masking fluid to reveal the brightest highlights. Next, paint the shadows by dropping a very pale wash of ultramarine violet and burnt umber

wet into wet on to dampened paper. Random stippling conveys the texture of the fruits and contrasts well with the wet-into-wet washes used on the smooth china bowl.

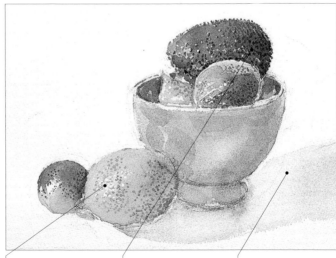

The brightest highlights are left unpainted, protected by masking fluid until the final stages.

Random stippling conveys the pitted surface of the fruits perfectly.

The shadows help to anchor the painting and show that the subject is not floating in mid-air.

# Drybrush

In the drybrush technique, paint is put on with a brush that is quickly skimmed over the paper, leaving the colour on the ridges of the surface but not in the troughs. As you might expect, the brush should be fairly dry. If either the paper or the brush is too wet, the indentations of the paper will quickly fill with colour. Keep a piece of kitchen paper close to hand so that you can dab off any paint that is too wet.

The drybrush technique is useful for subjects such as wood bark or ageing stonework, and for foreground grasses. Because drybrush work is often used in the final stages of a painting, to add texture and visual interest, it is a good idea to test your loaded brush on a piece of scrap paper before you use the technique in your almost completed work.

**Using a round brush**
Dip the brush in your chosen paint colour and, using your fingertips, squeeze out any excess paint so that the brush is almost dry and splay out the bristles. Drag the brush over the surface of the paper. It will make broken, textured marks.

**Using a fan brush**
A fan brush, in which the bristles are naturally splayed, allows you to cover a wider area of the paper.

## Practice exercise: **Lily with drybrushed leaves and buds**

The drybrush technique is perfect for subjects with slightly broken textures, such as leaf forms. On rough paper, dragging an almost dry brush across these areas will give an immediacy and freshness to the painting.

**Materials**
- *2B pencil*
- *140lb (300gsm) rough watercolour paper, pre-stretched*
- *Watercolour paints: aureolin, sap green, yellow ochre, rose madder deep, ultramarine blue, cadmium orange*
- *Brushes: medium round, fine round*
- *Kneaded eraser*
- *Kitchen paper*

**Tip**: If you find it hard to get the shape of the half-open lily flower right, try to think of it as a simple geometric shape – such as an inverted cone – on top of which you superimpose an ellipse and the triangular shapes of the individual petals. Taking an objective approach to your subject can be helpful when dealing with irregular shapes.

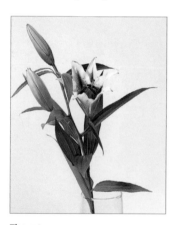

**The set-up**
Position your subject on a large sheet of white paper: this is a good way of practising the technique, without having to worry about painting a complicated background. Turn the lily around until you find an angle that allows you to see the inside of the half-opened flower.

1 Using a 2B pencil, make a light sketch of the lily. It is important to count the number of petals and leaves beforehand, and to work out the position of each one carefully.

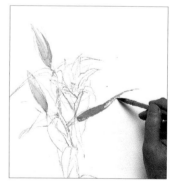

2 Mix a yellowish green from aureolin, sap green and a little yellow ochre. Holding an almost dry brush vertically, paint the buds. Add more sap green and paint the leaves in the same way.

3 Continue putting in the leaves in the same way. Use a slightly darker version of the same mixture for the stalks and one edge of some of the main leaves, so that the painting starts to take on a three-dimensional quality.

4 Mix a dark pink colour from rose madder deep and drybrush it on to the petals of the open lily flower.

5 Mix a very pale ultramarine blue and paint the shadow on the underside of the petals. Paint the stamens in cadmium orange. Using a fine round brush, stipple tiny dots of the dark pink colour inside the petals.

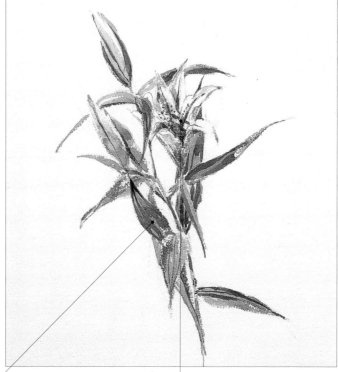

6 Mix a dark green from ultramarine blue and sap green and, using a fine round brush, drybrush this mixture over the leaves to paint the veins. Paint the same colour on the unopened buds to delineate the individual petals.

**The finished painting**
Rub out some of the superfluous pencil markings with a kneaded eraser and the painting is complete. Working on dry paper, with an almost dry brush, is the perfect way to delineate the fine leaf forms and the lines that separate the petals of this lily. The technique has also allowed the texture of the paper to show through, creating a painting that is full of visual interest.

The drybrush work on the leaves has created an interesting texture.

Warm and cool colours help to make the lily look three-dimensional: the warm rose advances, while the cooler purple recedes.

# Sponging

Sponges can be used to lift off unwanted colour while the paper is still damp (for example, to wipe out clouds in a dark sky) and instead of a brush to dampen paper. However, the main purpose of sponging is to produce texture.

Natural sponges are more randomly textured than synthetic ones, which have a very regular pattern. Experiment with different kinds to find out what kind of marks they make. You can sponge on to dry or damp paper. On damp paper, the marks will merge together, while on dry paper they will be more crisply defined.

Sponging is a useful technique for painting stone walls and pebbled paths and beaches. It is also excellent for misty trees and anything that needs a soft edging, and for creating the effect of lichen on walls and wooden gates.

**The technique**
Wet the sponge so that it is soft and pliable and squeeze out any excess water. Dip the sponge in your chosen paint (you will need to mix a large wash, as the sponge is very absorbent). Gently dab it on to the paper.

**The effect**
The sponge leaves a series of pitted marks that are ideal for conveying texture. This technique is particularly useful for painting clumps of foliage.

## Practice exercise: **Removing and adding colour with a sponge**

In this exercise, sponging is used both to remove paint, softening colours applied with a brush, and to add it, creating small areas of soft texture.

**Materials**
- *300lb (640gsm) rough watercolour paper*
- *Watercolour paints: alizarin crimson, Prussian blue, cadmium lemon, ultramarine blue, cadmium yellow*
- *Brushes: medium round*
- *Small sponge*

**The original scene**
This array of bouquets on a market stall is almost overpoweringly colourful. The artist decided to paint a single bouquet in order to concentrate on the effects created from the sponging technique.

1 Mix a deep pink from alizarin crimson with a tiny amount of Prussian blue. Using a medium round brush, loosely paint the shapes of the outer ring of flowers in the bouquet.

2 While this paint is still wet, dampen a small sponge in clean water and squeeze out any excess moisture. Wipe the sponge over the paint around the inner edge of the ring of flowers, removing colour and softening the brush marks. This creates the basis for a ring of lighter-coloured flowers.

3 Dilute the pink mixture used in Step 1 by adding more water. Dip the sponge into the mixture and gently dab it into the empty centre of the bouquet to reduce the starkness of the white.

**4** You may find that the centre now looks too dark. If so, rinse the sponge in clear water and squeeze out any excess moisture. Gently wipe the sponge over the centre of the bouquet to remove some of the colour you have just applied and soften any hard edges.

**5** Load the sponge with a more highly pigmented version of the mixture used in Step 3 and gently dab it into the centre of the bouquet, to create an inner ring of flowers, and around the outer ring to create some texture and more depth of colour in this area.

**6** Using a slightly bluer version of the mixture and a medium round brush, loosely delineate the edges of individual flowers within the bouquet and around the outer rim.

### The finished painting

Complete the painting by lightly brushing in the foliage around the outside of the bouquet, using a light green mixed from cadmium lemon and a little ultramarine blue and a darker green mixed from cadmium yellow and ultramarine blue and paint the darkest outer leaves in the same way. This is a loose, but lively, interpretation which owes much of its success to the random sponging technique, used here both to add colour and to remove it.

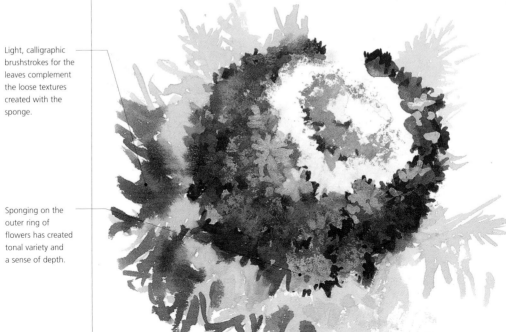

Light, calligraphic brushstrokes for the leaves complement the loose textures created with the sponge.

Sponging on the outer ring of flowers has created tonal variety and a sense of depth.

# Additives

There are all kinds of materials that can be added to the brush or mixed into watercolour paint. Some materials alter the characteristics of the paint, while others create textures that could not be achieved using a brush alone. These additives should be used in moderation and only in carefully selected areas of the painting, as they can easily become too dominant and detract from the effect of the work as a whole, but they are useful additional tools in your armoury.

## Additives that alter the characteristics of the paint

One of the most useful additives in this category is gum arabic. Adding a few drops to your paint mixture has two effects. First, it slows down the drying time, giving you more time to work. Second, it gives the paint a slight sheen, which is particularly useful when you are painting shiny or varnished surfaces such as a wooden table in a still life. Gum arabic also makes colours appear stronger and more saturated. Glycerin will also slow down the drying time and makes the paint slightly sticky and easier to control on the paper.

Another additive that changes the characteristics of the paint is granulation medium. Some colours, such as French ultramarine, granulate naturally, but this medium allows you to exploit that characteristic with any colour, although it works better with darker colours and ones that have a natural tendency to granulate.

**Gum arabic**
Pour a few drops of gum arabic into pre-mixed watercolour paint and mix thoroughly. Apply the paint to the paper with a brush. Because the gum arabic retards the paint's drying time, you can then work into it with a palette knife or the tip of a brush handle.

**Granulation medium**
Add a few drops of granulation medium to pre-mixed watercolour paint and mix thoroughly. Apply the paint to the paper as normal. When the paint dries, it will have a slightly speckled, granular appearance. This is an effective way of painting old, worn stonework.

## Additives for texture

Texture pastes and gels can be applied directly to the paper with a palette knife or mixed with watercolour paint first and brushed on. When they dry, the surface is slightly raised. Paint applied on top of the raised surface will settle in intriguing ways.

Sand, grit, tissue paper and other textured materials can be added to glue. Apply the glue to your painting, stir or press the required material into the glue, and allow to dry thoroughly before painting on top.

Finally, common household salt can create some exciting effects. Drop salt into a wet watercolour wash and leave to dry before brushing off the crystals. The salt leaches the colour out of the watercolour. The result depends on how wet the wash is: if it is too wet, the effect will not be so pronounced, and if it is too dry the salt will have no effect.

**Texture medium**
This is a viscous, white-coloured fluid. Mix it thoroughly into the pre-mixed watercolour paint, or apply it directly to the paper, and stipple it on to the painting surface with a palette knife. When the paint dries, the surface will be slightly raised.

**Salt**
Sprinkle common household salt on to a wet wash. When it is completely dry, gently brush off the salt crystals. The salt will leach the colour out of the paint, leaving mottled marks. This is a useful technique for painting snow or textured subjects, such as lichen.

## Practice exercise: **Textured stone and iron**

In this study of a rusty chain on a worn, lichen-encrusted harbour wall, the artist has indulged in a little lateral thinking: if salt can create interesting textures, why not see what you can achieve with other items from the kitchen? Here, olive oil and plain white flour have been used as inexpensive alternatives to oil-pastel or candlewax resists and texture medium. Don't feel constrained by convention: painting should be all about experimenting and having fun.

**Materials**
- HB pencil
- 220lb (450gsm) rough watercolour paper, unstretched
- Watercolour paints: yellow ochre, burnt umber, cadmium red, alizarin crimson, ultramarine blue, Naples yellow, burnt sienna
- Gouache paints: Chinese white
- Brushes: medium flat, medium round, fine round, large wash
- Olive oil
- Salt: fine-grained, coarse-grained
- Flour

**The original scene**
The lovely, subtle colours on this old stone wall give you the opportunity to work wet into wet, allowing the colours to merge on the paper. The speckled textures in the wall provide additional visual interest, while the chain forms a diagonal line across the frame, giving a dynamic composition.

1 Using an HB pencil, sketch the subject, indicating the position of the chain and rope and the main bands of colour on the wall behind. Look at how the links of the chain are joined and at how the rope loops twist and fall over each other: the composition is very simple, but elements such as this are key to making it look realistic.

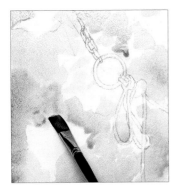

2 Mix three very pale washes for the background colours: yellow ochre, burnt umber, and a pinkish mixture of yellow ochre, cadmium red and alizarin crimson. Using a medium flat brush, dab yellow ochre on at the top of the paper, burnt umber at the base, and the pink mixture on the left-hand side. Dampen any unpainted areas with clean water so that the whole paper is wet.

3 While the first washes are still wet, dip a medium round brush in olive oil and dab large and small marks into the washes. The oil acts as a resist and repels watercolour paint, and will give a mottled appearance when dry – although, because the oil is applied on top of the watercolour, rather than the other way round, the effect is subtle and understated.

4 Mix a dark brown from burnt umber and ultramarine blue and dab it on to the darker areas at the base of the picture. While it is still wet, dab on more olive oil. Leave to dry. Mix a pale, rusty brown colour from burnt umber, alizarin crimson, Naples yellow and ultramarine blue. Using a fine round brush, paint the iron chain and ring.

▶

5 Add a little ultramarine blue to the pinkish mixture used in Step 2 to make an orangey brown. Using a large wash brush, dab the mixture over the left-hand side of the wall. While this is still wet, sprinkle a little fine-grained salt over it.

6 Mix an opaque, creamy yellow from yellow ochre and Chinese white gouache. Using a medium round brush, dot it on to the chain and the salted area on the left of the picture. This area is still damp, so the paint spreads a little and looks like small patches of lichen.

7 Add burnt sienna and ultramarine blue to the opaque yellow mixture used in Step 6 to make a pale, bluish grey. Using a medium round brush, dab the mixture over the light area at the top of the wall. Sprinkle on some coarse-grained salt.

8 Mix an opaque pinkish grey from yellow ochre, alizarin crimson, Naples yellow, a little ultramarine blue and Chinese white gouache. Brush it over the shaded parts of the chain and ring; suddenly they look three-dimensional. Add more ultramarine blue to the mixture and paint inside the rope loops and around the chain. Mix a dark brown from burnt umber, ultramarine blue and a little alizarin crimson and paint inside the ring.

9 Using a medium round brush, dab the same dark brown mixture on to the left-hand side of the wall. Sprinkle flour into the wet areas; it will sink into the wet paint in clumps, leaving a slightly raised surface when it dries.

10 Outline the links of the chain in pure burnt sienna, taking care to break the line where the links overlap to give a three-dimensional effect.

**Tip**: Take plenty of time over this stage and study your reference photo carefully: these dark lines indicate how the links of the chain are joined together, so it's important to get them right.

**11** Mix a pale blue from ultramarine blue, burnt sienna and Chinese white gouache. Paint the rope strands and the shadows underneath the rope.

**12** Mix Chinese white gouache with a tiny amount of ultramarine blue and paint the mortar lines in the brickwork of the wall.

**13** Gently brush off the dry salt crystals to reveal mottled, bleached-out marks that look like lichen growing on the harbour wall.

**The finished painting**
Often, insignificant details can make intriguing paintings: there is nothing exceptional about this subject, but the soft colours and contrasts of texture make it very appealing. The artist has applied a number of additives – some more unusual and unorthodox than others – to the wet watercolour washes, thereby creating interesting textures that could not have been achieved by brushwork alone.

Salt leaches colour out of the paint, creating a mottled effect like lichen.

The flour has dried on to the paint in lumps, creating a slightly raised surface that looks like worn, uneven stonework.

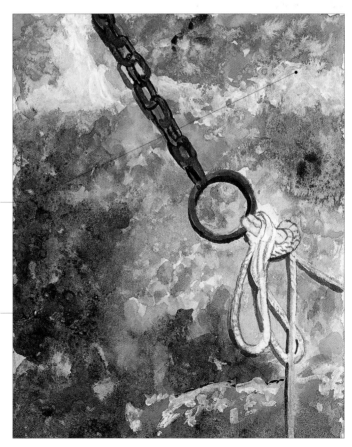

# Line and wash

Combining inks with watercolours – a technique that is commonly known as line and wash – is one of the most challenging and exciting of all watercolour techniques. It enables you to combine the precise detail of pen-and-ink work with the fluidity and transparency of watercolour washes.

It doesn't matter whether you do the ink drawing or the watercolour washes first; that really depends on what you want to say about your subject. The real danger, especially for beginners, is putting in too much linear detail and consequently overworking the picture. Make a conscious effort to simplify your subject and put down only the essentials.

The key to a successful line-and-wash painting is to maintain a balance between the two media. Although there are no hard-and-fast rules, a useful guideline is that if your subject contains relatively little colour you can afford to do a lot of pen work, while a very colourful subject will probably require less. (Lots of pen work in a painting of a colourful flower border, for example, would detract from the colours of the subject; with an action subject such as a dancer or sporting scene, you might choose to make the pen work tell most of the story, applying just a little colour for atmosphere.) It takes a certain amount of practice and skill to get the balance right.

Experiment with different inks, as there are both waterproof and water-soluble kinds. If you want the pen marks to be permanent, use waterproof inks. Water-soluble ink marks will blur and run when you apply watercolour washes on top of them, but you can create some exciting effects in this way.

Try different kinds of pen, too, to find out which ones you like using, and use the back of the nib, as well as the tip, to create different widths of line. Steel-nibbed dip pens make lovely lines, but they hold relatively little ink and you may find it frustrating to have to keep stopping to re-load the pen. Fountain pens and technical drawing pens have an ink reservoir, but the quality of line that they make may be a little too neat and regular for some people's tastes.

**Watercolour wash over ink**
Provided you use waterproof ink, as here, and allow it to dry completely, the lines will remain permanent and unsmudged even when you apply a watercolour wash over the top.

**Semi-opaque paint over ink**
The top half of the image shows a mixture of watercolour paint and permanent gouache applied over ink: the semi-opaque paint partially covers the ink, making the lines more muted. Compare this with the deep lines of the ink covered by pure watercolour in the bottom half of the image.

## Practice exercise: **Church spire in line and wash**

Line and wash is the perfect technique for architectural subjects such as this picturesque church steeple and spire. Details can be held sharply in ink while watercolour washes provide colour and tonal variety. The dip pen used here provides a less regular and mechanical quality of line than a technical drawing pen, which helps to make the study of the building more lively.

### Materials
- *2B pencil*
- *300lb (640gsm) rough watercolour paper*
- *Watercolour paints: yellow ochre, raw umber, ultramarine blue, cadmium red, burnt sienna, ultramarine blue, cadmium yellow*
- *Brushes: medium round*
- *Medium-nibbed steel dip pen*
- *Black waterproof ink*

### The original scene
There is a lot of interesting detail in this scene. The arched bell-tower windows and a rounded turret cry out to be depicted in a crisp, linear way, while the soft transitions from light to dark tones in the stonework require soft-edged wet-into-wet washes.

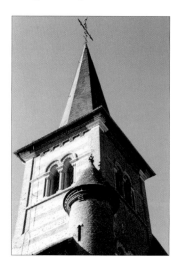

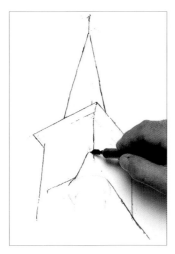

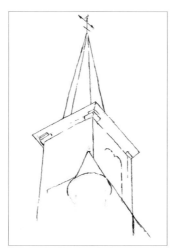

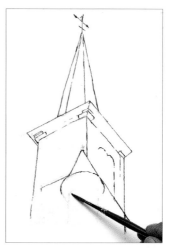

1 Using a 2B pencil, sketch the building. (If you are confident, start working in pen and ink straight away – but you cannot erase mistakes.) Using a medium dip pen and waterproof black ink, ink over the pencil lines.

2 Continue with the pen-and-ink work until you have put in all the main lines of the spire, steeple and rounded turret. Leave to dry completely before going on to the next stage of the painting.

3 Mix a pale wash of yellow ochre. Using a medium round brush put in the lightest tone, which is on the left-hand side of the steeple and spire. This establishes the underlying colour of the honey-coloured stonework.

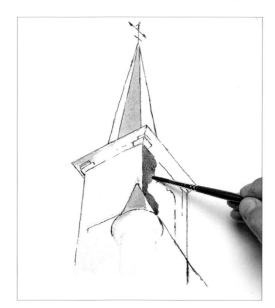

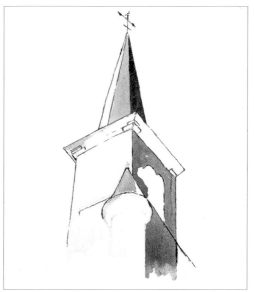

4 Mix a mid-toned grey from raw umber with a little ultramarine blue. Put in the second facet of the spire, the shadow under the eave on the left, and the roof of the rounded turret. Add a little cadmium red and paint the right-hand side of the steeple, painting around the arched window.

5 Mix a dark brown from burnt sienna and ultramarine blue and put in the darkest facet of the steeple, the side that is in shade. The building is now starting to look three-dimensional, and this will be reinforced in the later stages of the painting.

▶

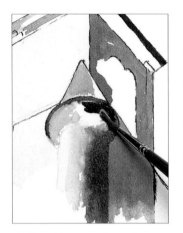

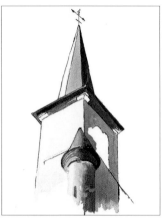

6 Mix a rich, orangey-brown from cadmium yellow, cadmium red and a little ultramarine blue and paint the rounded turret. Use the dark brown mixture from Step 5 to paint the shaded right-hand side of the turret and the eaves under the right-hand side of both the steeple and turret.

7 Using the orangey-brown mixture from Step 6, "draw" concentric lines underneath the conical roof of the turret so that you begin to establish the form of this structure. Paint the window in the turret in the same colour. Darken the mixture and paint under the eave on the right-hand side of the steeple.

8 Darken the middle facet of the spire using the dark brown mixture from Step 5. Using the steel-nibbed dip pen and waterproof black ink, reinforce some of the structural lines of the building and put in the curves of the arched window on the left-hand side of the steeple.

9 The right-hand side of the steeple looks too light, so mix a warm brown from ultramarine blue and cadmium red and darken it. Mix a neutral mauve from yellow ochre and ultramarine blue and paint the window on the right-hand side of the steeple.

10 Brush pale yellow ochre over the left-hand side to warm up the colour of the stone. Use the dark brown mixture from Step 5 to paint the recessed window on the left. Paint horizontal and vertical lines to the left of and below the window, indicating that the façade is not completely flush.

**The finished painting**

The artist has achieved a good balance between linear pen work and watercolour washes, with the ink establishing the structure and some of the fine detail of the building and the watercolour the subtle tonal transitions from light to dark.

On its own the pen work could have looked rather tight and mechanical, but successive layers of watercolour washes have helped to enliven the study and provide it with some depth and colour.

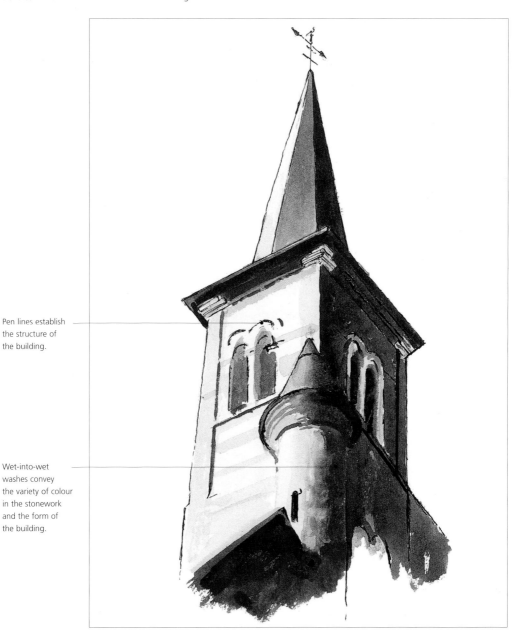

Pen lines establish the structure of the building.

Wet-into-wet washes convey the variety of colour in the stonework and the form of the building.

# Water-soluble pencils

The advantage of water-soluble pencils is that they combine the linear appeal of pencil work with the fluidity of transparent watercolour washes. They are incredibly versatile: you can use them wet or dry, on their own or in conjunction with other media, and the colours do not go muddy. Easily portable, water-soluble pencils are a real boon when it comes to making sketches on location, but they are equally useful in the studio.

Water-soluble pencils are available in a breathtaking range of colours – there are far more shades available than you will find in any range of paints. You can also blend several colours together on the paper to produce subtler shades. However, some brands of water-soluble pencil seem to blend better than others, so it is worth experimenting with different brands in order to find one that you like.

**Dry on dry**
Applied dry on top of dry paper or watercolour washes, water-soluble pencils can be used to draw fine lines and details, such as veins in flower petals and leaves, feathers, mortar lines in brickwork, wood-grain effects, and highlighting on objects such as bottles.

**Wet on dry**
Dipping the tip of the pencil in water before you apply it to the dry paper has two effects: it intensifies the colour and it also fixes the pencil marks, so that they do not blur (or do not blur as much) when a watercolour wash is applied on top.

**Dry marks brushed with water**
If water or a watercolour wash is brushed over dry water-soluble pencil marks, they will blur and spread a little – a useful technique for implying that objects are far away, such as a distant woodland. (Foreground details should always be crisp and sharp.)

**Blending water-soluble pencil marks**
Brushing clean water over water-soluble pencil marks will allow you to blend colours together easily.

 **Tip**: Make heavy scribbles in a range of colours and use them as easily portable "palettes": when you brush the scribbles with clean water, you can pick up enough colour on the brush to work with them in the same way as watercolour paints. However, the "paints" thus produced are generally less intense in colour than real watercolour paints.

## Practice exercise: **Peacock feathers**

This exercise demonstrates the linear characteristics of using water-soluble pencils dry, and it gives you the chance to practise mixing colours optically by overlaying one colour on top of another. It also shows how the colour intensifies into a smooth, velvety finish when the tips of the pencils are dipped in water and used wet. For the best effect, use a smooth, HP paper.

### Materials
- *HP paper, unstretched*
- *Water-soluble pencils: yellow-green, jade green, orange, light violet, light green, dark green, emerald green, turquoise, light blue, ultramarine blue, ivory black*

### The display
When a male peacock displays, his tail feathers fan out into a shimmering mass of iridescent colours. Although you won't find true iridescent colours in your range of water-soluble pencils, you can come close to recreating the effect by carefully overlaying colours on the paper, so that they mix optically.

1 Outline the "eyes" of the peacock feathers with a pale, yellow-green line. Draw around the outside of the yellow lines with a jade green pencil.

2 Using the jade green pencil again, draw long, feathery strokes on the outer edges of the eyes. Draw an orange line inside the first yellow-green lines and fill in the lower half of the eyes in orange.

▶

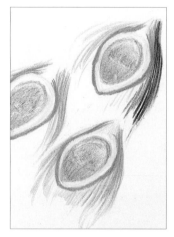

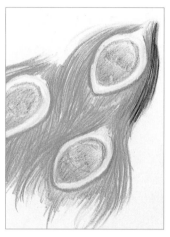

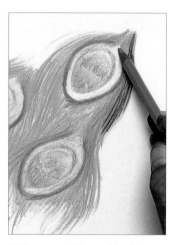

**3** Fill in the upper half of the eyes with light violet. Following the direction of the peacock feathers, draw light green marks over the straggly jade green feathers, so that the two greens blend optically. Then repeat the process using a dark green pencil.

**4** Go over the other greens again, and the large spaces between the eyes, with an emerald green pencil – again, making sure that your pencil marks follow the direction in which the feathers grow. Take care not to block in the colour too heavily.

**5** Draw around the outside of the eyes with a turquoise pencil and draw over the initial yellow-green lines with jade green. Note how you are beginning to build up the depth of colour while still maintaining the linear quality of the pencil work.

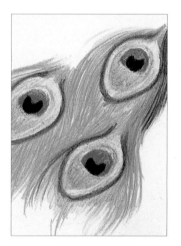

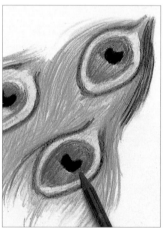

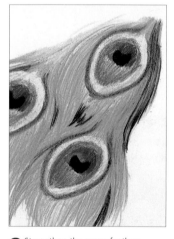

**6** Go over the light violet of the eyes with a light blue pencil. Although you can't really see the underlying violet any more, the colours merge on the paper to create a purplish blue that you could not have created by using just one pencil on its own. Draw the "pupils" of the eyes in ivory black. (Note the irregular shape: they are not a neat circle or semi-circle.).

**7** Dip the tip of an orange pencil in water and go over the orange colour again. Note how using the pencil wet intensifies the colour and creates a smooth, velvety block of colour in which the individual pencil strokes can no longer be clearly differentiated.

**8** Strengthen the green feathers further by applying layers of emerald green and light green pencil. As before, follow the direction of the feathers and take care not to block in the colours completely, otherwise the feathers will look like a solid mass rather than individual strands. Draw in small touches of ivory black between the feathers: this adds drama.

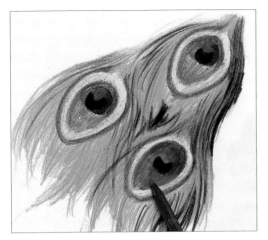

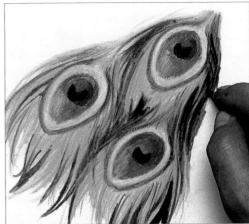

**9** The green markings look a little too green at this stage; you need to relieve the intensity and also hint at the iridescence of the feathers. Go over the green markings in places with an ultramarine blue pencil. Dip the ultramarine blue pencil in water and intensify the blue of the eye. Strengthen the orange of the eye in the same way.

**10** Dip a dark green pencil in water and go over any areas that you want to be very dark. Because the pencil is used wet, the resulting marks are very smooth and intense in colour. Dip an ivory black pencil in water and build up more of the base feathers. This provides a background against which the colours will stand out more strongly.

**The finished work**
More a drawing than a painting, this little detail sketch nonetheless shows the range of marks and intensity of colour that can be produced with water-soluble pencils. It is also a lovely example of optical colour mixing.

Greens and blues intermingle to create subtle optical mixes that hint at the iridescence of the feathers.

The individual pencil strokes can clearly be seen.

More solid blocks of colour are achieved by dipping the tip of the pencil in water.

# Using a toned ground

Although it is more usual for traditional transparent watercolour to be painted on white paper, it is possible – and, in some cases, even preferable – to work on a coloured or toned ground or paper.

Using a toned ground can create a colour harmony as, to a greater or lesser extent, the colour of the ground influences the colour of the washes that are applied over the top. It establishes a colour key that can help create a mood. A toned ground can also simplify and cut down considerably on the amount of time it takes to paint the picture: applying a wash over the whole paper in order to establish a colour key is often the first stage in making a watercolour painting.

Ready-prepared watercolour papers are available from art stores in shades of cream, oatmeal, grey, light blue and light green. If you require another colour, you will need to prepare the paper yourself by applying a wash of the desired hue in either watercolour or acrylic paint. Acrylic paint has the additional advantage of being permanent: there is no risk of the colour being disturbed by subsequent layers of watercolour washes. However, it does leave a slight residue and seals the surface, and this can affect the way the watercolour lies on the paper.

The toned ground need not be flat and uniform. If appropriate to the subject, you could create a textured ground using sponges or rough brush work.

The colour you choose for the ground should reflect the mood and atmosphere of the piece and complement the colours to be used. This is particularly important when using transparent watercolour. If you are using opaque watercolour (that is, watercolour to which body colour has been added), the opacity and covering power of the paint make the colour of the ground less noticeable.

If you are using opaque watercolour, the colour of the toned ground can lean towards the complementary colour of the main colours in the painting – for example, a predominantly green landscape on a pale red ground. Because of the effect of simultaneous contrast, a ground in a contrasting colour can make the colours used in the painting seem brighter.

## Practice exercise: **Log and axe on toned ground**

This exercise shows how to create an overall colour harmony by using a toned ground. When you first start experimenting with toned grounds, keep the subject very simple, with a limited colour range, and think carefully about what colour will work best. Here, the overall colour of the wooden log and axe is a warm brown and so a pale, warm ground is the obvious choice.

### Materials
- 2B pencil
- Soft graphite pencil
- 200lb (425gsm) NOT watercolour paper, pre-stretched
- Watercolour paints: yellow ochre, burnt umber, Payne's grey, raw umber, ivory black, burnt sienna
- Brushes: large wash, medium round

### The set-up
The plain cream paper on which the log is set is helpful in some ways, because it allows you to see the cast shadow very clearly, but it is also very stark and bright and detracts from the subject.

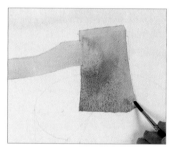

1 Tone the paper with a pale wash of yellow ochre. Leave to dry. Using a 2B pencil, sketch the outline of the axe and log. Paint the axe handle in a dilute wash of raw umber. Mix a light brown from burnt umber and Payne's grey and paint the axe head. Leave to dry.

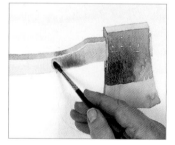

2 Mix a dark brown from burnt umber and ivory black and paint the dark on the side and bottom of the axe head. Add raw umber and burnt sienna to the mixture and paint the handle, leaving the underlying colour where the light hits the handle. Leave to dry.

**3** Add a little Payne's grey and plenty of water to the mixture to lighten the colour, then paint the side and top of the log. Using a slightly darker version of the same mixture, begin to paint some of the growth rings on the top of the log, but leave the split in the wood unpainted as parts of it are considerably lighter in tone than the surrounding wood.

**4** Paint a series of fine burnt umber lines along the length of the axe handle to suggest the grain and pattern in the polished wood. Mix a warm brown from burnt umber and raw umber and paint the side of the log, using the side of the brush and a slight scrubbing action in order to create a broken, uneven texture.

**5** Using the same raw umber and burnt umber mixture, paint the growth rings on the top of the log. Add burnt umber and Payne's grey to the mixture and paint the shadow inside the split. Using a soft graphite pencil, indicate the grain and growth rings on the side and top of the log. Once dry, rework the dark shadows deep within the split.

**The finished painting**
Crisp shadows painted in a warm grey mixed from Payne's grey and a little burnt umber complete the image and make it look three-dimensional. The yellow ochre ground harmonizes well with the colours used to paint the axe and log, whereas a white ground would have looked too stark and would have competed for the viewer's attention. It makes a subtle but important contribution to the overall warm tone of the image.

The yellow ochre ground is similar in colour to the axe and log.

The texture of the log is convincingly portrayed.

# Working into wet paint

Watercolour washes can be manipulated in several ways when they are wet. They can be moved around, removed or worked into using various tools. The only restriction is the amount of time available before the paint dries to such an extent that it is no longer movable.

Certain papers facilitate working into wet paint better than others. The fibres in highly absorbent papers soak up the washes and make any manipulation impossible, even immediately after they have been applied. Even better are papers that have been sized to such a degree that washes sit on the surface and dry slowly, rather than soak in.

Some techniques work better when the paint is very wet, while others are more effective when the paint has dried a little. Adding gum arabic to your washes can facilitate certain techniques, as it thickens the paint, increasing its viscosity so that it is less fluid. Thickening the paint prevents it from flowing freely and allows you to work into it more readily.

You can work into wet paint to depict any type of textured surface. You can remove paint by using textured fabrics, absorbent paper, man-made and natural sponges, to name but a few.

You can also make marks in wet paint by using a variety of tools that you might not normally associate with painting, such as combs, palette knives, pieces of stiff card, or the wooden end of your brushes. These are all excellent for this purpose, as is the relatively new range of rubber paint-shaping tools. Pressing fabrics, paper, and even aluminium kitchen foil or clear film (plastic wrap) all create interesting textures that you could not achieve using an ordinary brush.

When a wash is partially dry, dropping water or paint into it results in an effect known as a back-run (sometimes called the cauliflower effect). This can be put to good use when painting cloudy skies or flowers, as it creates a crinkled, often highly pigmented edge as the wetter paint pushes into the drier paint. A similar effect can be seen when paint that has collected in a puddle on buckled paper dries at a much slower rate than paint on the surrounding area.

## Lifting off colour

There will be many occasions during your painting when you find that you need to remove some colour from your work – either to make minor corrections or simply to soften tones and edges. The methods shown below are particularly useful for lifting out clouds from a blue sky – but remember to turn the paper or sponge around in your hand each time you use it in order to find a clean area, otherwise you run the risk of dabbing paint back on.

**Absorbent paper**
First, lay a wash. While it is still wet, blot off any excess paint with a scrunched-up piece of clean, absorbent tissue or a paper towel.

**Sponge**
You can also lift off colour from a wet wash using a sponge. This gives more texture, as the texture of the sponge is impressed into the wet wash.

## Pressing materials into wet paint

You can create interesting textures by pressing things into wet paint and removing them once the paint is dry. The results are a little unpredictable, but well worth experimenting with. Two possible materials are shown below, but you can easily come up with others from readily available household items. Lace, soft absorbent fabrics, such as cotton and felt, thick wool: experiment to see how many different effects you can create with whatever you have to hand.

### Clear film

1 Scrunch up a piece of clear film (plastic wrap) in your fingers and gently press it into a wet watercolour wash. Leave it to dry.

2 When the paint is dry, carefully remove the clear film. The lines of the scrunched-up food wrap are clearly visible in the dry paint.

**Aluminium kitchen foil**

1 Scrunch up a piece of cooking foil and press it into a wet wash. Leave to dry.

2 When the paint is dry, carefully remove the foil. This creates crisper, sharper lines than the food wrap.

## Practice exercise: **Graffiti-style abstract**

Remember how much fun you had as a child, messing around with poster paints and coming home with your fingers stained with bright, primary colours? This exercise is all about recapturing that sense of fun and excitement and getting a feel for how wet watercolour paint behaves. The result is an abstract mass of colour and texture, rather like graffiti sprayed on to a wall.

Feel free to experiment with materials other than the ones shown here: there are no limits to what you can use. Work quickly while the paint is still wet. Above all, don't try to plan ahead, simply react to the way the paint flows and puddles on the paper.

**Materials**
- *300lb (640gsm) rough watercolour paper*
- *Watercolour paints: alizarin crimson, cobalt blue, burnt sienna, ultramarine blue, cadmium yellow*
- *Watercolour pigments: alizarin crimson*
- *Brushes: old brush for masking, medium round*
- *Masking fluid and tape*
- *Paper towels*
- *Toothbrush*
- *Card*
- *Cotton bud*

1 Brush on random swirls of masking fluid and leave to dry. Cut abstract shapes from masking tape and press them on to the paper. Wash alizarin crimson and cobalt blue on to the paper, allowing the colours to merge.

2 While the first washes are still wet, brush on burnt sienna and ultramarine blue, again allowing the colours to run together and merge on the paper in a completely random way. Tilt the board to facilitate this.

3 Brush on more alizarin crimson and dab a piece of kitchen paper onto the paper to lift off and soften colour.

4 You have now established a mass of abstract wet colours into which you can work.

▶

5 Using thick paint straight from the tube, brush on a few long strokes of cadmium yellow. This gives an impasto-like texture similar to oil paint.

6 Drag an old toothbrush over the yellow lines to spread and diffuse them. Because the bristles of the toothbrush are stiff and the paint is relatively thick, you can clearly see the marks that are left behind – an unusual way of adding texture to a watercolour.

7 Take a small piece of card and scrape into the wet paint, dragging it from one colour into the next. The card is flexible, so you can make curved lines, while its thin edge allows you to create lines that are clearly defined. An old, cut-up credit card would have the same effect.

8 Pick up a little powder pigment on a piece of card and, gently tapping it with your finger, lightly sprinkle the pigment on to the paper. Note how the pigment colour spreads and blurs in damp areas but remains on the surface, creating an impasto-like texture, in dry parts.

**9** Dip a brush in clean water and brush over the pigment particles to blur and spread them. The more water you have on the brush, the further the powder will spread and the paler the colour will become.

**10** Pull off the masking tape and rub off the fluid to reveal small areas of bright white. Brush more alizarin crimson on to selected areas of the paper and, while it is still wet, drag a toothbrush through it as before.

**11** Dip a cotton bud in ultramarine blue paint and dot it on to the paper to make more clearly defined marks in selected areas.

**The finished painting**
This is a completely abstract, explosive riot of colour and texture. It was not pre-planned in any way, but was created by the artist responding to the way the wet paint behaved on the paper. Exercises like this will teach you a lot about manipulating paint and free you from any hang-ups about having to paint lifelike subjects.

Clear lines and dots are created by scraping into the paint with card and dotting on colour with a cotton bud.

Allowing the paint to merge wet into wet creates soft background colour.

Using thick cadmium yellow paint straight from the tube creates an impasto-like effect.

# Sgraffito

The technical name for scratching into dry paint comes from the Italian, *graffiare*, which means to scratch. Sgraffito can be used to reveal white paper beneath a wash, and is a good way to create highlights, such as sunlight on water. It can also be used to scratch through one layer of colour to reveal the layer beneath.

Paint can be scratched into using a variety of sharp implements. A scalpel or craft (utility) knife is useful for scratching fine lines, as are sharpened brush handles, paper clips and even your fingernails. For larger areas, sandpaper is very effective; experiment with fine and harsh grades of sandpaper for different results.

You can also use sgraffito to remove small areas of paint to correct minor mistakes – for example, if you want to neaten an edge or the outline of an object. To do this, scrape gently, using the edge of the scalpel blade rather than the point, so that the paper is not torn and the scraped area remains flat.

All these techniques work better if the paint sits on the paper surface, rather than soaking into it to any depth, so try to avoid using sgraffito with staining colours such as alizarin crimson, viridian or phthalocyanine blue. Needless to say, it is best to use sgraffito on heavy paper (say, 300lb/640gsm) as it is less likely to tear, and on top of dry washes.

**Scalpel or craft knife**
To scratch fine lines, such as highlights on water, use the tip of a scalpel or craft (utility) knife, pulling the blade sideways to avoid slicing into the paper and damaging it.

**Fine sandpaper**
Stroke the sandpaper over the surface of the dry paint. This is particularly effective on rough watercolour paper, as the paint remains in the troughs but is removed from the higher ridges.

**Coarse sandpaper**
Because the sand particles on course paper are bigger, the sgraffito lines are further apart. You can also fold the sandpaper to create a crisp edge, enabling you to scratch off sharp lines.

## Practice exercise: **Conch shell**

This conch shell contains a number of different textures, from hard, raised ridges and points to the mottled surface of some of the flatter areas and the porcelain smoothness of the inside. The following exercise gives you the chance to practise two methods of sgraffito, using sandpaper for general areas of texture and a scalpel or craft (utility) knife for the crisp, sharp ridges on the outer side of the shell.

**The set-up**
Arrange the shell at an interesting angle, so that you can see both the hard, spiky outer shell and the smooth, slightly shiny interior. This provides an attractive contrast of textures and makes it easier to appreciate the form of the object.

**Materials**
- *2B pencil*
- *300lb (640gsm) NOT watercolour paper*
- *Watercolour paints: yellow ochre, Payne's grey, alizarin crimson, raw umber*
- *Brushes: medium round*
- *Medium-grade sandpaper*
- *Scalpel or craft (utility) knife*

1 Using a 2B pencil, lightly sketch the shell to establish the general outline shape and the main ridges. Using a medium round brush, establish the overall colour with pale washes of yellow ochre, Payne's grey and a little alizarin crimson, allowing the colours to blend together on the paper and create a surface with subtle variations in colour. Leave to dry.

2 Take a small piece of medium-grade sandpaper and stroke it over the paper to recreate the rough, pitted surface of the shell. (Leave the areas of smooth shell that lie deep within the interior untouched.) To scratch into small or tight areas of the image, fold the sandpaper to make a crisp, sharp edge.

3 Mix a cool brown from yellow ochre and Payne's grey and paint the areas in shadow and some of the linear detail. When the paint dries, it will leave a rough texture on areas of the paper that have been rubbed with sandpaper. Mix a dull pink from alizarin crimson and yellow ochre and paint the warm colours on the shell "lip". Leave to dry.

4 Using a sharp scalpel or craft (utility) knife, gently scratch into the dark paint until clean paper fibres are revealed, creating the ridges on the outer side of the shell.

**The finished painting**
The dense, cast shadow is painted in a darker, more pigmented mixture, which anchors the shell to the surface on which it rests, and also has the effect of throwing it into sharp relief. When painted over, the rough texture made by the sandpaper creates a broken effect that contrasts well with the fine, crisp lines made with the point of the scalpel or craft (utility) knife blade.

5 Mix a mid-toned grey from Payne's grey and a little yellow ochre and paint the shadow inside the shell. Mix a darker grey from Payne's grey and raw umber and wash in the background, painting very carefully around the shell.

A scalpel or craft (utility) knife is used to scratch off these crisp lines on the outside of the conch shell.

General areas of rough texture are created using medium-grade sandpaper.

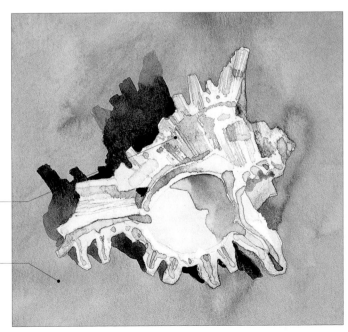

# Body colour

Traditional transparent watercolour uses no white paint. Instead, you have to leave any areas of the painting that you want to be white, such as clouds or highlights sparkling on water, free of paint. Colours are made paler by adding more water.

The white of the paper also serves to reflect light back through transparent coloured washes. Depending on the depth of the colour, this can make them appear lighter or darker. Because the washes are transparent, when one colour is painted on top of another the underlying colour will always show through. This makes it impossible in pure watercolour to paint a light colour on top of a dark one.

Body colour is somewhat different. White and pale shades are obtained by adding white pigment, which adds "body" to the paint and renders it opaque. Chinese white, which is made from zinc oxide and gum arabic, was traditionally used as body colour. It is a dense white with a very high tinting strength. A good alternative, which many artists use, is white gouache.

You can use body colour straight from the tube to create highlights and details that would normally have been made by preserving the white of the paper – catchlights in people's eyes, for example, or white whiskers on a cat. You can also

mix it with transparent watercolour paint to produce light, opaque pastel tints that can then be painted on top of dark colours. This is particularly useful when you want to add subtle pale details or textures – for example, by spattering white paint on to the support to represent falling snow in a snow scene.

Body colour comes into its own when you are working on a coloured or tinted ground because it enables you to use light tones and colours without them being influenced by the underlying ground colour, which can completely overpower pale, transparent washes.

Body colour can also be used to correct mistakes – perhaps highlights that you have forgotten to leave white, or even entire passages that you want to cover up and repaint. Use it cautiously, however, as too much can look heavy and deaden the lovely translucent quality for which pure watercolour is renowned.

You need a degree of competence and flair to mix the two techniques of body colour and transparent washes. It is easy for the two techniques to jar and work at odds with one another, but if used carefully, body colour can extend the creative possibilites of watercolour as a medium, and will bring another dimension to your watercolours.

**Light watercolour over dark watercolour**
When a paler or lighter transparent watercolour paint is applied over the top of a darker paint, the underlying dark wash will show through.

**Light gouache over dark watercolour**
When a paler or lighter watercolour paint is combined with Chinese white gouache, the mixture becomes opaque. It then becomes possible to apply a lighter colour on top of a darker one.

## Practice exercise: **Painting light on dark**

A lighter blue pattern on a rich, dark blue background: in pure watercolour, the only ways to paint the pattern on this little embossed vase would be either to mask the light areas, which might look too bright when the masking is removed, or to paint the light areas first, and then carefully paint the darker blue around them, which is quite a fiddly process.

With body colour, however, things are much simpler. By mixing Chinese white gouache with transparent watercolour paints, you can create pale, opaque mixtures that can be painted on top of the dark, underlying colours. The opaque pattern also contrasts well with the translucent watercolour used to paint the blue of the vase.

**The set-up**
Tiny orange flowers were chosen to contrast with the rich blue of the vase – orange and blue are complementary

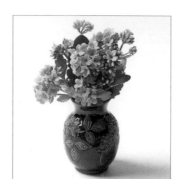

colours and they work well together. Positioning a table lamp to one side of the vase helps to pick up the texture of the embossed pattern.

**Materials**
- *B pencil*
- *140lb (300gsm) rough watercolour paper, unstretched*
- *Watercolour paints: ultramarine blue, burnt sienna, cadmium lemon, cadmium red, cadmium yellow*
- *Gouache paints: Chinese white*
- *Brushes: medium round, large wash*

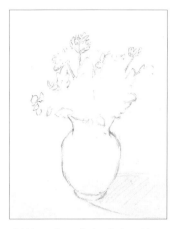

1 Using a B pencil, sketch the subject. Don't attempt to draw every single leaf and flower: a light indication of the general areas is sufficient.

2 Mix a rich blue from ultramarine blue with a little burnt sienna. Using a medium round brush, paint the vase, adding a little more burnt sienna for the right-hand side of the vase, which is in shade. Dilute the mixture for the shadow cast by the vase.

3 Mix a dull green from cadmium lemon, ultramarine blue and a little cadmium red and brush in the broad shapes of the leaves. Add more cadmium lemon to the mixture and paint the lighter leaves. Dot the same mixture over the unopened buds.

4 Add a little cadmium yellow to the dilute shadow mixture used in Step 2 and, using a medium round brush, brush it over the background to relieve the whiteness. Mix an orangey green from cadmium lemon, ultramarine blue and cadmium red and start to put in the flower buds that are just starting to open. Mix a pale, opaque blue from ultramarine blue and Chinese white gouache and paint the pattern on the vase.

5 Add a tiny amount of burnt sienna to the opaque blue mixture and continue painting the pattern on the right-hand side of the vase. These subtle changes in tone help to establish which areas are in shade, as a result of which the vase begins to take on a more three-dimensional quality. Burnt sienna is also slightly orange in tone: shadow colours often contain a hint of a complementary colour.

6 Mix a bright orange from cadmium red and cadmium yellow, and paint the tiny open flowers. Note how this use of complementary colours (the orange flowers against the blue of the vase) immediately makes the painting look more lively and dynamic.

7 Mix a dark green from ultramarine blue, burnt sienna and cadmium yellow and paint the darkest leaves. Mix a light green from cadmium yellow and ultramarine blue and paint the unopened buds. Mix orange from cadmium lemon, cadmium red and Chinese white gouache and paint the opening buds.

8 Add Chinese white gouache to the bright orange used in Step 6 to make it opaque. Use the mixture to paint the flowers that overhang the deep green leaves.

9 Mix a pale orange from cadmium yellow and cadmium red and brush it over the surface on which the vase sits. This will tone down the brightness and will provide a visual link to the colour of the flowers. Mix an opaque light green from cadmium lemon, ultramarine blue and Chinese white gouache and paint some light leaves over the dark ones.

### The finished painting

Combining pure watercolour paint with Chinese white gouache makes it possible to paint light colours on top of dark ones. Because of its opacity, the body colour is also very effective in suggesting the embossed texture of the vase. Note also the effective use of the complementary colours blue and orange for the flowers.

Chinese white gouache has been used to tone down the bright orange of the flowers.

Pure watercolour paint is used for most of the vase. The translucency of the paint conveys the shiny glaze very effectively.

The opaque, pale blue mixture completely covers the underlying dark blue wash.

# Scale and perspective

The further away something is from you, the smaller and less distinct it seems with the naked eye. In order to convincingly depict depth and recession, and so add a sense of realism to your work, you need to depict this shift in scale accurately. This is done by using a technique known as perspective.

At first sight, perspective may seem complex and confusing, but the basics are easy to understand and even a rudimentary grasp of the fundamentals will enable you to position elements in your work so that they appear to occupy their correct "space" in the composition.

As with any endeavour, planning is the key to success. You need to consider any perspective issues from the moment you begin a work and incorporate them from the outset. If you are unsure, make a sketch or a working drawing before you begin work on the painting. This will allow you to work out any problems in advance.

## Aerial perspective

Sometimes known as atmospheric perspective, aerial perspective refers to the way the atmosphere combined with distance influences and affects what you see. Being able to identify and utilize these effects will enable you to paint realistic and convincing three-dimensional landscapes.

Four things are directly influenced by distance: these are texture, colour, tone and size. The most obvious of these is size. Objects gradually become smaller the further away from you they are. You can see this most clearly by looking along a row of identically sized telegraph poles, fence posts or trees.

Second, detail and textures become less evident with distance. Close-up texture and detail are often large and in sharp focus, while texture and detail that is further away is vague and less clearly defined.

Third, colours seen in the foreground and near distance appear bright and vibrant because the warm colours – reds, oranges and yellows – are in evidence. Colours in the far distance appear much less bright. They are also cooler and contain more blue and violet.

Finally, tonal contrast is dramatically reduced with distance, and sometimes it disappears completely, so that distant hills, for example, might appear as one pale mass.

These effects on size, detail and colour are caused by our own visual limitations. They are also caused by the gases, dust and moisture present in our atmosphere, which create a veil through which light has to filter. In addition, all these effects are directly influenced not only by the time of day, but also by the season of the year, the location, and the inherent local weather conditions.

The principles of aerial perspective apply not only to terra firma but also to the sky. Clouds appear larger when they are viewed immediately overhead. The sky alters colour too, being a warmer, deeper blue immediately overhead, gradually becoming paler and often with a cool yellow tinge as it falls towards the horizon and the far distance.

**The effects of aerial perspective ▼**
This simple landscape clearly illustrates the effects of aerial perspective and shows how atmosphere combined with distance influence the way we see things.

Colours in the foreground look warmer and brighter.

Clouds appear
smaller the closer
they are to the
horizon.

Colours in the
distance are cooler
and less intense.

Detail is less
apparent in
the distance.

Tonal contrast
is reduced in
the background.

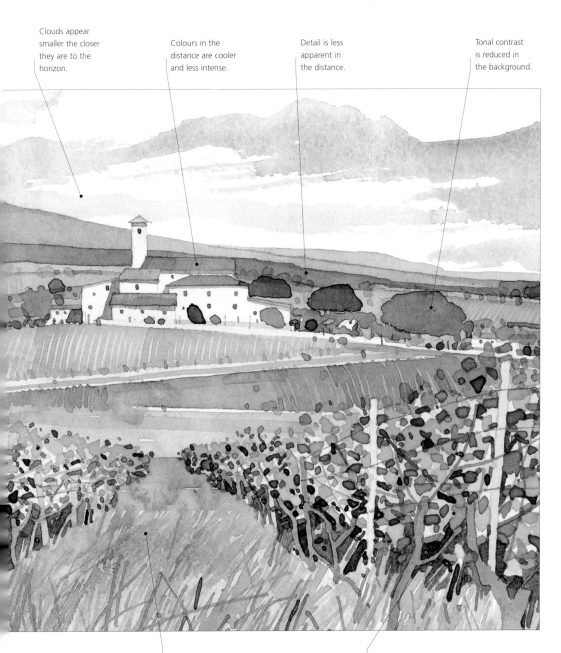

Detail is more
apparent in
the foreground.

A full range of
tones can be seen
in the foreground.

## Linear perspective

Linear perspective is a system or device that allows you to create the illusion of three-dimensional space on a two-dimensional flat surface. The system is based on the principle that all parallel lines, known as perspective lines, when extended from any receding surface meet at a point in space known as the vanishing point.

The vanishing point is on what is known as the horizon line, which runs horizontally across the field of vision. The horizon line is also known as the eye level, because it always runs horizontally across the field of view at eye level, regardless of whether you are sitting or standing. All perspective lines that originate above the eye level run down to meet the vanishing point and all perspective lines that originate below the eye level run up to meet it. All vertical lines remain vertical.

The simplest form of perspective is single, or one-point, perspective. This occurs when all the receding perspective lines meet at one single point. The vanishing point in single-point perspective always coincides with your centre of vision, which is directly in front of you.

You can see the effect of single-point perspective by looking along a train track that runs straight away from you into the distance. The two rails are, in reality, consistently spaced the same distance apart, but because they are resting on the ground plane, which is receding away from you, the rails appear to converge the further away they get, eventually meeting when they reach the vanishing point.

A similar effect can be seen when you are standing in a straight road and looking into the distance along a row of identical houses. Using straight perspective lines to extend the roof line, the gutters, the top and bottom of the windows and doors, you will see that they all meet at the same vanishing point.

**Parallel lines receding away from the viewer ▼**
In this simple illustration of one-point perspective the trees – which, in reality, are all of similar size – appear to get smaller the further away they are. All perspective lines above eye level run down to the vanishing point (VP) and all perspective lines below eye level run up to the vanishing point.

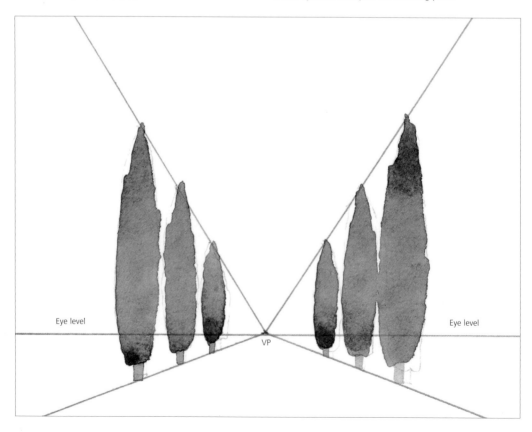

Eye level           VP           Eye level

### Parallel lines receding to one side ▼

Here, all the elements on the front of the house are on the
same plane and so they all meet at the same vanishing point.

VP

Eye level

### Subject below eye level ▼

As in the other examples shown on these two pages, a single
vanishing point is all that is required in this view of a chess
board, because the chess board is orientated with one side
square to the viewer.

All the receding parallel lines on the board extend to the
vanishing point. Because the board is below eye level, the

perspective lines run up to meet the vanishing point. The
width of each row of squares is arrived at by measurement;
the depth of the board is also measured. Drawing a diagonal
line from corner to corner of the board will help you to work
out the depth of each row of squares, as the corners of these
squares have to fall on the diagonal line.

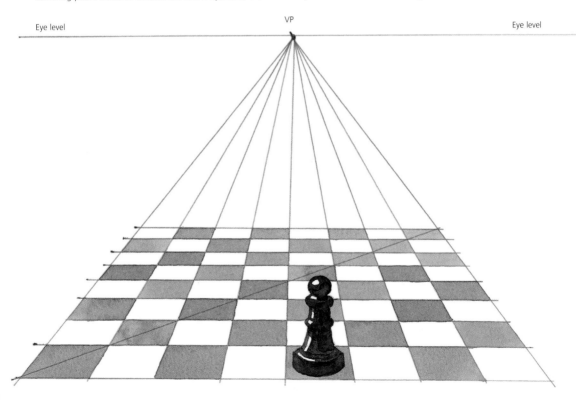

Eye level

VP

Eye level

## Two-point perspective

If any two sides of an object can be seen at the same time, then two-point perspective comes into play. The principle remains the same as that discussed in one-point perspective, but because two surfaces are visible and both surfaces are at different angles, any parallel lines on those surfaces will eventually meet at their own vanishing point.

In two-point perspective, neither vanishing point falls at your centre of vision. Perspective lines on the right-hand side will converge at a vanishing point off to the right and perspective lines on the left-hand side will converge at a vanishing point off to the left. Even if you move to a position that is higher than your subject, the horizon line on which any vanishing points are situated will still run across your field of

vision at eye level, so all perspective lines will run at an upwards angle to meet it. Similarly, if you move to a position below your subject, so that you are looking up at it, all perspective lines will run at a downwards angle to meet the horizon line.

**Two planes visible – two-point perspective ▼**
Two-point perspective needs to be taken into consideration when you can see two or three sides (planes) of a rectangular object at the same time. Here, we see two sides of a row of coloured boxes, all of which are orientated the same way. The perspective lines of each side of each box extend to the same vanishing point.

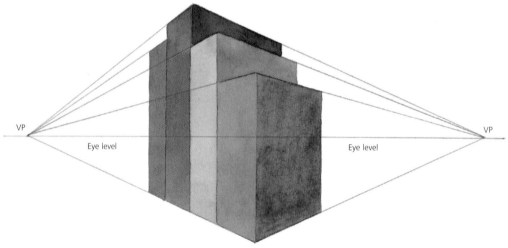

## Multiple-point perspective

When several objects are arranged at different heights and angles, then multiple-point perspective comes into play. It looks a little more complicated, but the rules remain the

same. Each object needs to be treated as a separate entity and its vanishing points and perspective lines should be plotted accordingly.

**Objects at different angles – multiple-point perspective ▶**
Here, three box-like shapes are resting on what might be a table top. Each box is facing in a slightly different direction, so each one needs to have separate vanishing points – as does the table top, which is orientated differently to the boxes.

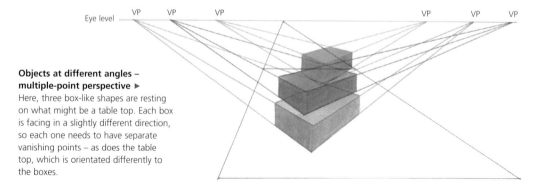

# Drawing curved and circular objects in perspective

Understanding the principles of perspective enables you to represent not only simple box-like structures, as in the examples that we've looked at so far, but also highly complex-shaped objects that possess curved, as well as flat, surfaces.

Curved and circular objects become ellipses when they are seen in perspective. To draw them accurately, first work out the area they occupy using squares and rectangles, which are also in perspective.

**1** First work out the area that the object (in this case, a cylinder) occupies, using simple squares or rectangles seen in perspective. Here the cylinder is viewed from directly in front and slightly above. A simple cube seen in single-point perspective indicates the position and approximate size of the cylinder.

**2** Find the centre of the top of the cube by drawing lines from corner to corner. Further divide the top of the cube into quarters by drawing a line (A–B) parallel to the front of the cube through the centre point and by drawing another line (C) through the centre point to line up with the vanishing point (VP). Do the same to the base of the cube.

**3** From point C on the front edge of the top of the cube, measure halfway to the corner (D). Drop a line at right angles to E, the same length as the measurement C–D. Position a compass point at C, with the radius set to E. Swing the compass from here to find points F. Draw a line from F to line up with the vanishing point (VP). Repeat on the base.

**4** The exact curvature of the top of the cylinder is established by drawing a curved line to connect points A, B and C at point G – through the points where the line F–VP intersects the lines that run from corner to corner. Follow the same procedure to find the curvature at the bottom of the cylinder.

# Composition

The way in which all the visual elements within a painting are put together is known as composition. The factors that govern composition include shape, scale, perspective, colour and texture. The purpose of composition is to manipulate and lead the eye while finding a pleasing visual balance of all these elements. Balance does not mean visual symmetry: shape can be offset with texture or colour with scale.

Composition can also be used to create mood. A composition can evoke feelings of heaviness and oppression, or be airy, light and uplifting. There are certain rules to composition, but breaking these rules often gives a work a certain edge that can lift it from the mundane and pedestrian into something much more eyecatching.

## Formats

The first thing you need to consider is what shape (or format) to make your painting. The three main formats are vertical (also know as portrait), horizontal (also known as landscape) and square. Needless to say, portraits can be painted on landscape-format supports and landscapes on portrait ones. Two other formats that are often used are round (or oval) and a wider horizontal format known as panoramic.

### Catching the light ▼
The roughly square format suits the subject perfectly: the neck and head curve around, balancing the bulk detail of the body.

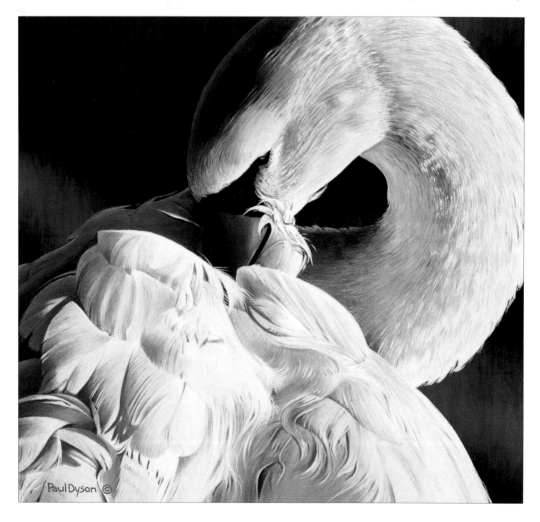

Paul Dyson ©

**Robin ▼**

A wide, panoramic format has been chosen for this painting of a robin on a branch. At first glance, it might seem that the subject is quite insignificant and does not warrant such an extreme format, but exaggerating the width of the painting has introduced a tension that would be lacking if the more usual landscape format had been used. The clever device of the arching branch, which runs the entire width of the image, prevents the picture from appearing one-sided: the eye wanders along it and across the picture, but always returns to the brilliant flash of red on the bird's breast.

**Seaside steps ▶**

The vertical format of this work again suits the subject. The eye is pulled along the length of the craft and up the steps towards the building. The golden yellow stonework pulls the eye down to the bottom of the picture and the circular journey begins again.

**Etretat, Normandy ▼**

The image of these cliffs in northern France sits comfortably in the horizontal format. The curve of the waterline sweeps the eye around to the cliffs and into the painting. At the base of the cliffs, the viewer's attention is caught by the dark ripples and reflection in the water; these in turn bring the eye down to the breaking waves and round again.

## Dividing the picture area

The principle of good composition is that nothing should dominate to such an extent that it holds the viewer's attention completely and exclusively – although, of course, there are occasions when artists deliberately choose to do precisely that. Dividing the picture area up and deciding exactly what should go where can be difficult, but there are some general guidelines that will help you.

Over the centuries, artists have devised ways of positioning the main pictorial elements and focal points on an invisible grid around specific positions within the picture area. The classic compositional device, and the one that is considered to be the ideal division of an area and aesthetically superior to others, is based on the golden section – the term used for a mathematical formula devised by Euclid and developed by Plato. Also known as divine proportion, it states that a line or area can be divided so that the "smaller part is to the larger as the larger part is to the whole".

A simpler and less rigid grid, which is easier to follow and use, is made by splitting the picture area into thirds, regardless of the format chosen. This is done by simply dividing the image area into three, both horizontally and vertically, which

gives a grid consisting of nine sections, with lines crossing at four points. The theory is that positioning major elements of the image near these lines or at their intersections will result in a pleasing image. As with the golden section, the formula is a good starting point on which to base your compositions.

It is generally considered inadvisable to position your subject in the very centre of the picture area, as it makes for a rather static image. However, a feeling of calmness and inactivity are sometimes exactly what the subject requires. Be guided by your instincts, even if they sometimes appear to be going against the rules.

**Beach, early morning ▼**
This simple painting of a beach umbrella and sun loungers silhouetted in the early morning sun is firmly based on the rule of thirds. The umbrella provides a strong vertical element approximately a third of the way in from the right-hand side, while the shoreline and sun loungers provide a horizontal element approximately one third of the way up from the bottom of the picture. These dark shapes are balanced by the empty area of water.

**The Tuileries, Paris** ▲
The chairs and litter bin are the centre of interest and are loosely positioned on the intersecting grid lines to the right of the image while the top third of the painting is filled with row upon row of leafless trees. Together, they balance the empty space in the bottom left of the image.

**Flamenco guitarist** ▶
Although it is perhaps not immediately apparent, this portrait is also based around the rule of thirds. The head of the guitarist, the bulk of the guitar body, and the tuning head are all positioned at points where the grid lines intersect, while the figure's torso and the ornate pillar are placed a third of the way in from the left- and right-hand sides respectively.

## Leading the eye

In a successful composition, the viewer's eye should be directed towards the image's centre of interest and encouraged to linger on the picture. Introducing curves and lines within the picture, either real or implied, are one way of doing this. Obvious examples of this might be a road leading up to a building, a river snaking its way through a landscape, or a line of trees receding into the distance.

All compositions are either "open" or "closed". A closed composition is one in which the eye is held within the picture area. It may be induced to move around from object to object, but essentially its focus is firmly held. An example of a closed composition might be a view from a dark interior through a window, with the window surround acting as a frame within a frame. An open gateway or tree trunks and branches might serve the same purpose. An open composition encourages the eye to move around the image, but also seems to suggest that the image continues well beyond the boundaries of the picture area. Many landscapes are perfect examples of open compositions.

Another strong compositional device, especially when painting landscapes, is the positioning of the horizon. This can have a profound effect on the mood of the image. Landscapes can be given extra impact by making the horizon very high within the picture area or even eliminating it altogether. Clouds can also be an important compositional consideration, providing large, eye-catching shapes in what might otherwise be an empty space.

**Louvre Museum, Paris** ▲
This is a good example of a closed composition. The eye is unavoidably pulled into the work past the sculpture and out the window into the centre of the image. The dark window surround acts as a visual barrier and encourages the eye to linger in the central area.

◄ **Clos de Vosges**
These weathered gate pillars act as a frame within a frame, drawing the eye through to the vineyard and buildings beyond. Because the pillars are placed centrally, the eye can move around within the rest of the painting. If they were placed closer to the edge of the image, the composition would seem more closed and confined.

**Springs** ▼

Rules are made to be broken. Placing the horizon line across the centre of an image is generally considered bad practice, but it can be made to work. Here, the strong sense of perspective leads the eye into the centre of the image.

The visual activity on the horizon line acts as a buffer, pushing the eyes out to either side. The bottom part of the image is roughly divided into thirds. The wide expanse of sky is broken by the row of telegraph poles.

**Mont St Michel** ▶

This is an example of both an open composition and breaking the so-called rules about where to position the horizon. The landscape and building are placed low in the picture area, with the horizon running across the image about a quarter of the way up. This has the effect of drawing attention to the sky, which is a featureless pale blue. One would not normally expect so much emphasis to be given to seemingly empty space, but in this instance the sheer size and weight of the sky provide a counterbalance to the visual activity in the lower part of the painting. The result is a powerful, atmospheric image that is possessed of a perfect spirit of place.

# Watercolour Projects

# Painting Skies

Skies have always both fascinated and frustrated artists. The fascination comes from the infinite combinations of cloud formations and colours, which can change minute by minute depending on the weather conditions and the time of day, and the frustration from trying to decide on the most appropriate way in which to represent them.

Although skies can be painted as a subject in themselves, they are more commonly viewed as part of a landscape – and an important part, at that. It is from the sky that light comes to illuminate the landscape below, and the colour and mood of all landscapes are directly influenced by the sky above.

When you are painting a sky as part of a landscape, you must make sure that each looks connected and related to the other. The best way to achieve this is to make the sky an integral and important part of the overall composition. As with all things, however, you can exercise a degree of artistic licence. A dramatic and powerful sky can very easily overpower a less interesting landscape, so don't be afraid to alter the balance from what you can actually see in reality.

Although the use of colour is important, particularly when you are painting sunsets, the most critical elements in any sky scene are the cloud formations. Getting to know cloud formations is a useful step towards painting skies well. Artists who paint skies frequently tend to make practice studies of the clouds before they begin.

Beginners often make the mistake of depicting clouds as flat objects against a background of blue, but the reality is very different. Clouds have a top (which the light hits), sides, and a bottom (which is often in deep shadow). They also conform to the laws of perspective, and appear smaller with less distinct colours as they stretch to the horizon. Applying the rules of aerial perspective to clouds can throw up an anomaly, however, for while skies are usually more intense and warmer in colour immediately overhead, becoming cooler and paler nearer the horizon, the exact reverse can be seen on occasions – particularly when looking out to sea, or in large cities with atmospheric pollution.

There are several techniques that you can use to paint clouds successfully. The sky colour and cloud positions might be made using wet-into-wet washes. Cloud shapes can be left as white paper or lifted out using a paper towel or a dry brush. As these washes dry, darker washes can be flooded on to create the parts of the clouds that are in shadow, with more washes being painted over the top to strengthen colour or redefine shapes when the first washes are dry.

Alternatively, you could paint the sky using only wet on dry washes, assessing the colour and tone of each so that the shape and colour of the clouds are built up in layers. Avoid hard edges, which look out of place in a sky scene. Cloud edges can be softened periodically by using clean water and a brush or by blotting with a natural sponge or paper towel.

**The Thames at Richmond** ▼
In this expansive view, the landscape and the sky are of equal importance. Placing the horizon on the halfway mark is risky, but the image works because the carefully arranged cloud formations balance the intricate landscape. The clouds were created by means of carefully planned wet on dry washes. The blue colour in the sky was painted last, with the cloud shapes being "cut out" as it was applied.

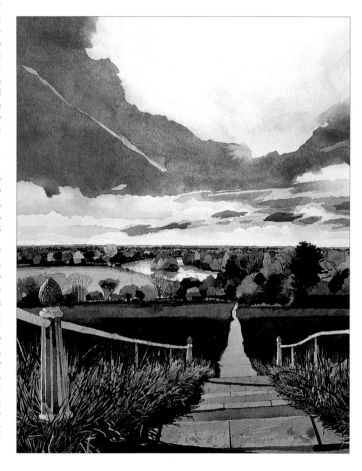

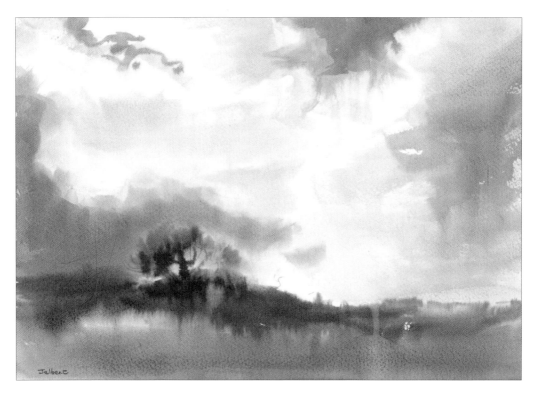

Jelbert

**Storm clouds** ▲

This loose impression of storm clouds gathering in a pale grey sky uses the same colours as the dark, wet landscape below. Washes were applied wet into wet in order to give a feeling of indistinct focus, which is often apparent in falling rain.

**Sunset** ▼

A gradated pale blue wash provided the foundation for this sunset. The pale orange strip of light on the horizon takes on an added brilliance seen against the dark landscape and the deep grey clouds above.

**Tips**: • Use clouds to balance dominant elements in the landscape.
• Take care not to make clear blue skies dominate your landscapes as, without clouds to add interest, such skies tend to look flat and boring.
• Remember that skies and clouds conform to the same laws of perspective as the land. As a general rule, colours get paler the nearer they are to the horizon, with clouds becoming smaller and less distinct.
• Practise painting various wash and cloud combinations. Only by knowing what your materials can do and how they behave will you be free to concentrate on creating the effects you want.

# Clouds at sunset

The presence of a few clouds in the sky almost always adds to the drama of a sunset, as the clouds pick up reflected light and add textural interest that might otherwise be lacking.

This project is an excuse to have fun and to play around with wet-into-wet washes to see what effects you can create. Although the wet-into-wet technique is perfect for depicting the gradual transitions of colour that you find in a sunset, it is also notoriously unpredictable. Different papers give different effects, and the degree of wetness also plays an important part. Knowing how wet the paper should be to create a particular effect is something that comes with practice, so don't despair if things initially turn out very differently from what you'd expected. Instead of aiming for a photo-realistic rendition, with every cloud and subtle tonal change in exactly the "right" place, use the scene as a starting point for your explorations: let the flowing paint do the work and adapt your ideas as you go, responding to the shapes and colours that emerge.

Include a hint of the land beneath in a sunset painting, even if it's just a tiny sliver at the very base of the picture. This anchors the image and provides a context for the visual feast above.

**Materials**
- 140lb (300gsm) rough watercolour paper, pre-stretched
- Watercolour paints: cobalt blue, cerulean blue, cadmium yellow, cadmium red, alizarin crimson, ultramarine violet
- Brushes: large round
- Sponge

**The original scene**
Pinks, oranges and violets; glowering clouds fringed with a pure and intense light: a sunset guaranteed to take away the breath of even the most hardened cynic! Clouds like these, with dramatic contrasts of light and dark, are generally much more interesting than fluffy white clouds in a brilliant blue sky.

Reflected light on these clouds provides a much-needed "lift" of colour.

These brooding clouds dominate the scene and add textural interest.

1 Using a large round brush, dampen the paper with clean water, leaving a few areas untouched. Mix a deep blue from cobalt blue and a little cerulean blue and lay a gradated wash, fading to almost nothing and stopping about halfway down the paper.

2 Mix a pale orange from cadmium yellow and a little cadmium red. Using a large round brush, wash this mixture over the lower half of the painting and dot it into the sky, where the setting sun catches the top of some of the cloud formations.

3 Touch the orange mixture into the dry cloud shapes left in Step 1. Working quickly, while the paper is still damp, deepen the orange colour on the lower half of the painting. Mix a dark purple from cobalt blue, alizarin crimson and ultramarine violet and drop this mixture into the centre of the painting, so that the colours blur.

4 Add more purple across the middle of the painting, going into both the blue and the orange areas, to establish the dark bank of cloud that runs across the centre of the image. Leave to dry completely before moving on to the next stage.

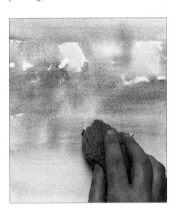

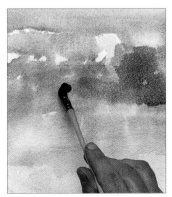

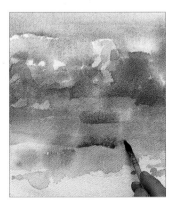

5 Dip a sponge in water, squeeze out any excess water and stroke it across the top half of the paper.

6 Using a large round brush, touch the purple mixture used in Step 3 into the dark clouds at the top.

7 Using the same paint mixtures as before, continue touching colour into damp areas, allowing it to spread and find its own way. Watch what happens rather than starting out with preconceived ideas: you will find that the paint suggests shapes that you can then strengthen and make an integral part of the painting.

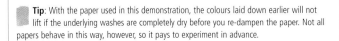

**Tip**: With the paper used in this demonstration, the colours laid down earlier will not lift if the underlying washes are completely dry before you re-dampen the paper. Not all papers behave in this way, however, so it pays to experiment in advance.

**Clouds at sunset**

This is an expressive painting, with subtle shifts from one colour to another, which demonstrates one of the main attributes of watercolour – its translucency – to the full. Although it is not a painstaking copy of the original scene, it nonetheless captures the quality of the light and the sense of rapidly changing lighting conditions very well.

The artist has exploited the unpredictability of the wet-into-wet technique by responding to changes as they occur on the paper, and so the painting has a lovely sense of freshness and spontaneity. At the same time he has paid careful attention to the light and dark areas so that the clouds really do look three-dimensional.

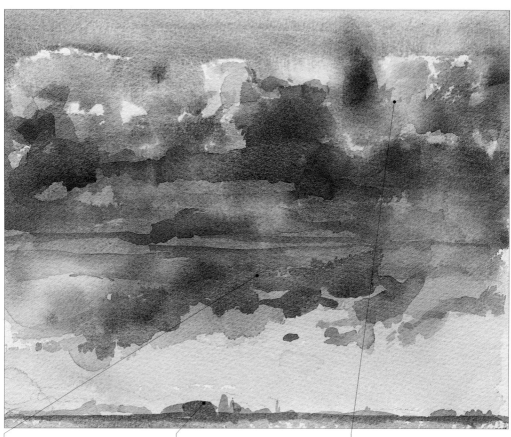

Successive wet-into-wet applications build up depth of tone.

Silhouetted shapes on the horizon anchor the scene.

The rough surface of the paper also helps to add textural interest.

## Variation: **Clouds at sunset painted on smooth paper**

The same scene painted on smooth paper gives a rather different result. In the previous painting, the rough texture of the paper played an important role. In this painting, however, the smooth surface means that there is a more uniform band of colour across the top of the image. The paint also behaves differently on smooth paper: although this scene was also painted by dropping colour wet into wet, there are a number of hard-edged rings. It is impossible to say that one type of surface is better than the other for this type of work: it is entirely down to personal preference.

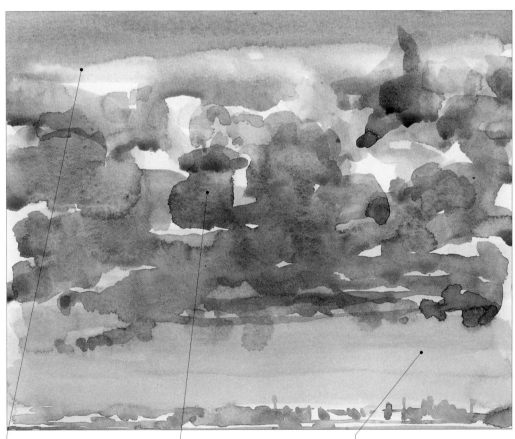

Allowing some of the initial wash to show through is an effective technique for skies.

On smooth paper, hard-edged rings of colour sometimes appear.

The paint goes on smoothly, and the paper texture is less evident.

# Storm clouds and rainbow

Watercolour is a wonderful medium for painting clouds. The translucency of the paint enables you to create a feeling of light and air, while wet-into-wet washes are perfect for creating subtle transitions from one colour to another.

One of the most important things to remember is that you need to make your clouds look like solid, three-dimensional forms, not just wispy trails of vapour in the sky. Clouds have a top, a bottom and a side. The top usually faces the sun and is therefore lighter than the side and the bottom. Before you start painting, work out which direction the light is coming from so that you can decide which areas of cloud are in shadow and need to be darker in tone.

Make sure that any changes in tone are very gradual. You can soften colours where necessary by lifting off paint with a piece of kitchen paper or a sponge, but try to avoid hard edges at all costs.

The rules of perspective that apply to painting land also apply to painting the sky, and clouds that are further away will appear smaller than those that are immediately overhead. They will also be lighter in tone.

In this project, dramatic banks of cumulus cloud before an evening storm are the focus of interest and the land below is almost an irrelevance. Although the land is so dark that relatively little detail is visible, it is an important part of the picture, as it provides a context for the scene and an anchor for the painting as a whole. In any landscape, the sky must relate to the land beneath and so you need to continually assess the tonal balance between the two.

## Materials
- 2B pencil
- 140lb (300gsm) rough watercolour paper
- Watercolour paints: yellow ochre, cadmium lemon, sap green, raw umber, ultramarine blue, cadmium yellow, Prussian blue, cadmium red, burnt sienna, alizarin crimson, viridian
- Brushes: medium round, fine round, large wash
- Kitchen paper

### The original scene
This is a dramatic and unusual sky. Although the clouds and rainbow provide the main focus of interest, the low-angled early evening sunlight picks out enough detail on the land to relieve the monotony of the dark foreground.

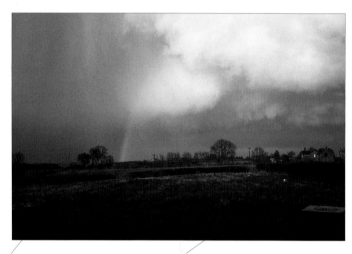

Silhouetted tree shapes provide a visual link between sky and ground.

Low-angled sunlight picks out the house and a patch of the foreground field.

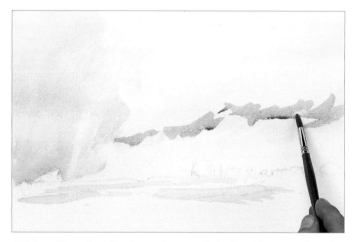

1 Using a 2B pencil, outline the tree shapes on the horizon. Mix a very pale wash of yellow ochre and, using a medium round brush, loosely brush it over the sky, leaving gaps for the lightest areas. Mix cadmium lemon and sap green and brush the mixture over the lightest areas of the fields. Mix a dilute wash of dark brown from raw umber and a touch of ultramarine blue and brush it on to the clouds in the top left of the picture. Add more ultramarine blue to the brown mixture and brush loose strokes over the base of the clouds on the right.

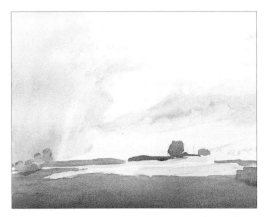

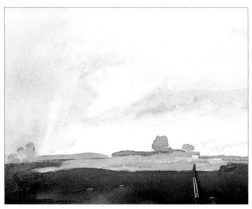

2 While the sky is still damp, add more raw umber to the mixture and brush short calligraphic strokes over the clouds to delineate the lower edges, dabbing some of the paint off with kitchen paper to soften the edges. Mix a dark olive green from cadmium yellow and ultramarine blue and block in the dark areas of the foreground and the silhouetted shapes on the horizon.

3 While the foreground is still damp, mix a bluish green from cadmium yellow, ultramarine blue and Prussian blue and brush it over the foreground to darken it. Mix a warm yellowish green from cadmium lemon and cadmium red with a little ultramarine and brush the mixture over the brightest areas of the fields, which are illuminated by shafts of low-angled evening sunlight.

4 Finish blocking in the silhouettes on the skyline. Mix an orangey red from cadmium red and yellow ochre and, using a medium round brush, block in the shape of the distant house.

**Tip**: The only details you need on the house are the roof and walls. The rules of perspective make further detail, such as windows, unnecessary.

**Assessment time**
With the addition of a hint of blue sky and the dark hedge that marks the boundary between the house and the field, the painting is really starting to take shape. The foreground is very dark, and so the next stage is to work on the sky so that the picture has a better overall balance.

The sky is too pale to hold any interest.

The foreground is oppressively dark; the sky needs to be much stronger to balance it.

Note how the red house immediately attracts the eye, even though it occupies only a small area.

▶

5 Mix a rich, dark brown from ultramarine blue and burnt sienna. Using a large wash brush, loosely scrub it into the left-hand side of the sky, leaving a gap for the rainbow and dabbing off paint with kitchen paper to soften the edges. Note how this creates interesting streaks in the sky.

6 Using the same colour, make a series of short calligraphic strokes on the sky at the base of the clouds. The clouds are lit from above, so giving them dark bases helps to establish a sense of form. Brush yellow ochre on to the sky above the dark clouds.

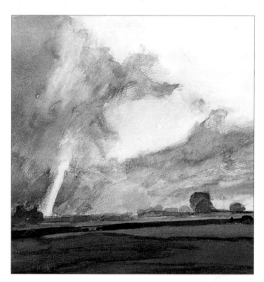

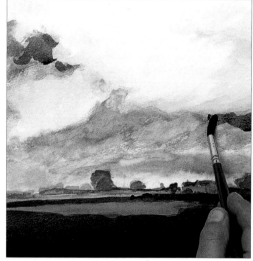

7 Again, dab off paint with kitchen paper to get rid of any obvious brushstrokes and create interesting streaks and wispy textures in the clouds. The clouds should look as if they are swirling overhead, their brooding presence dominating the entire scene.

8 Using a darker version of the mixture, darken the clouds again so that the sky has more impact. You need to continually assess the tones in a painting like this, as an alteration to one area can disrupt the tonal balance of the painting as a whole.

**9** Finally, paint the rainbow, using a very fine round brush and long, confident strokes. There is no distinct demarcation between one colour and the next, so it doesn't matter if the colours merge. If you do want to boost any of the colours, allow the paint to dry and then strengthen the colours with a second application.

**Storm clouds and rainbow**
This is a bold and dramatic interpretation of glowering storm clouds. In the sky, the paint is applied in thin, transparent layers, softened in places by dabbing off paint with kitchen paper, and the white of the paper is allowed to show through, creating a wonderful feeling of luminosity. The land below, in contrast, is solid and dark and forms a complete counterpoint to the rapidly moving clouds above.

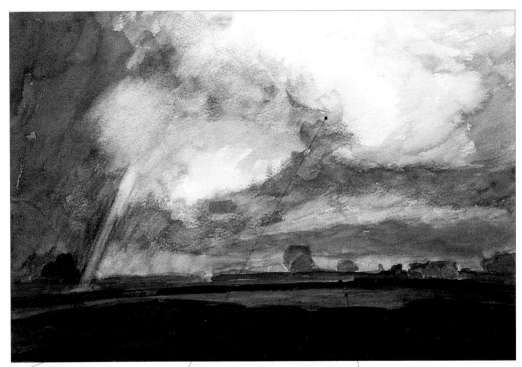

Successive layers of colour applied quite thickly in the foreground create a feeling of solidity.

The clouds have an airy texture, achieved by applying the paint wet into wet and then dabbing it off with kitchen paper.

A shaft of warm, evening sunlight leads the viewer's eye across the painting.

# Painting Water

Watercolour is, by its very nature, the perfect material for painting water. Its fluidity and transparency, and its habit of puddling, pooling and generally behaving in an unpredictable way, are characteristics that can be used to great effect.

The colour and appearance of water are heavily influenced by the predominant weather conditions, the reflected colours and shapes in the environment, and the colours of any rocks, sand or vegetation seen beneath the surface. The sea is blue because it reflects the sky, for example, while a pond deep in the woods looks deep and foreboding because it reflects the dark foliage of the surrounding trees.

Several watercolour techniques are particularly suited to painting water. Broad wash techniques, using as large a brush as possible, should be used to paint large expanses of water. Washes can be worked wet on wet to suggest subtle colour changes, or wet on dry to suggest wave or ripple shapes or reflected objects and colours.

Broken colour techniques using a dry brush dragged across rough paper give the impression of ripples or dappled sunlight. Scraping back into wet paint, using a cut-off piece of card or one of the purpose-made rubber paint shapers, is a particularly good way of representing ripples, especially on smooth, hot-pressed paper. Highlights in the water can be created by scratching back to reveal white paper or by applying masking fluid prior to making any washes.

> **Tips**: • Always follow the rules of perspective. Waves of equal size will appear smaller the further away from you they are, while colour becomes less intense and cooler and detail is less evident.
> • Note how objects in the water are slightly distorted due to the way light waves are refracted. The colours of objects reflected in water are generally less intense and more subdued than the colours of the objects themselves.

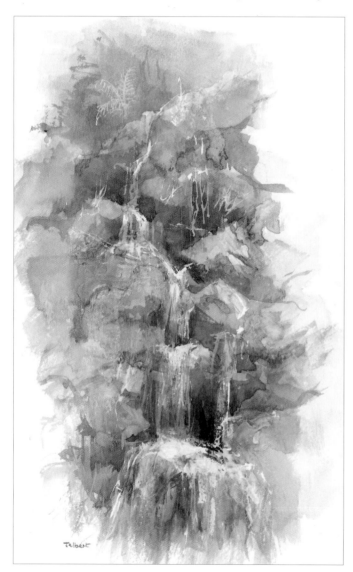

Talbert

◀ **Waterfall**
White body colour was applied using a mixture of fluid wash and drybrush techniques to capture the light catching on the falling water as it tumbles over rocks and boulders. The stones and boulders were painted using a texture paste to give them added form.

### 8 a.m, Venice Lagoon ▲

This painting, made as the early-morning light highlighted the ripples on the water, uses carefully applied wet-on-dry washes. The dappled sunlight on the water surface was created by applying masking fluid prior to making any washes. Colours were kept crisp and clean by using no more than three overlapping washes. Note how the ripples conform to the laws of perspective by getting smaller as they get closer to the horizon.

### ◄ Willows

Wet-into-wet washes lay the foundation and general shape of the reflections of these riverside trees. Wet-on-dry washes define the shapes further, while a little linear brush and coloured pencil work hint at a slight breeze rippling the almost still surface.

> **Tip**: Choose a surface to complement the subject. A rough sea will look rougher if painted on a rough-surface paper, while a smooth, hot-pressed paper is ideal for a painting of a tranquil, mirror-like pond.

# Woodland waterfall

Waterfalls offer particular challenges to watercolour artists. Not only do you have to paint a liquid that lacks any real colour of its own but takes its colour from its surroundings, but you also need to make that liquid look wet and convey a sense of how quickly it is moving.

As always, the key is to try to convey an overall impression, rather than get caught up in attempting to recreate life, and paint every single water droplet and leaf. Before you start painting, and even before you make your first preliminary sketch, stop and think about what it is that appeals to you in the scene. Is it the intensity of the rushing water or the sunlight sparkling on the water surface? Is the waterfall itself the most important feature or are the surroundings just as interesting? This will help you to decide on the main focus of interest in your painting – and armed with this knowledge, you can decide how best to tackle the painting as a whole.

In real life, all your senses come into play: you can hear the water cascading down and feel the dappled sunlight on your face. In a painting, however, you have to convey these qualities through visual means alone. Sometimes this means you need to exaggerate certain aspects in order to get the message across – making the spray more dramatic, perhaps, or altering the composition to remove distracting features or make interesting ones more prominent.

## Materials
- *B pencil*
- *Tracing paper*
- *140lb (300gsm) NOT watercolour paper, pre-stretched*
- *Watercolour paints: cadmium lemon, phthalocyanine green, Payne's grey, burnt sienna, phthalocyanine blue, alizarin crimson*
- *Brushes: large round, fine round, medium wash, old brush for masking fluid*
- *Masking fluid*
- *Low-tack masking tape*
- *Drawing paper to make mask*
- *Household candle*
- *Gum arabic*

## The original scene
Although the scene is attractive, the lighting is flat and the colours dull. Here, the artist decided he needed to increase the contrast between light and shade. To do this, you need to carefully work out which areas will be hit by light from above and which will be in shadow. He also increased the size of the pool below the waterfall: paradoxically, the waterfall itself has more impact if it is surrounded by calmer areas.

The waterfall ends too near the bottom of the frame.

The colours are very subdued. Increasing the contrast between light and shade will make the painting more interesting.

1 Using a B pencil, make a sketch on tracing paper to establish the main lines of your subject and work out the size and shape of your painting. When you are happy with the result, transfer your tracing on to pre-stretched watercolour paper.

2 Place a sheet of white drawing
paper between the watercolour
paper and the tracing paper and draw
around the waterfall area. Cut out the
shape of the waterfall and place it in
position on the watercolour paper as
a mask, fixing it in place with low-tack
masking tape. Gently rub a household
candle over the area of water below
the waterfall, keeping the strokes very
loose. This will preserve some of the
white of the paper and add an
interesting texture.

3 Using an old brush, apply masking
fluid over the white lines of the
waterfall. Leave to dry.

4 Apply masking fluid to the bright highlight area of sky at
the top of the picture area and leave to dry. Using a large
round brush, brush clean water over the trees. Mix a strong
wash of cadmium lemon and brush it over all the damp areas.
Leave to dry.

5 Mask off the water area with paper. Mix a mid-toned
green from cadmium lemon and a little phthalocyanine
green. Holding a fine round brush at the same angle at
which the branches grow, spatter water across the top of the
picture. Spatter the damp area with green paint. Leave to dry.

6 Continue spattering first with water
and then with the green mixture
of phthalocyanine green and cadmium
lemon, as in Step 5, until you achieve
the right density of tone in the trees.
Leave each application of spattering
to dry completely before you apply the
next one.

**Tip**: Spattering clean water on to
the paper first, before you spatter
on the paint mixture, means that the
paint will spread and blur on the wet
paper. If you spatter the paint on to dry
paper, you will create crisply defined
blobs of colour – a very different effect.

7 Add Payne's grey to the phthalocyanine green and cadmium lemon mixture and, using a fine brush, put in the very dark tones along the water's edge in order to define the edge of the river bank.

8 Using a fine brush, brush burnt sienna between the leaves adjoining the dark spattered areas. Mix a rich brown from burnt sienna and Payne's grey and paint the tree trunks and branches. Leave to dry.

9 Using your fingertips, gently rub and peel the masking fluid off the sky area. The sky area is very bright in comparison with the rest of the scene, and so it is important to reserve these light areas in the early part of the painting – even though they will be toned down very slightly in the later stages.

### Assessment time

The surrounding woodland is now almost complete. Before you go any further, make sure you've put in as much detail as you want here. The water takes its colour from what's reflected in it. Because of this it is essential that you establish the scenery around the waterfall before you begin to put in any of the water detail.

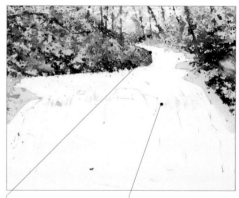

The line of the riverbank is crisply painted, establishing the course of the river.

The rocks in the waterfall have been marked in pencil, providing an underlying structure for the scene.

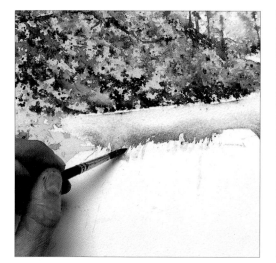

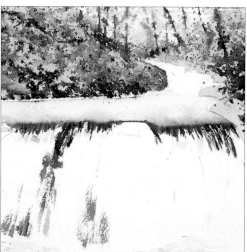

**10** Using masking fluid, mask the long strokes of white that cascade down from the waterfall into the pool below. Leave to dry. Using a medium wash brush, brush clean water horizontally across the top of the water above the waterfall. Brush a little gum arabic on to the damp area. Keeping the brush fairly dry in order to control the colour, brush vertical strokes of phthalocyanine blue mixed with a little alizarin crimson and burnt sienna on to the damp area.

**11** Brush straight lines of Payne's grey across the top of the waterfall to denote the edge over which the water topples. Mix Payne's grey with phthalocyanine blue and brush on to the waterfall itself, using a drybrush technique. On the lower part of the fall, make the marks longer and rougher to indicate the increased speed of the water. Leave to dry.

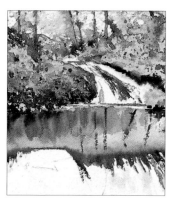

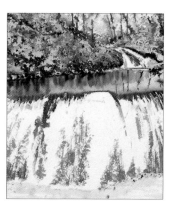

**12** Re-wet the pool above the fall. Using a fine, round brush, touch cadmium lemon into the damp area. Dab on vertical strokes of cadmium lemon, burnt sienna, and phthalocyanine green for the tree trunk reflections. The colours will merge together and the fact that they are blurred helps to convey the wetness of the water.

**13** Brush burnt sienna mixed with Payne's grey on to the cascade of water than runs into the pool.

**Tip**: By applying clean water to the surface before you paint, the strokes diffuse and blur, giving soft blends rather than hard-edged streaks of colour.

**14** Working from the bottom of the waterfall upwards, brush a mixture of Payne's grey and phthalocyanine blue into the waterfall. Note how the texture of the candle wax shows through. Keep the brush quite dry, dabbing off excess paint on kitchen paper, if necessary. Add a little alizarin crimson to the mixture for the darker water at the base of the fall.

▶

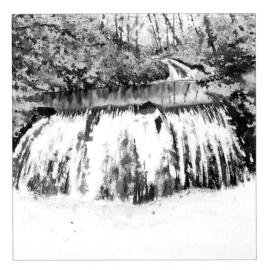

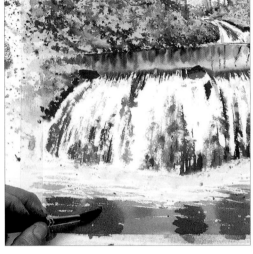

**15** Paint the rocks under the waterfall in a mixture of Payne's grey, phthalocyanine blue and a little alizarin crimson. Use the same mixture to paint more rocks poking up through the foam of the water. Drybrush water along the left and right edges of the painting and apply the rock colour – again with an almost dry brush. The paint will spread down into the damp area.

**16** Stipple little dots of masking fluid on to the base of the pool below the waterfall for the white bubbles of foam. Leave to dry. Apply a light wash of phthalocyanine blue mixed with a little Payne's grey over the pool below the waterfall, brushing the paint on with loose, horizontal strokes. While the paint is still damp, run in a few darker vertical lines of the same mixture. Leave to dry.

**17** Using a large brush and a darker version of the phthalocyanine blue and Payne's grey mixture, paint the dark area at the base of the pool with bold, zigzag-shaped brushstrokes. Leave to dry.

**18** Using your fingertips, gently rub off the masking fluid on the lower half of the painting. Stand back and assess the tonal values of the painting as a whole. If the exposed area looks too white and stark, you may need to touch in some colour in the water areas to redress the overall balance of the scene.

## Woodland waterfall

This is a very lively rendition of a waterfall in full spate, which conveys the mood and atmosphere of the scene rather than capturing every leaf and twig in painstaking detail. Much of the paper is left white, in order to convey the full force of the rushing water. The painting has a stronger feeling of light and shade than the original photo, and hence more impact.

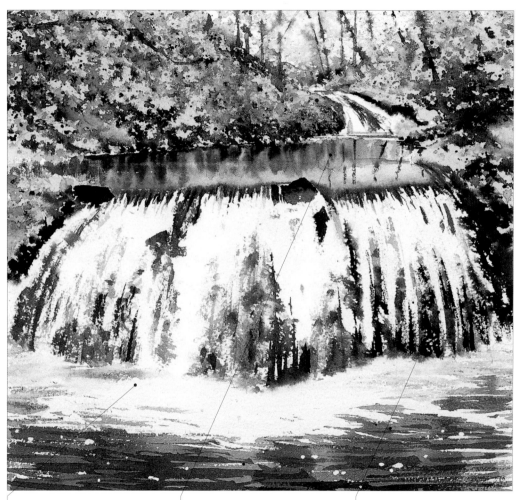

The white of the paper conveys the cascading, foaming water.

Skilful use of the wet-into-wet technique has allowed colours to merge on the paper, creating realistic-looking reflections.

Longer brushstrokes in the lower part of the waterfall help to create an impression of movement in the water.

# Crashing waves

This project depicts a massive sea wave just as it is about to break over craggy rocks. Your challenge is to capture the energy and power of the scene.

Few people would go as far in their search for realism as the great landscape artist J.M.W. Turner, who is reputed to have tied himself to a ship's mast in order to experience the full force of a storm at sea. Fortunately, there are easier and less perilous ways of adding drama to your seascapes.

The first thing to think about is your viewpoint. Construct your painting as if you are viewing the scene from a low viewpoint, so that the waves seem to tower above you.

For maximum drama, capture the waves while they are building or when they are at their peak, just before they break and come crashing down. You can gauge the height of the waves by comparing them with nearby rocks or clifftops, while including such features in your painting will provide you with both a focal point and a sense of scale.

Try to attune yourself to the sea's natural rhythms. Watch the ebb and flow of the waves and concentrate on holding the memory of this rhythm in your mind as you are painting. This will help you to capture the energy of the scene.

Finally, remember that water takes its colour from objects in and around it. You may be surprised at how many different colours there are in a scene like this.

## Materials
- 4B pencil
- 140lb (300gsm) NOT watercolour paper, pre-stretched
- Watercolour paints: Payne's grey, phthalocyanine blue, cadmium yellow, lemon yellow, Hooker's green, cerulean blue, yellow ochre, raw sienna, sepia, violet, burnt sienna, cobalt blue
- Gouache paints: permanent white
- Brushes: medium round, fine round
- Mixing or palette knife
- Fine texture paste
- Ruling drawing pen
- Masking fluid
- Sponge

## The original scene
It is notoriously difficult to photograph a breaking wave at exactly the right moment, and so the artist used this photograph merely to remind herself of the energy of the scene and the shapes and colours.

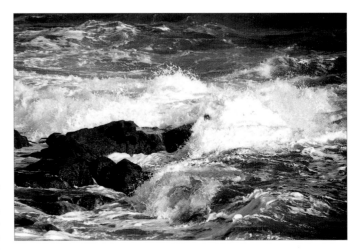

## Reference sketches
Tonal sketches are a very good way of working out the light and dark areas of the scene. You will find that it helps to think of the waves as solid, three-dimensional objects, with a light and a shaded side. Try several versions so that you get used to the way the waves break over the rocks.

1 Using a 4B pencil, lightly sketch the scene, putting in the foreground rocks and the main waves. Take time to get the angles of the waves right: it is vital that they look as if they are travelling at speed and are just about to come crashing down.

2 Using a palette knife, apply fine texture paste over the rocks. Leave to dry. (Texture paste is available in several grades; the coarser it is, the more pronounced the effect. Here, the wave is more important than the rocks, so fine texture paste is sufficient).

3 Using a ruling drawing pen, apply masking fluid over the crest of the main wave and dot in flecks and swirls of foam in the water. Using a small sponge, dab masking fluid on to selected areas of the sea to create softer foamy areas. Leave to dry.

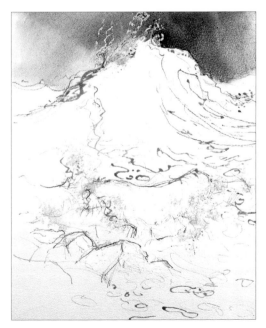

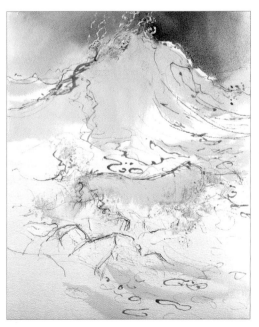

4 Mix a mid-toned wash of Payne's grey and another of phthalocyanine blue. Dampen the sky area with clean water and brush Payne's grey on to the right-hand side and phthalocyanine blue on to the left-hand side. Leave to dry.

5 Mix a strong wash of cadmium yellow with a touch of lemon yellow. Dampen the waves with clean water and lightly brush the bright yellow paint mixture over the tops of the waves.

▶

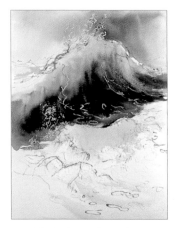

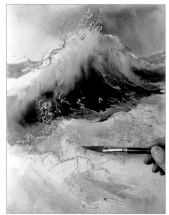

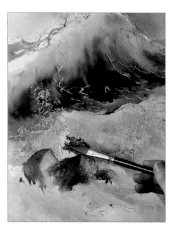

6 While the first wash is still wet, brush Hooker's green into the yellow so that the colours merge together. Mix a darker green from Hooker's green, phthalocyanine blue and a little cadmium yellow and brush this mixture into the lower part of the waves, feathering the mixture up into the yellow so that the colours blend imperceptibly on the paper. Brush over this darker green several times to build up the necessary density of tone.

7 Mix a dark blue from phthalocyanine blue and cerulean blue and brush this mixture into the lower part of the large wave, feathering the colour upwards. Because the previous washes are still wet the colours spread and merge together on the paper, building up darker tones without completely blocking out the underlying colours. Use loose, swift brushstrokes and try to capture the energy and power of the sea.

8 Mix a mid-toned wash of yellow ochre and brush it over the texture paste on the rocks, adding raw sienna and sepia for the dark foreground.

**Tip:** Allow the colour to "drift" into the sea so that it looks as if the sea is washing over the rocks. Unless you do this the rocks will simply look as if they are floating on the water.

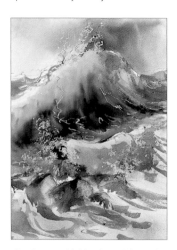

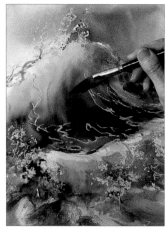

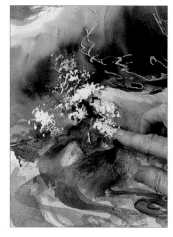

9 Mix a greyish blue from violet and Hooker's green. Brush little touches of this colour into the waves and into the pools at the base of the rocks, making swirling brushstrokes to help convey the movement of the water.

10 Using the dark green mixture from Step 6 and the brown used on the rocks, put a few dark accents into the waves. Soften the brushstrokes by brushing them with clean water to blend them into the other wave colours.

11 When you are sure that the paint is completely dry, gently rub off the masking fluid with your fingertips to reveal the foaming crests of the waves and the spattered highlights on the water.

## Assessment time

Now that all the masking fluid has been removed, you can see how effectively the white of the paper has been reserved for the swirls and flecks of foam in the sea. However, these areas now look glaringly white and stark: they need to be toned down so that they become an integral part of the scene. However, you will need to take great care not to lose the very free, spontaneous nature of the swirling lines or the water will start to look too static and overworked. The contrast between the light and the very dark areas also needs to be strengthened a little in order to give a better feeling of the volume of the waves.

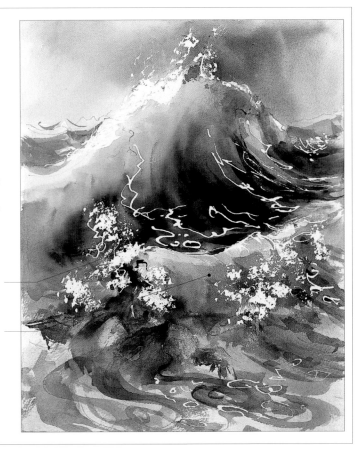

The exposed areas are much too bright.

The colours work well in this area, but there is not enough of a sense of the direction in which the water is moving.

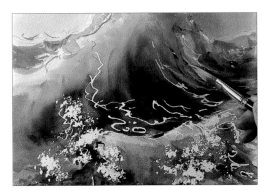

**12** Mix an opaque mauve from permanent white gouache, violet and a tiny touch of burnt sienna. Brush this mixture under the crest of the main wave, so that it looks like shadows under the very bright, white foam.

**13** The exposed white areas look too stark against the dark colours of the water and rocks. Mix a very pale opaque blue from cobalt blue and permanent white gouache and cover up the exposed swirls of white in the water.

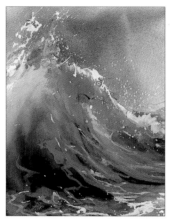

**14** Soften the harsh markings by brushing over more of the cobalt blue and gouache mixture. Paint some swirls of white gouache at the base of the main wave. Putting a little opaque colour into the water helps to give it some solidity.

**15** Spatter a few specks of white gouache above the crest of the wave for the flecks of foam that fly into the air. Don't overdo it: too much gouache could easily overpower the light, translucent watercolour washes that you've worked so hard to create.

**16** Spatter a few specks of the cobalt blue and white gouache mixture above the rocks. (This area is very dark and pure white gouache would look too stark.)

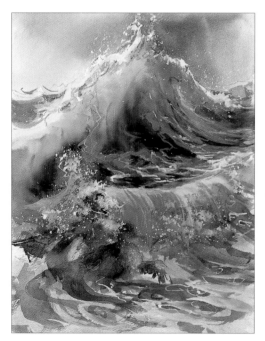

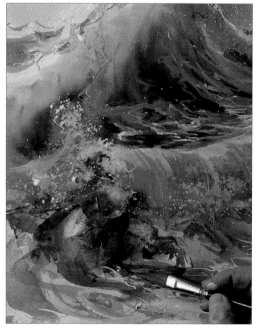

**17** Stand back from the painting and assess the tonal values. You may find that you need to darken some of the colours in the centre of the painting.

**18** Using the same dark brown mixture as before, build up the tones on the rocks. They need to stand out from the water that surrounds them.

## Crashing waves

This is a dramatic and carefully observed painting that captures the energy of the scene to perfection. Note the many different tones in the water and the way the brushstrokes echo the motion of the waves. The rocks provide solidity and a sense of scale, but do not detract from the large wave that is hurtling forwards.

Spattering is the perfect technique for depicting foam-flecked waves.

Dark tones in this area contrast with the light edge of the breaking wave and help to give it volume.

The rocks provide a necessary point of solidity in the scene.

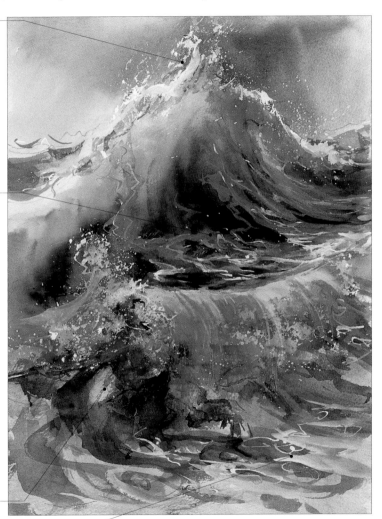

Loose, swirling brushstrokes capture the motion of the sea.

# Lake with reflections

Who could resist the bright, sunny colours of this lakeside scene in the heat of the summer, with its reflections of hillsides covered in trees? Any artist would be happy to while away a few hours sketching and painting in such a tranquil setting.

However, straightforward symmetrical reflections can sometimes look a little boring and predictable, so look out for other things that will add interest to your paintings. Sweeping curves, such as the foreshore on the right in this scene, help to lead the viewer's eye through the picture, while interesting textures are always a bonus.

This project also provides you with the challenge of painting partially submerged objects. Here you need to think about the rules of perspective: remember that things look paler and smaller the further away they are. As an added complication, the way that water refracts lights also distorts the shape of submerged objects. Trust your eyes and paint what you see, rather than assuming you know what shape things actually are.

## Materials

- B pencil
- Tracing paper
- 140lb (300gsm) NOT watercolour paper, pre-stretched
- Watercolour paints: alizarin crimson, Naples yellow, phthalocyanine blue, phthalocyanine green, burnt sienna, French ultramarine, Payne's grey, quinacridone magenta
- Brushes: medium round, fine round, old brush for masking fluid
- Masking fluid
- Gum arabic
- Kitchen paper

**Tip:** Leave the tracing paper attached to one side of the watercolour paper, so that you can flip it back over if necessary during the painting process and reaffirm any lines and shapes that have been covered by paint.

### The original scene

You can almost feel the heat of the sun when you look at this photograph of a lake in southern Spain. The foreshore and hillside are dry and dusty, while the lake itself appears to be slowly evaporating, exposing rocks in the shallows. Because of the angle at which the photograph was taken, the colours are actually less intense than they were in real life. The artist decided to exaggerate the colours slightly to emphasize the feeling of heat.

The distant mountains are muted in colour and will benefit from being made more intense in the painting.

Much of the foreground is made up of submerged stones. You could put some exposed stones in this area to add interest.

1 Using a B pencil, make an initial sketch on tracing paper to establish the main lines of your subject. When you are happy with the result, trace your sketch on to pre-stretched watercolour paper. Using an old brush, apply masking fluid to some of the large foreground stones. Leave to dry.

2 Mix alizarin crimson with a little Naples yellow and, using a medium round brush, brush the mixture over the mountains and up into the sky. Leave to dry. Mix a bright blue from phthalocyanine blue and a little phthalocyanine green. Dampen the sky with clear water and, while the paper is still wet, brush on the blue mixture, stopping along the ridge and drawing the colour down into the mountains. Leave to dry.

3 Mix a mid-toned orangey brown from Naples yellow and burnt sienna, and paint the dry and dusty foreshore of the lake, dropping in more burnt sienna for the darker areas. Leave to dry.

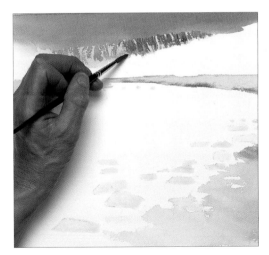

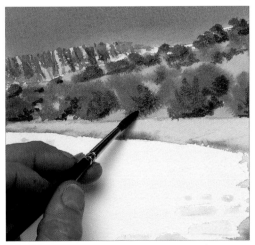

4 Mix a purplish grey from burnt sienna, French ultramarine and alizarin crimson. Using a fine round brush, brush clean water across the mountains and then brush on marks of the grey mixture. Leave to dry.

5 Make up more of the burnt sienna and Naples yellow mixture and, using a medium round brush, paint the arid, sandy background on the top right of the painting. While this area is still wet, mix an olive green from phthalocyanine green, burnt sienna and a little Naples yellow and, using a medium round brush, paint in the loose shapes of trees and bushes. Paint the shadow areas in the trees in the same purplish grey mix used in Step 4. Leave to dry.

▶

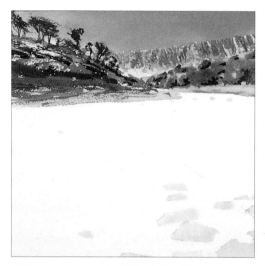

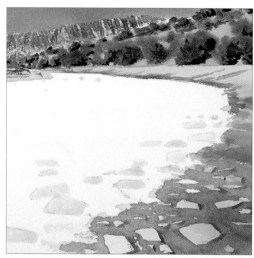

6 Paint more trees on the left-hand side of the painting in the same way. Brush clean water across the sky. Mix Payne's grey with a little phthalocyanine green and, using the tip of the brush, dot this mixture into the damp sky area to denote the trees that stand out above the skyline. The colour will blur slightly. Leave to dry.

7 Using a B pencil, map out a few more stones on the shoreline. Mix a warm brown from burnt sienna and French ultramarine and brush in on to the foreground, working around the stones. Add more French ultramarine to the mixture and paint shadows around the edges of the stones to establish a three-dimensional effect. Leave to dry.

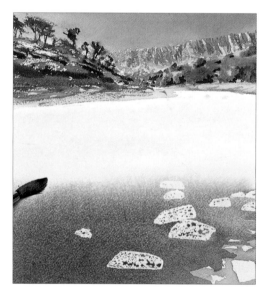

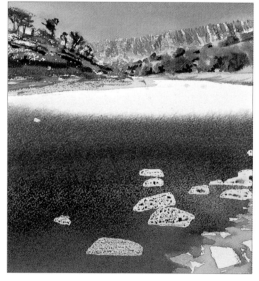

8 Brush clean water over the lake area. Mix burnt sienna with a little quinacridone magenta and, using a medium round brush, wash this mixture loosely over the shallow foreground of the lake, where partially submerged stones are clearly visible.

9 While the lake is still damp, brush phthalocyanine blue over the centre of the lake, adding a little quinacridone magenta as you work down over the stones in the foreground. Apply a second layer of the same colours over the same area and leave to dry.

### Assessment time

Wet the blank area at the top of the lake and brush gum arabic on to the damp area. Using a fine brush, brush on vertical strokes of Naples yellow, burnt sienna, quinacridone magenta mixed with French ultramarine, and the olive green mixture used in Step 5. Leave to dry.

With the reflections in place, the painting is nearing its final stages. All that remains to be done is to put in some of the fine detail. Step back and think carefully about how you are going to do this. Far from making the painting look more realistic, too much detail would actually detract from the fresh, spontaneous quality of the overall scene.

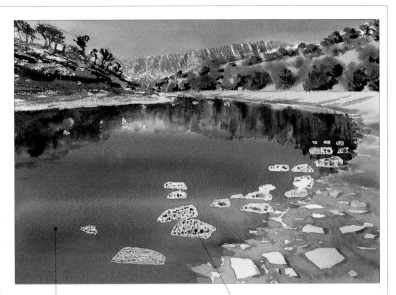

This area lacks visual interest. Adding submerged stones here will indicate both the clarity of the water and how shallow it is at this point.

These stones look as if they're floating on the surface of the water.

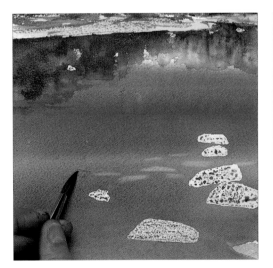

**10** Dip a medium round brush in clean water and gently lift off the flattened, elongated shapes of underwater stones, varying the sizes. You may need to stroke the brush backwards and forwards several times on the paper in order to loosen the paint.

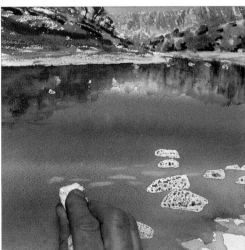

**11** As you lift off each shape, dab the area firmly with clean kitchen paper to remove any excess water. Turn and re-fold the kitchen paper each time you use it, to prevent the risk of dabbing paint back on.

▶

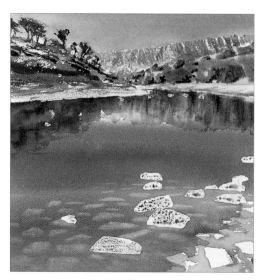

**12** The submerged stones in the foreground of the lake add visual interest to what would otherwise be a dull, blank area of the scene, but as yet they do not look three-dimensional. The large stones above the surface of the water and on the shoreline also need more texture if they are to look convincing.

**13** Mix a dark brown shadow colour from burnt sienna and French ultramarine and, using a medium round brush, use this mixture to loosely paint the shadows underneath the submerged stones. This makes the stones look three-dimensional and allows them to stand out more clearly from the base of the lake. It also adds texture to the base of the lake. Leave to dry.

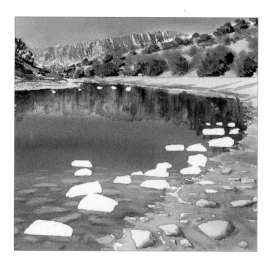

**14** Using a fine brush, wet the area at the base of the reflection and touch in a mixture of French ultramarine and alizarin crimson to soften the edges. Mix burnt sienna with a little French ultramarine and use it to touch in the shadows under the largest rocks on the shoreline. Leave to dry. Using your fingertips, gently rub off the masking fluid.

**15** Using a fine, almost dry brush, brush water over the exposed rocks and then drop in a very pale wash of burnt sienna. Leave to dry. Drybrush a darker mixture of burnt sienna on to the rocks in places, for dark accents. To make the rocks look more three-dimensional, stroke on a little French ultramarine for the shadow areas.

## Lake with reflections

This is a truly inviting image. The lake looks so realistic that you want to dabble your toes in it, while the feeling of heat is almost tangible.

The artist's skilful use of complementary colours (the bright blue of the sky set against the rich orangey brown of the stones and earth) has helped to create a really vibrant painting.

Textural details, such as the dry brushwork on the rocks and the distant trees painted wet into wet, are subtle but effective, while the careful blending of colours in the reflections conveys the stillness of the water perfectly. The composition is simple, but the foreshore leads the eye in a sweeping curve right through the painting.

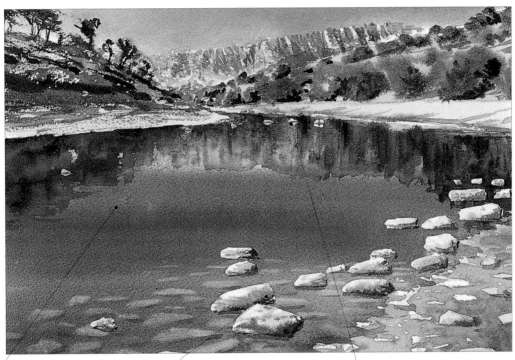

The lake is not a uniform blue throughout, but takes its colour from the objects that are reflected in it, as well as from the visible shallow areas.

A judiciously placed shadow under one edge of the stones helps to make them look three-dimensional.

The easiest way to paint the reflection of the small rocks in the distance is simply to paint a thin line of burnt sienna right through the middle.

# Harbour moorings

Ports and harbours are a never-ending source of inspiration for artists. The scene is constantly moving as the tide ebbs and flows, and the changing seasons bring different weather and lighting conditions. Reflections in the water, patterns in the sand, and countless details from boat masts to barnacles: there are thousands of things to stir the imagination. It's not just a visual feast: the sound of lapping water and squawking gulls, and the smell of seaweed combine to make this one of the most satisfying of all subjects to paint.

The key is to plan ahead and think about what you want to convey. Harbours are busy places, with lots of things going on and a host of fascinating details and textures to distract the eye, and you will almost invariably need to simplify things when you're painting. Decide on your main focus of interest and construct your painting around it. You may find that you need to alter the position of certain elements within the picture space, or to subdue some details that draw attention away from the main subject and place more emphasis on others.

This particular project uses a wide range of classic watercolour techniques to create a timeless scene of a working harbour at low tide. Pay attention to the reflections and the way the light catches the water: these are what will make the painted scene come to life, and there is no better medium for these transient effects of the light than watercolour.

## Materials
- *4B graphite pencil*
- *140lb (300gsm) NOT watercolour paper, pre-stretched*
- *Watercolour paints: cadmium orange, Naples yellow, phthalocyanine blue, cerulean blue, permanent rose, raw sienna, ultramarine blue, burnt umber, cadmium red, burnt sienna, light red*
- *Gouache paints: permanent white*
- *Brushes: old brush for masking, 1in (2.5cm) hake, small round, medium filbert, fine filbert, fine rigger*
- *Masking fluid*
- *Masking tape*
- *Plastic ruler or straightedge*

## The original scene
The tilted boats, wet sand and textures on the harbour wall all have the potential to make an interesting painting, but the sky and water are a little bland and there is no real focus of interest.

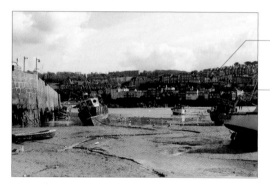

The town on the far side of the estuary is a little distracting.

The boats form a straight line across the image; it is unclear where the main focus of interest lies.

## Preliminary sketch
The artist decided to make more of the water in his painting, introducing reflections that were not there in real life. He made this preliminary charcoal sketch to work out the tonal values of the scene. He then decided that the boats were too close together and that the scene was too cramped. In his final version, therefore, he widened the image so that the right-hand boat was further away; he also introduced two figures walking across the sand to provide a sense of scale.

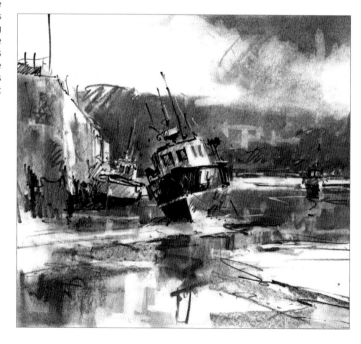

1 Using a 4B graphite pencil, sketch the scene, putting in the outlines of the harbour wall, distant hill, boats and figures and indicating the different bands of sand and water in the foreground.

2 Using an old brush, apply masking fluid over the foreground water and the brightly lit right-hand side of the main boat to protect the highlight areas that you want to remain white in the finished painting. To get fine, straight lines, place a plastic ruler or straightedge on its side, rest the ferrule of the brush on top and gently glide the brush along.

3 Spatter a little masking fluid over the foreground of the scene to suggest some random texture and highlights in the sand and water. Be careful not to overdo it as you need no more than a hint of the sun glinting on these areas.

4 Mix a pale orange from cadmium orange and Naples yellow. Wet the sky in places with clean water. Using a hake brush, wash the orange mixture over the left-hand side of the sky and phthalocyanine blue over the right-hand side, leaving some gaps for clouds.

5 Using the same mixtures, carry the sky colours down into the water and sand, paying careful attention to the colours of the reflections in these areas. The warm colours used in the sky and sand set the mood for the rest of the painting.

▶

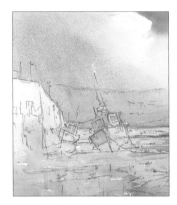

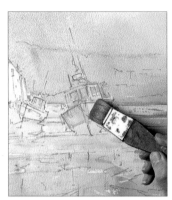

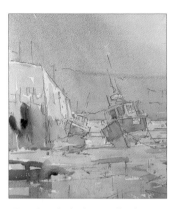

**6** Mix a dilute wash of pale greyish purple from cerulean blue and a little permanent rose. Wet selected areas of the sky with clean water so that the colours will merge on the paper. Using the hake brush, wash the mixture over the darkest areas of cloud on the left-hand side of the sky and bring the colour down into the background hills and water. Darken this greyish purple mixture by adding more pigment to it and start putting a little colour on the shaded side of the largest boat in the scene.

**7** Using the same mixture of cerulean blue and permanent rose, continue building up washes on the sides of the largest boat.

**8** Darken the harbour wall with a wash of cadmium orange mixed with Naples yellow. While still wet, drop in a mixture of phthalocyanine blue and a little raw sienna. Paint the reflections of the harbour wall in the wet sand. Apply a little cerulean blue to the main boat and the one behind it.

> **Tip**: Do not make the wall too dark at this stage: assess how strong it should be in relation to the background.

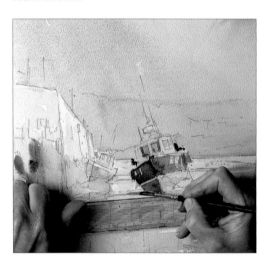

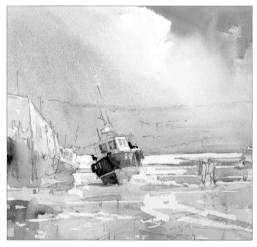

**9** Using a small round brush, apply a dark mixture of ultramarine blue, burnt umber and a little cadmium red to the main boat. Mix a purplish grey from cerulean blue and permanent rose and, using a ruler or straightedge as in Step 2, paint the shadow under the main boat. Leave to dry.

**10** Using your fingertips, gently rub off the masking fluid to reveal the highlights on the water and sand.

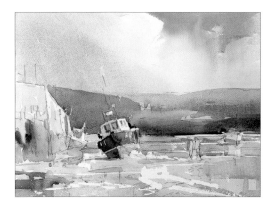

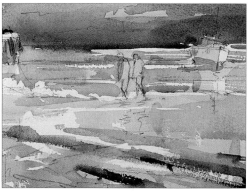

**11** Apply further washes, wet into wet, over the hill in the background of the scene so that the colours fuse together on the paper, using ultramarine blue and light red, with a touch of raw sienna for the dark areas in the middle distance. Continue building up the tones of the reflections and intensify the colour of the water by adding a little cerulean blue with a touch of Naples yellow.

**12** To add more texture to the ridges of sand in the foreground, apply strokes of burnt sienna straight from the tube, lightly stroking an almost dry medium filbert brush over the dry painting surface. This allows the paint to catch on the raised tooth of the paper, creating expressive broken marks that are equally suitable for depicting the sparkle of light on the water.

**Assessment time**

The basic structure of the painting is now in place. There are four principal planes – the sky, the landscape on the far side of the river which has put some solidity into the centre of the picture, the boat and harbour wall (the principal centre of interest in the painting), and the immediate foreground, which is structured to lead the eye up to the boat. Now you need to tie everything together in terms of tones and colours.

All the boats need to be strengthened, as they are the main interest in the painting.

The land is not sufficiently well separated from the estuary area.

More texture and depth of tone are needed on the harbour wall to hold the viewer's eye within the picture area.

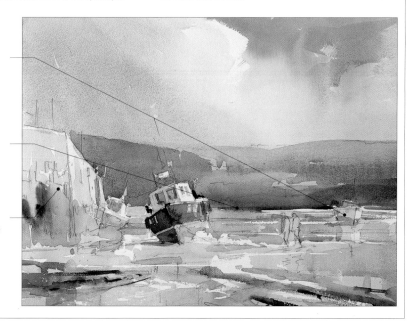

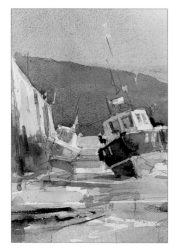

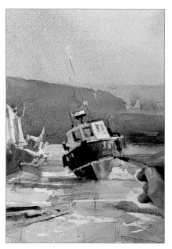

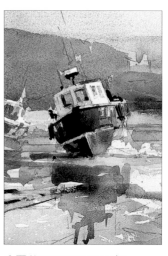

**13** Now you can begin gradually to build up the washes to achieve the correct tonal values. Darken the harbour wall, using the original mixture of cadmium orange and a touch of raw sienna and build up the sandy area immediately in front of the main boat with the same mixture.

**14** Using a small round brush and a dark mixture of ultramarine blue and light red, put in some of the detail on the boats.

**15** Now concentrate on the reflections of the boats, using colours similar to those used in the original washes. Do not to make the reflections too opaque. Keep these washes watery and as simple as possible. Use vertical brushstrokes so that they look more like reflections.

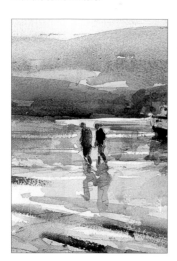

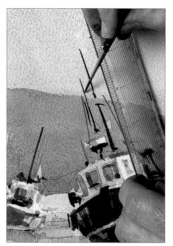

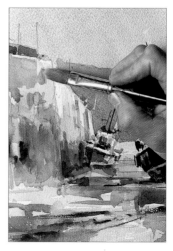

**16** Mix a warm blue from cerulean blue, permanent rose and a touch of burnt umber and put in the two figures and their reflections.

**17** Using a fine rigger brush and resting the ferrule on a plastic ruler or straightedge, as in Step 2, put in the masts on the main boat in a mixture of ultramarine blue and light red and the rigging in a paler mixture of cerulean blue and permanent rose.

**18** Using a filbert brush and the original mixture of cadmium orange and a little permanent rose, darken the stonework on the harbour wall. These uneven applications of colour give the wall texture and make it look more realistic.

**Harbour moorings**

This project brings together a range of classic watercolour techniques – wet into wet, building up layers of colour, using masking fluid to preserve the highlights, drybrush work – to create a lively painting that captures the atmosphere of the scene beautifully. The background is deliberately subdued in order to focus attention on the moorings. The main subject (the largest boat) is positioned at the intersection of the thirds, with the diagonal line of the sand directing the viewer's eye towards it. The different elements of the scene are perfectly balanced in terms of tone and composition.

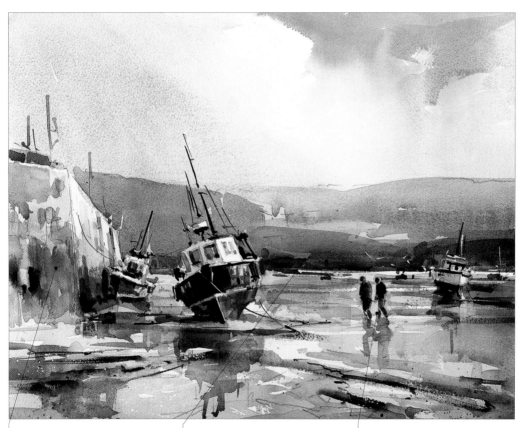

The harbour wall is painted wet into wet to create muted but interesting colours and textures.

The town in the original scene has been replaced by an atmospheric blend of colours that suggests wooded hills.

The two walking figures introduce human interest to the scene and provide a sense of scale.

# Painting Trees

It is virtually impossible to paint landscapes without painting trees as they feature heavily, even in many urban views. Trees add texture, colour and pattern, and they provide an important vertical element that often cuts startlingly across or through a work, dividing the picture area and drastically affecting the composition.

The most common mistake when painting trees is to make them all look the same. Even trees of the same species can look surprisingly different to each other, with no two trees growing in exactly the same way.

Trees are complex objects and not the easiest of things to draw or paint well. The best way to approach the subject is to simplify it, so that you paint the underlying structure and general shape of the tree before adding any detail. All trees can be seen as simple shapes which are either rounded, rectangular, columnar or pointed

in their overall shape. The underlying structure is best seen in winter, when trees are devoid of leaves. The skeletal network of limbs, branches and twigs shows how the trees grow upwards and outwards from the roots and central trunk.

Although you can paint foliage as blocks of colour, you should remember that trees are composed of thousands upon thousands of delicately shaped individul leaves. Do not attempt to paint every leaf, but pay attention to the broken edge quality of the tree shape and carefully depict any spaces that you see between the leaves and branches, where the sky becomes visible.

Colour is another very important consideration. Foliage is not always green, nor are tree trunks always brown. Silver, yellow, orange, red and even purple foliage can be found, and the colour of trunks and stems can vary just as much.

A number of watercolour techniques are especially useful when painting trees. Drybrush is perfect for painting the texture on bark, as are sgraffito and linear marks made using a pencil or a fine brush. Broken colour techniques are particularly successful for foliage: try using natural sponges to gently dab a second colour over dry washes.

**Winter trees ▼**
The initial scene was established using wet-into-wet washes. Once these had dried, further washes were applied to bring out the intricate forms and pattern of the crossing jumble of gnarled branches and the shadows they cast across the trunk. The shadow of the tree seen coming in from the bottom of the picture is a compositional device, indicating that things do not end at the picture edge.

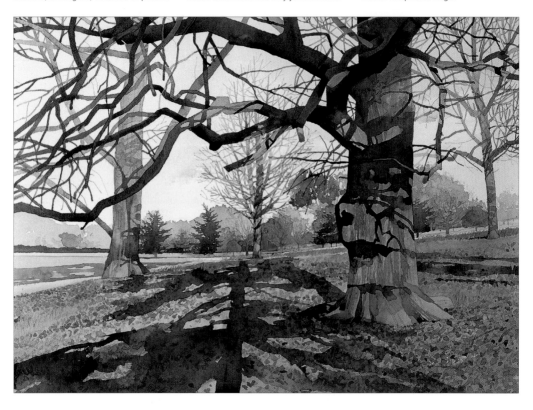

**Autumn beech tree** ▼
The fine linear textures on the trunk of this beech tree were made by applying masking fluid with a pen. The same technique was used for some of the fine branches.

The foliage colour was flooded on using orange, yellows and browns applied wet into wet, while the foliage texture was achieved by sprinkling rock salt onto the wet paint.

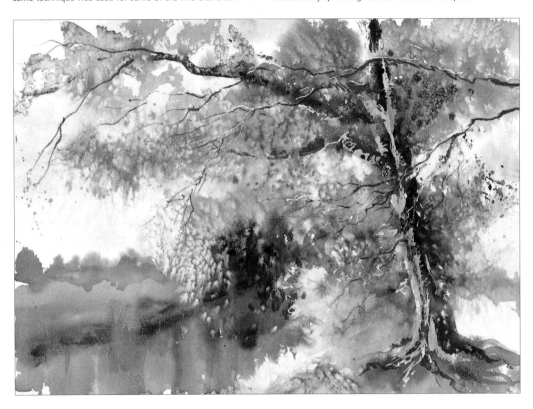

**Cedar tree** ▶
This delicate painting carefully observes the way the branches spread and fall in layers around the thick central trunk. Painted using a fine brush and wet-on-dry washes, the foliage colours consist of only three tones of the same silver-green colour.

**Tips**: • Study the tree's growth habit and break it down into a simple basic shape. Establish the overall shape of the tree before adding surface detail.
• Use drying marks where paint has puddled and dried at different speeds to suggest clumps of foliage.
• Experiment with textural techniques like wax resists, sponging, and using rock salt.
• Instead of using colours straight from the paint box, mix greens and other tree colours: the results will look far more natural and subtle.

# Woodland in spring

Green is, without any doubt, the most important colour in the landscape artist's paint palette. Once you start to look, it is astonishing how many different shades there are, from the bright, almost acidic greens of fresh spring growth through to muted tones of olive and sage.

Although a quick glance through any paint manufacturer's catalogue will reveal a wide range of ready-made greens, it is quite unusual to find one that suits your needs exactly, and you almost always have to modify commercial colours or mix your own. This project, of a spring woodland in the late-afternoon sunlight, gives you the opportunity to do precisely that.

So that you build on what you learn here, make a point of painting different types of woodland: a coniferous forest, for example, tends to contain darker greens than the deciduous woodland shown here. It is a good idea to keep a note of the paint colours used in successful colour mixes so that you can easily recreate them at a later date.

The time of year makes a difference, too. At the height of summer, you will find that leaves are larger and darker than they are in spring, and the tree canopy is more dense, making it harder for light to penetrate through to the woodland floor. In a deciduous woodland in winter, on the other hand, the trees will have lost their leaves and so it will be much easier to see the underlying shapes and structure of different tree types.

The direction and angle of the light also affects the shade of green: the same leaves can look completely different in colour depending on whether the sun is to one side or behind. A single back-lit leaf, with the veins clearly visible, can make an interesting watercolour study in its own right.

### Materials
- *2B pencil*
- *90lb (185gsm) rough watercolour paper, pre-stretched*
- *Watercolour paints: cadmium red, yellow ochre, lemon yellow, alizarin crimson, phthalocyanine blue, cobalt blue, raw umber*
- *Brushes: Chinese*

**The original scene**
This photograph captures the essence of the scene – the slender trees and dappled light – but there is no real focus of interest. The artist decided to make one tree more prominent by bringing it forwards. This breaks the straight line across the centre of the image and allows the viewer's eye to weave in and out of the trees.

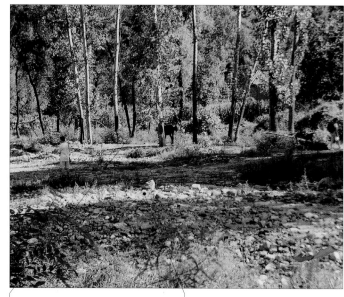

The trees form a straight line across the picture and appear to merge together.

Bright, wide shafts of sunlight indicate that the tree canopy is not very dense.

1 Using a 2B pencil, lightly sketch the scene, putting in the trunks of the main trees and indicating some of the clumps of grass alongside the track.

2 Mix a pale golden brown from cadmium red and yellow ochre. Using a Chinese brush, loosely brush the mixture on to the trunks of the main foreground trees and the pebbly track to establish the warm undertones of the painting. Mix a pale wash of lemon yellow and brush it over the foliage area as a base colour, leaving some gaps for where the brightest patches of sky show through. Add a little more pigment to the wash as you get closer to ground level, as not as much light reaches this area. Brush the same lemon yellow wash loosely over the clumps of grasses in the foreground. Leave to dry.

3 Mix a warm purplish grey from alizarin crimson and phthalocyanine blue and brush it over the shaded areas of the track. Paint the tree trunks with the same mixture. Mix a warm brown from yellow ochre and cadmium red and paint the larger stones on the track. Using a 2B pencil, lightly sketch in the leaf masses on the trees.

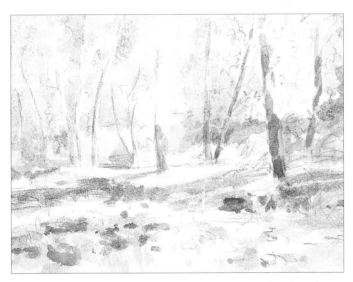

5 Mix a dark green from lemon yellow and phthalocyanine blue and paint the grasses growing under the trees, using short vertical strokes.

4 Mix a cool green from lemon yellow and cobalt blue and brush in the mid-tone foliage areas. Take care not to obliterate all the very lightest foliage areas that you applied in Step 2, otherwise you will lose the feeling of dappled light and fresh spring growth in the image.

**Tip**: When painting foliage and grasses, try to make your strokes follow the direction of growth.

▶

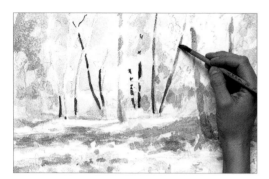

6 Add more phthalocyanine blue to the mixture and dab it over the foliage for the darkest greens. Strengthen the tree trunks, using the same grey mixture as in Step 3. Mix a dark brown from phthalocyanine blue, alizarin crimson and raw umber, and paint the shaded sides of the tree trunks, cutting in and out of the foliage masses.

7 Put in the darker tones of the main foreground tree, using the same mixture. Mix a bright, dark green from phthalocyanine blue and raw umber and dot in the darker foliage tones on the foreground trees. It is important to have more detail in the foreground, as it is closer to the viewer, while impressionistic blurs will suffice in the background.

**Assessment time**
The woodland scene is beginning to take shape but the details are still relatively indistinct and much more needs to be done to separate the foreground elements from the background. When you move on to the next stage, make sure you don't concentrate on one area at the expense of the rest. Work across the painting as a whole, standing back every now and then to assess the tonal values and compositional balance.

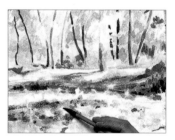

8 Strengthen the shadow colour on the track, using the same alizarin crimson and phthalocyanine blue mixture as before. Add more alizarin crimson and put in some thin trunks on the left of the painting. Using a blue-biased mixture of alizarin crimson and phthalocyanine blue, start dotting in some dark pebbles on the track.

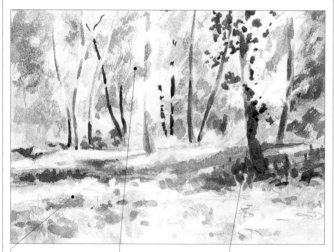

The foreground shadows need to be strengthened to enhance the feeling of dappled light coming through the trees.

The background is all of a similar tone. As a result, there is not a strong enough sense of depth in the image.

The main tree is beginning to stand out from the background, but more detail is still needed here.

9 Some of the foliage areas look very light. Dot in a mid-toned green to tone down the brightness a little.

## Woodland in spring

With its bright, fresh greens and dappled light, this painting is suffused with a wonderful feeling of spring sunlight. The painter has used a little artistic licence to make the composition more dynamic than it was in real life: one tree has been placed at the intersection of the thirds to provide a focus of interest, and the straight line of trees has been staggered in order to encourage the viewer's eye to move around the whole picture.

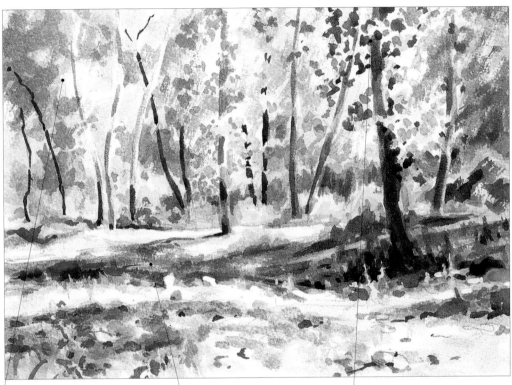

Soft, pale colours and a lack of detail imply that this area of the scene is further away from the viewer.

Long shadows lead the viewer's eye through the scene and indicate low-angled afternoon sunlight.

Crisp leaf detail helps to separate this tree from those in the background, where the foliage is much less distinct.

# Autumn tree

Many trees are at their most dramatic in the autumn, when the leaves change from green to dazzling displays of reds, russets and golds. Combine those colours with early-morning mists, as in this scene, and you will have the makings of a very atmospheric painting.

When you are painting trees, always start by establishing the overall shape. The oak tree in this project has a spreading habit: the branches radiate outwards from the main trunk, while the crown is rounded and reasonably symmetrical. When trees are in leaf the underlying "skeleton" can sometimes be hidden from view, but you need to be aware of it. The leaves do not simply sit on top of the branches in clumps; they are attached to branches and twigs, and you must convey a sense of the shapes underneath and the directions in which the branches and twigs grow, even if you cannot see them clearly, in order for your painting to look convincing.

Because the sunlight in this scene is coming from behind the tree, the tree itself is in semi-silhouette. However, the light does catch the edge of the tree branches in places, creating warm wisps of colour against the dark branches and trunk. Pay careful attention to these highlights and look for areas where shafts of sunlight break through.

Textures, too, are important. Although you cannot see much detail because the tree is in semi-silhouette, the gnarled trunk is an essential part of the tree's character. Here, water-soluble pencils were used to establish a base texture that was then overlaid with watercolour washes.

## Materials

- 4B pencil
- 140lb (300gsm) NOT watercolour paper, pre-stretched
- Water-soluble pencils: sepia
- Watercolour paints: cadmium yellow, burnt sienna, alizarin crimson, cobalt blue, sepia, violet
- Gouache paints: neutral grey, permanent white
- Brushes: medium round, small round
- Ruling drawing pen
- Masking fluid

**Preliminary sketch**
The artist made a quick colour sketch in situ to work out the overall shape of the tree and which colours to use for the vibrant autumn leaves.

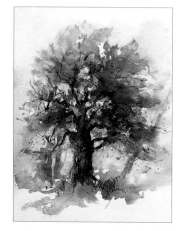

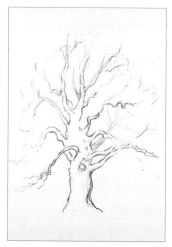

1 Using a 4B pencil, lightly sketch the scene, putting in the main branches of the tree. Look carefully at how they twist and overlap.

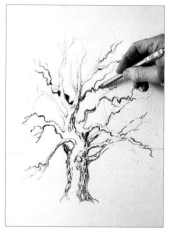

2 Dip the tip of a sepia water-soluble pencil in water and put in the dark textural markings of the gnarled trunk and the main branches. (Dipping the pencil in water intensifies the colour and makes the marks more permanent, so that this linear pencil work is still visible when the watercolour washes are applied to the tree in the later stages of the painting.)

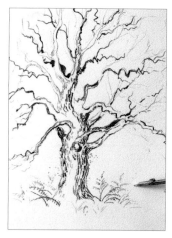

3 Using a ruling drawing pen, apply masking fluid to the highlighted edges of the branches and the foreground grasses. Leave to dry completely. The masking is subtle, but it plays an important role in establishing a sense of light and shade.

4 Mix a pale wash of cadmium yellow and wash it over the background behind the tree and the foreground grasses. Dot some of the same cadmium yellow mixture into the branches to establish the lightest-coloured foliage areas.

5 Wet the tree with clean water and touch in burnt sienna, dabbing it on with the side of the brush. The colour will spread over the damp paper and merge with the yellow applied in Step 4. Apply several layers wet into wet, in some places, to deepen the tones.

6 While the burnt sienna washes are still wet, drop alizarin crimson into the lower branches, angling your brushstrokes in the direction in which the branches and leaves naturally grow. The richness of the autumnal colours is now starting to develop. Leave to dry.

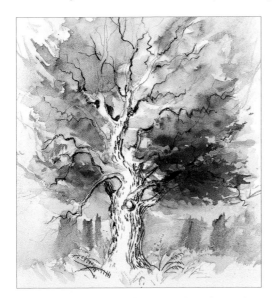

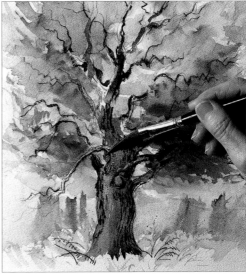

7 Wash around the edges of the tree and into the negative spaces with clean water. Mix a very pale, dilute grey from neutral grey gouache and cobalt blue watercolour and touch this mixture on to the damp paper. Add a tiny amount of burnt sienna to the mixture and paint the misty tree trunks in the background, wet into wet.

8 Mix a greyish brown from burnt sienna, sepia and a tiny amount of cobalt blue. Paint the branches of the main tree, looking carefully to see which branches go behind others. Even though you are brushing over the water-soluble pencil marks made in Step 2, they will show through again once the watercolour wash is dry.

▶

**Assessment time**

The main colours have been established but it is hard to tell which direction the light is coming from, and without any strong indication of light and shade, the tree looks rather flat and one-dimensional. For the remainder of the painting, concentrate on improving the tonal contrast and creating a feeling of sunlight streaming through the tree branches.

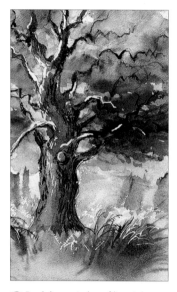

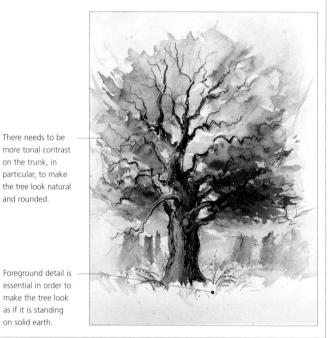

There needs to be more tonal contrast on the trunk, in particular, to make the tree look natural and rounded.

Foreground detail is essential in order to make the tree look as if it is standing on solid earth.

9 Brush loose strokes of burnt sienna into the foreground, bringing some of your strokes up over the yellow grasses. The warm colour and foreground texture help to bring this area of the painting forward. Leave to dry completely. Using your fingertips, gently rub off the masking fluid to reveal the highlighted edges of the branches and the foreground grasses. The feeling of light and shade in the painting is now much stronger.

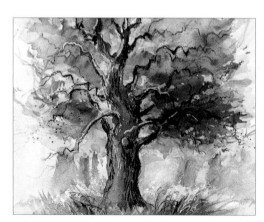

10 Mix a pale grey from white gouache, cobalt blue and violet and paint the exposed areas of the branches and trunk. Spatter alizarin crimson on to the leaves. Leave to dry.

11 Mix a very pale yellow from permanent white gouache with a little cadmium yellow. Brush in very thin shafts of misty early-morning sunlight.

**Autumn tree**
Painted in a free and spontaneous manner, this little study exploits the richness of autumn colours to the full. In any subject that is viewed against the light, the detail is subdued: here, the dense browns of the trunk and branches provide the necessary structure for the painting, while virtually everything else is reduced to an impressionistic mass of colour. The semi-opaque yellow mixture used to create the shafts of sunlight mutes the underlying colours but does not obscure them completely. This is a very effective way of creating the effect of early-morning mist.

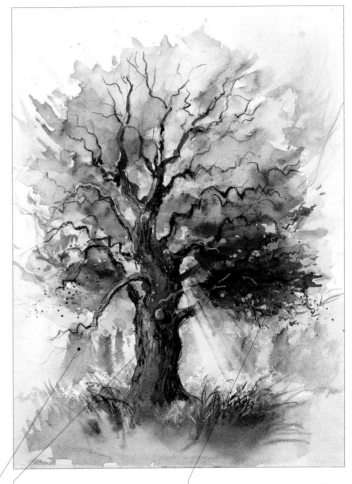

The misty trees in the background provide a hint of the landscape beyond.

Water-soluble pencil marks convey the texture of the tree bark beautifully.

Spattering provides the merest hint of leaf texture: too much would be distracting.

# Poppy field

Lush expanses of wild flowers are always attractive, and when those flowers are a rich and vibrant red, like this stunning array of poppies, the subject simply cries out to be painted.

This project presents you with several challenges. First and foremost, it is an exercise in painting spontaneously and in creating an impression of the scene, rather than trying to capture each individual flower. Work quickly and freely, and concentrate more on the overall tones than on specific details. Make sure you don't make the poppies look as if they have been planted in neat, straight rows. It is surprisingly difficult to position dots of colour randomly, but unpredictable techniques, such as spattering, can help.

Second, remember that this is not a botanical study: what you are trying to create is an overall impression of the scene, not an accurate record of how the flowers are constructed. You really don't want a lot of crisp detail in a scene like this, otherwise it will look stilted and lifeless. This is where watercolour really comes into its own. Wet-into-wet washes that merge on the paper create a natural-looking blur that is perfect for depicting a mass of flowers and trees gently blowing in the breeze.

Finally, take some time considering the tonal balance of the painting. Red and green are complementary colours and they almost always work well together, but if the greens are too dark they could easily overpower the rest of the painting. On the other hand, if they are too light they will not provide a strong enough backdrop for the flowers.

## Materials
- 2B pencil
- 140lb (300gsm) rough watercolour paper, pre-stretched
- Watercolour paints: cobalt blue, alizarin crimson, gamboge, raw sienna, sap green, Delft or Prussian blue, burnt umber, viridian, cadmium orange, cadmium red, Payne's grey
- Brushes: large mop, medium mop, fine rigger, old brush for masking fluid, medium round, fine round
- Masking fluid

## The original scene
This field is a blaze of red poppies as far as the eye can see, counter-balanced by a dark green background of trees. Although the horizon is very near the middle of the picture, which can sometimes makes an image look static, this is offset by the fact that the top half of the image is divided more or less equally into trees and sky. However, the sky is very bright, and this detracts from the poppies; adding colour here will improve the overall effect.

The sky lacks colour and needs to be made less dominant.

The dark trees provide a neutral background that makes the red of the poppies all the more vibrant.

1 Using a 2B pencil, lightly sketch the outline of the trees and some of the larger foreground poppies. Don't attempt to put in every single flower – a few of the more prominent ones are all you need as a guide at this stage. Using an old brush, apply masking fluid over the poppies in the foreground. In the middle ground and distance, dot and spatter masking fluid to create a more random, spontaneous effect. Draw some thin lines of masking fluid for the long grasses in the foreground. Clean your brush thoroughly and leave the painting to dry.

2 Using a medium round brush, dampen the sky area with clean water, leaving a few strategically placed gaps for clouds. Mix up a strong wash of cobalt blue and drop this on to the damp sky area, so that it spreads up to the gaps left for the cloud shapes. The colour is more intense than it was in reality, but the sky needs to look dramatic. Leave to dry.

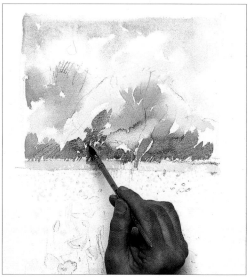

3 Apply a strong wash of gamboge to the tree tops. Add raw sienna and brush over the base of the trees and the horizon. Touch raw sienna into the clouds. While this is still damp, touch a purplish-blue mixture of cobalt blue and alizarin crimson on to the underside of the clouds. Leave to dry.

4 Mix a dark green from sap green, raw sienna and a little Delft or Prussian blue. Using a medium round brush, brush this mixture over the trees to create dark foliage areas, allowing some of the underlying gamboge to show through in places.

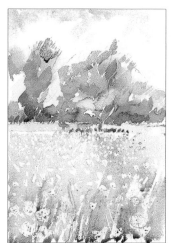

5 Continue building up the foliage on the trees, leaving a few gaps. Mix a mid-toned green from gamboge and sap green and, using a large mop brush, brush this mixture over the lower part of the painting – the poppy field. Leave to dry.

6 Mix a darker green from viridian and cobalt blue and apply this mixture to the foreground, using a large mop brush. Use the same colour to touch in some dark lines for the long shadows under the main tree. Leave to dry.

7 Mix a dark green from sap green, raw sienna and burnt umber and, using a fine rigger brush, brush thin lines on to the foreground. Leave to dry. Spatter the same mixture over the foreground to represent the grass seed heads and add texture. Leave to dry.

▶

### Assessment time

Cool greens and yellows have been put in across the whole painting, establishing the general tones of the scene. As you continue to work, you will probably find that you need to darken some of the background colours to maintain a balance between them and the foreground. This kind of tonal assessment should be an on-going part of all your paintings. Now it is almost time to start putting in the bright red poppies in the foreground, the finishing touches that will bring the scene to life. Try above all else to maintain a feeling of spontaneity in the painting as you work: the poppies must look as if they are randomly distributed over the scene.

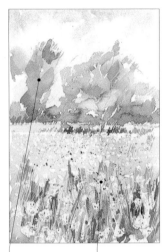

The dark tonal masses of the background have been established.

Spattering in the foreground gives interesting random texture.

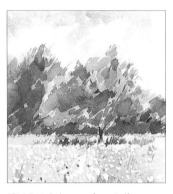

**8** Mix a dark green from Delft or Prussian blue, viridian and burnt umber and, using a medium mop brush, darken the trees, leaving some areas untouched to create a sense of form. Add a little more burnt umber to the mixture and, using a fine rigger brush, paint the tree trunks and some fine lines for the main branches. Leave to dry. Using your fingertips, gently rub off the masking fluid.

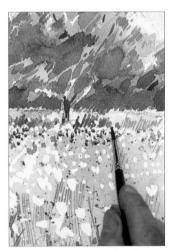

**9** Mix an orangey red from cadmium orange and cadmium red. Using a fine round brush, start painting the poppies in the background.

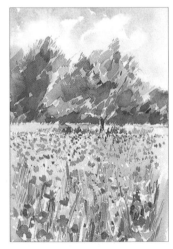

**10** Continue painting the white spaces with the red mixture used in Step 11, leaving a few specks of white to give life and sparkle to the painting. Apply a second layer of colour to some poppies while the first layer is still wet; the paint will blur, giving the impression of poppies blowing in the wind, and the tone will deepen.

**11** Using a fine, almost dry brush and the same dark green mixture used in Step 7, paint in the exposed foreground stalks and grasses. Finally, using a fine rigger brush, touch in the black centres of the poppies with a strong mixture of Payne's grey.

**Poppy field**

This is a loose and impressionistic painting that nonetheless captures the mood of the scene very well. It exploits the strong effect of using complementary colours (red and green), but the density of colour has been carefully controlled so that the whole painting looks balanced, with no one part dominating the rest.

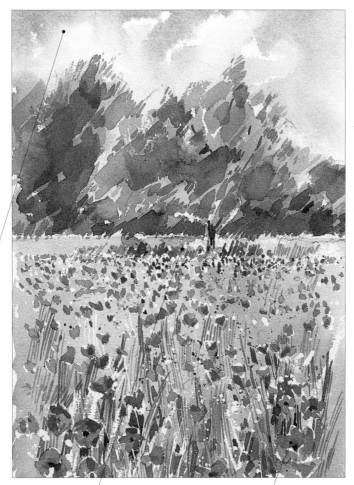

The sky is darker than in the original photograph, which helps to maintain the tonal balance of the scene.

The shadow under the tree is painted with short brushstrokes that echo the direction in which the grasses and flowers grow.

Only the foreground poppies have painted centres. Those in the background are so far away that a blur of colour suffices.

# Painting Flowers

The aim of botanical artists is to record for scientific purposes. They need to create as faithful a representation of the flower or plant as possible, with every detail in evidence. The so-called fine artists usually paint flowers for decorative and symbolic reasons, and, of course, because flowers and plants make such terrific subjects.

Like other subjects, you should start by looking at and understanding the basic shape of the flowers you are painting. Look at how they grow and at how the leaves are attached to the stem and radiate out from it. Remember that the flower or flowers are an extension of the stem and not simply something that is stuck on the end of it. The flower head is made up of several different parts: note how each is connected to the others.

Analysing and reducing these often complex elements into simple geometric shapes is a good way to start. Look closely and you will see that flower heads can resemble saucer-like discs, simple spheres, upright or inverted cones, bell or goblet shapes, to name but a few. Learning to look at flowers in this way will not only allow you to draw and paint them well, but it will also let you approach the subject in a looser, more impressionistic or expressionistic way, secure in the knowledge that you are capturing the character of your subject correctly.

You can use every watercolour technique in your repertoire when painting flowers, but planning the sequence in which you are going to work is essential. Unless you are using body colour, you will be working from light to dark, and this often raises the question of how to paint small, complex-shaped flowers against a dark background without painstakingly painting around each flower. (The answer is, of course, masking fluid.)

The colour of certain flowers can seem particularly elusive, as can the way in which colours often bleed into each other, or are distributed on the petals. Make your colour mixes a little stronger and more intense that you think they should be, as watercolour always looks paler when it is dry. Use wet-into-wet techniques, as these will allow the colours to run and mix together by themselves.

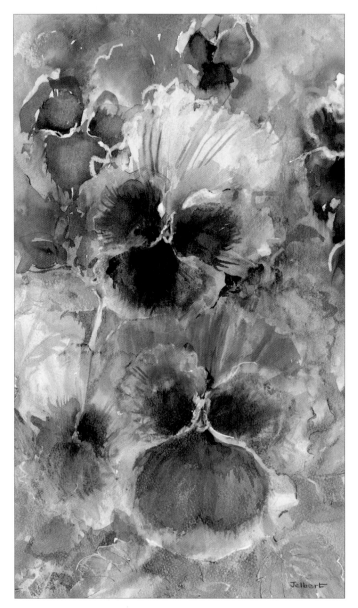

### ◄ Pansies
This colourful painting uses several watercolour techniques. The image was blocked in using wet-into-wet washes of transparent watercolour. Body colour was then added, some of which was removed by carefully blotting with a paper towel. Detail was added using more body colour and soft pastel.

**Parrot tulips ▼**
Wet-into-wet and wet-on-dry wash techniques were used to paint these parrot tulips. Chance back-runs and drying marks add to the pattern and interest on the leaves and flower heads, while the characteristic curve of the stems under the weight of the flower heads has been perfectly captured.

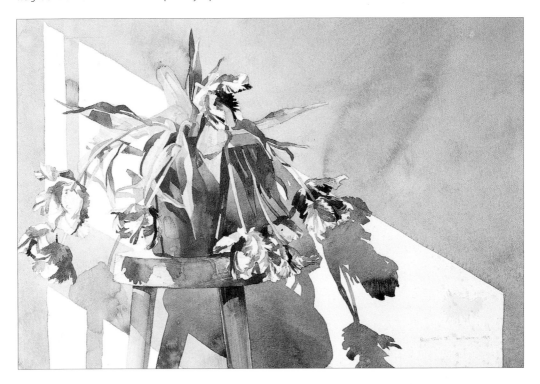

**Spring bouquet ▶**
Here, irises, tulips, anemones and small yellow narcissi have been painted in their wrapping paper. Although the arrangement looks casual, it was very carefully arranged. Wet-on-dry washes were used exclusively. The colours were kept bright by using no more than three layers of wash in any one place.

> **Tips:** • Look at the underlying structure and simplify what you see into basic geometric shapes.
> • Make several studies of your subject before you begin painting, to increase not only your technical skills, but also your familiarity with the subject.

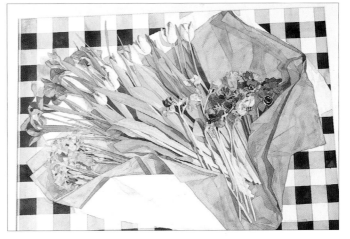

# Sunflower

Bold and bright, their faces turning to follow the sun as it travels through the sky, sunflowers are an artist's dream.

Although the aim of this project is not to produce a botanical illustration, with every last detail precisely rendered, a good flower "portrait" should show something of how the flower is constructed. Is the stem straight or twisted? Are the leaves grouped together at the base of the stem or spread out evenly? Does the flower consist of a single large bloom or lots of little florets? A side view will often tell you more than a face-on viewpoint and can make it easier to make the flower look three-dimensional, particularly when you are painting a relatively flat, symmetrical flower, such as a sunflower.

## Materials
- 4B pencil
- 140lb (300gsm) NOT watercolour paper, pre-stretched
- Oil pastels: orange, lemon yellow, bright yellow, sage green, light green, burnt sienna
- Watercolour paints: burnt sienna, violet, cadmium yellow, yellow ochre, Hooker's green, cobalt blue, cerulean blue
- Gouache paints: permanent white
- Brushes: medium round

## The set-up
Because sunflowers were not in bloom when this painting was done, an artificial sunflower was used for the composition. The stem and flowerhead have been twisted slightly to make the image more interesting.

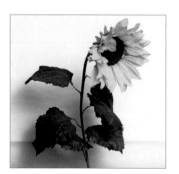

**Reference photograph**
The artist used a photograph as reference for the colours and the texture in the flower centre. However, the head-on viewpoint and frontal lighting do not make a very interesting composition as there are virtually no shadows or changes of tone in the petals.

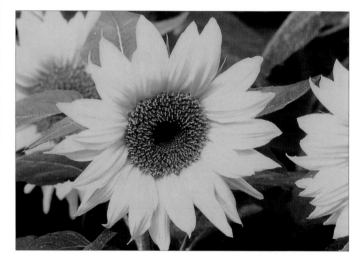

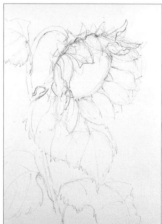

1 Angle the sunflower so that you can see both the interior of the flower and the backs of some of the petals. Using a 4B pencil, lightly sketch the sunflower, paying careful attention to the way the leaves are twisted.

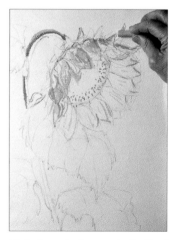

2 Begin putting in some detail with oil pastels, which will act as a resist and allow you to make short, textural marks that would be difficult to achieve using a brush alone. Use orange in the flower centre, lemon yellow and bright yellow on the lightest parts of the petals, and sage and light green on the stalk.

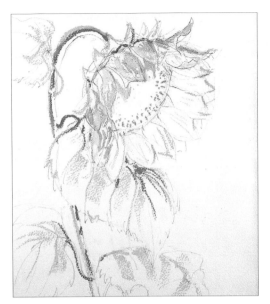

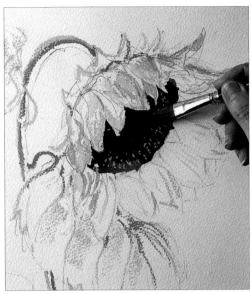

3 Continue using the oil pastels on the stalk and leaves, using sage for the shadowed side of the stalk and the deepest creases in the leaves and light green for the other leaf markings and highlights.

4 Mix a mid-toned wash of burnt sienna watercolour paint and brush it over the centre of the flower. Mix a dark brown from burnt sienna and violet and paint the darkest part of the flower centre.

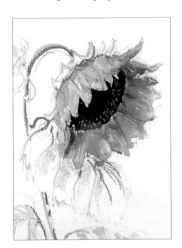

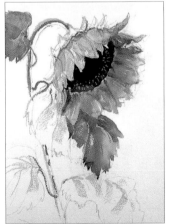

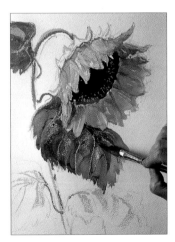

5 Mix a mid-toned wash of cadmium yellow and brush it all over the flower. While this first wash is still wet, mix a light brown from yellow ochre and burnt sienna and drop it wet into wet on to the inner petals, allowing some of the underlying yellow to show through as striations in the petals.

6 Mix a mid-toned green from Hooker's green with a little yellow ochre and begin brushing in the colour for the leaves. Add more yellow ochre to the mixture for the top leaf, which is slightly withered. Note how the oil pastel markings show through from beneath the watercolour.

7 While this first green wash is still wet, continue painting the leaves. Sunflower leaves are very textured, so paint the deep crinkles in the main leaf, wet into wet, in cobalt blue, using the tip of the brush. This foreground texture helps to imply that the leaf is closer to the viewer than the others.

▶

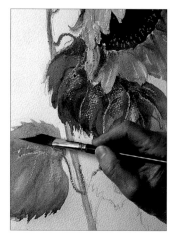

8 Paint the base petals around the outer edge of the flower in a light green mixture of Hooker's green and cadmium yellow. Paint the lowest leaf on the left in the same green mixture used in Step 6, adding cerulean blue to the mixture for the top edge. This cool colour helps to make the leaf recede. Brush yellow ochre, wet into wet, on to the outer edge of this leaf.

**Assessment time**
The use of warm and cool tones in the leaves is beginning to make the spatial relationships clearer. The cool blue-green of the leaf to the left of the stalk makes it recede, while the warmer greens and yellow ochre of the leaf immediately below the flower make it advance, implying that it is closer to the viewer. Although the painting is nearing completion, some subtle adjustments need to be made in order to create more texture and build up the tones.

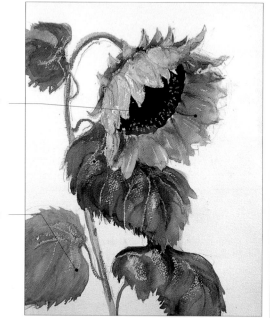

More variety of tone is needed on the petals.

The two lowest leaves are too similar in tone: the one at the base needs to be very slightly darker, so that it comes forward more.

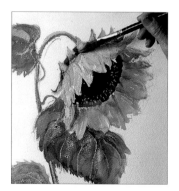

9 Enhance the feeling of light and shade by painting the shadowed side of the stalk in cobalt blue. Dot more blue in behind the base petals.

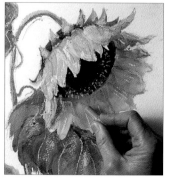

10 Darken the petals and add texture to the inside of the flower, which is shaded from the light, by dotting in orange oil pastel.

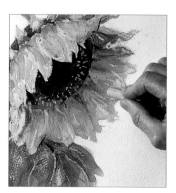

11 Dash short strokes of burnt sienna and yellow oil pastel on to the inner petals in order to darken the tones still further.

## Sunflower

This is a colourful and lively flower study that captures the essence of the plant. Note how wet-into-wet washes create subtle variations in tone on both the flower and the leaves, while the use of oil resists provides interesting textures and highlights. Angling the head of the sunflower and positioning the stalk on a slight diagonal have also helped to create a dynamic composition.

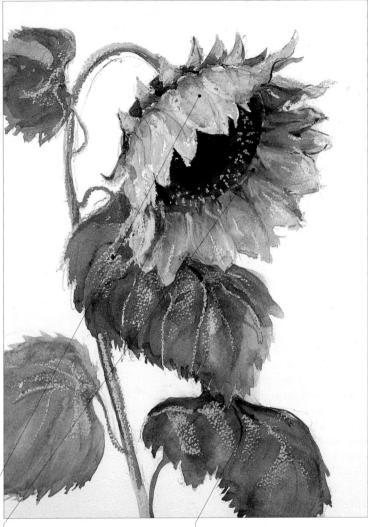

Using pale tones and leaving some of the white paper still visible indicate that this area receives the most direct light.

Oil pastel markings create important tonal and textural contrasts in the centre of the flower.

The shadow cast by the leaf above helps to define the spatial relationships of the leaves.

# Summer flower garden

This scene was invented entirely from the artist's imagination, using quick sketches of flowers in her own garden and photographs from a garden centre catalogue as reference. When you are combining material from several sources, take the trouble to check a few basic facts. Make sure that the flowers you've selected really do bloom at the same time, and check the relative sizes, so that you don't make a ground-hugging plant appear taller than a small tree.

The project gives you the chance to combine classic watercolour techniques with the relatively modern medium of water-soluble pencils. The characteristics of water-soluble pencils are exploited to the full here. The pencil marks are used dry, to create fine linear detail, particularly in the foreground. They are also covered with watercolour washes, so that the colours merge. You can control the amount of blur to a certain extent: if you wet the tip of the pencil before you apply it, the pencil marks will blur less, allowing you to hold some of the detail and texture in these areas.

## Materials

- *140lb (300gsm) NOT watercolour paper, pre-stretched*
- *Water-soluble pencils: dark blue, light brown, cerulean blue, light violet, dark violet, blue-green, olive green, red, yellow, orange, deep red, green*
- *Watercolour paints: cerulean blue, rose doré, Linden green, dark olive, olive green, cobalt blue, cadmium yellow, Naples yellow, burnt sienna, vermilion, alizarin crimson, Payne's grey*
- *Brushes: medium round, fine round*
- *Ruling drawing pen*
- *Masking fluid*

> **Tip**: Changing from a horizontal to a vertical format may alter other elements as well. In the final composition, the path still runs from the bottom right to the top left but the artist made the foreground flower border more prominent.

### Reference sketches

Look closely at detailed sketches, illustrations or photographs of individual flowers before you embark on your full-scale painting. Although a massed clump of foliage and flowers may look like an indistinct jumble, knowing the shape and colour of an individual bloom will help you capture the essential features of the plant.

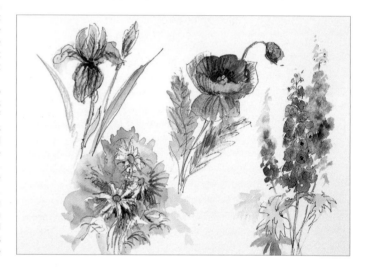

### Preliminary sketch

The artist invented a garden scene and made a small sketch to try out the colours and the composition. To begin with, she opted for a horizontal format. Then she decided that this placed too much emphasis on the pathway and that a vertical format, with the rose arch as the main feature, would have more impact.

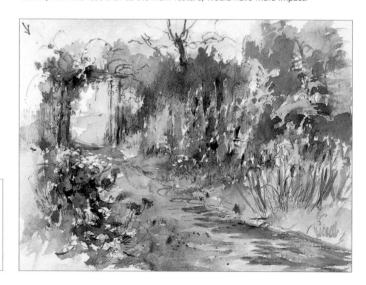

1 Using a dark blue water-soluble pencil, sketch the main shapes of your subject. Dip a ruling drawing pen in masking fluid and mask the lightest parts of the flowers.

2 One of the advantages of using a ruling drawing pen is that it holds the masking fluid in a reservoir. A range of marks is used to convey the different textures of each of the massed clumps – flowing lines for the poppy heads and little dashes for the daisy petal in the foreground. It would be more difficult to achieve this with a dip pen as the nib would block up, leaving blobs and blots on the paper.

**Assessment time**

Continue with these dots and dashes of pencil work until you have established the general colour scheme of the garden. Don't be tempted to do too much or the pencil work might begin to overpower the picture: this is a painting, not a drawing, and it is the watercolour paint applied in the subsequent stages that will give the work its character.

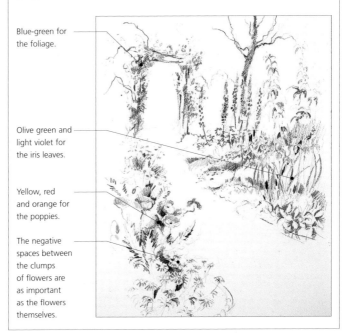

Blue-green for the foliage.

Olive green and light violet for the iris leaves.

Yellow, red and orange for the poppies.

The negative spaces between the clumps of flowers are as important as the flowers themselves.

3 Shade in the trunk of the tree with loose pencil strokes, using a light brown water-soluble pencil. (This makes the marks more permanent.) Dip the tip of the pencil in clean water and draw the branches. Draw the wooden rose arch in the same colour. Colour in the individual delphinium blooms with small dots of cerulean blue, changing to light and dark violet for the stems that are in deeper shade. Dip the pencil tip in water to make some of the marks.

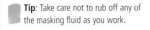

**Tip**: Take care not to rub off any of the masking fluid as you work.

▶

4 Dampen the background with water. Wash a pale mix of cerulean blue watercolour paint over the sky, brushing around the branches. Dot rose doré over the rose arch: the paint will blur, suggesting full-blown blooms. Brush Linden green under the arch and dot a mixture of dark olive and cerulean blue into the background and between the delphiniums. While the paint is still damp, add bright olive green with cerulean blue and brush over the first blue wash.

5 Dampen the middle distance with clean water. Dot cerulean blue, rose doré and cobalt blue on to the delphiniums. Both the paint and the initial water-soluble pencil marks will blur and spread, causing the flowers to look slightly out of focus. Mix a neutral brown from olive green and rose doré and brush it into the negative spaces between the iris stems. The flowers will begin to stand out more against this dark background.

6 The distance and middle ground have now been established. Note how the soft tones and lack of clear detail help to imply that these areas are further away from the viewer.

7 Mix a bright green from cerulean blue and cadmium yellow and dot it loosely into the pathside area for the hummocks of low-growing ground-cover plants that spill over on to the path.

8 Dampen the path. Starting near the arch, brush pale Naples yellow over the path, adding burnt sienna towards the foreground. Brush clean water over the tip of a brown water-soluble pencil and spatter colour on to the path, using the brush. Start spattering in the foreground and work towards the rose arch. As the brush dries, the drops of water – and the dots of colour – get smaller, and this will help to create a sense of recession.

9 Note how effectively the curved path leads the eye to the focal point of the painting – the rose-covered arch. The spattered drops of colour provide important texture in what would otherwise be a large expanse of flat brown.

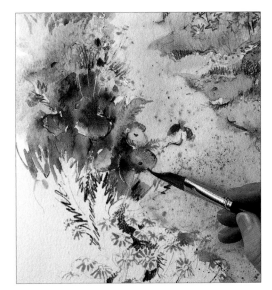

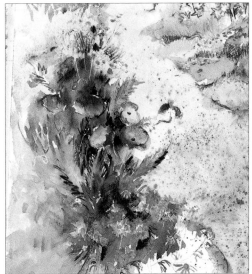

10 Brush cadmium yellow and then vermilion over the red poppy heads, allowing the colours to blend on the paper, and brush a tiny bit of alizarin crimson over parts of the foreground poppies to give added depth of tone.

11 Mix Payne's grey with olive green for some of the background poppy leaves and stems. Add a little cobalt blue to the mixture for the foreground poppy leaves. Dot cadmium yellow in the centre of the daisy flowers.

▶

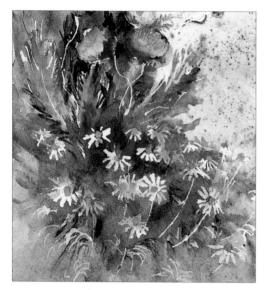

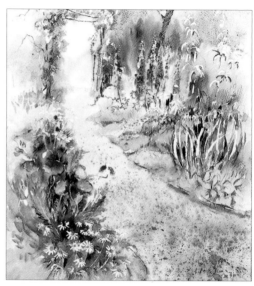

**12** Finish the bottom left-hand corner, using the same green mixture as before.

**13** Using your fingertips, gently rub off the masking fluid to reveal the white parts of the flowers.

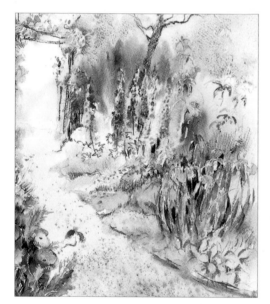

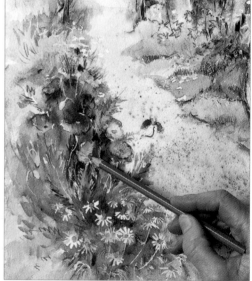

**14** Some of the exposed white areas now look too stark – particularly in the background. Mix a very pale wash of cerulean blue and brush it over some of the iris stems to tone down the brightness – otherwise the viewer's eye will be drawn to these areas, which are not the most important parts of the scene.

**15** Now go back to the water-soluble pencils to add sharper details in the foreground. Use a deep red pencil to delineate the petals and frilly edges of some of the larger poppies, and draw a green pencil circle around the yellow centres of the poppies. Darken the spaces between the daisy petals with a dark blue pencil.

## Summer flower garden

This painting is a romantic, impressionistic portrayal of a traditional flower garden. Softly coloured poppies, irises, daisies and delphiniums line the winding path, which leads to the focal point of the image – the rose arch. There is a hint of mystery in the painting, too: what lies on the other side of the archway?

Flowers in the background are more blurred than those in the foreground, but some linear detail is still visible.

The poppies are painted with a number of different techniques – masking for the twisting stems, wet-into-wet washes for subtle colour blends, and fine pencil detail.

Reserving the white of the paper for the daisy petals adds sparkle to the image.

The textured path provides subtly coloured but necessary foreground interest.

# French vineyard

This deceptively simple-looking scene is a useful exercise in both linear and aerial perspective. Take care over your underdrawing, as it underpins all the rest of the painting: if the rows of vines appear to be going in the wrong direction it will look very strange. It is worth taking plenty of time over this stage.

You also need to mix tones carefully. Note how the dark green vine leaves in the foreground give way to a much paler, yellower green in the distance – and then see how these pale greens gradually darken again above the horizon line, shifting from a mid green to a very bluish green on the distant hills. Remember to test out each tone on a scrap piece of paper before you apply it to the painting.

## Materials
- *2B pencil*
- *140lb (300gsm) rough watercolour paper, pre-stretched*
- *Watercolour paints: cerulean blue, Naples yellow, gamboge, light red, sap green, ultramarine violet, cobalt blue, viridian, Payne's grey, burnt umber*
- *Brushes: large mop, medium mop, fine round*

## Reference photographs
Sometimes one reference image simply doesn't give you enough information to create the painting you want. Don't be afraid to combine elements from several photos or sketches to create the desired effect. Here, the artist referred to the long panoramic-format photograph for the close-up detail of the vine leaves and the farm buildings, but based his composition on the larger photograph, in which the rows of vines are angled in a more interesting way.

1 Sketch the outline of the hills and vines, then dampen the sky with clean water, leaving some gaps. Mix a wash of cerulean blue and drop it on to the damp areas. Leave to dry.

2 Mix a pale wash of Naples yellow and touch it into the dry cloud shapes and along the horizon line. Leave to dry.

3 Darken the top of the sky with cerulean blue and leave to dry. Mix gamboge with light red and brush over the vines. Paint light red on the foreground and in between the vines.

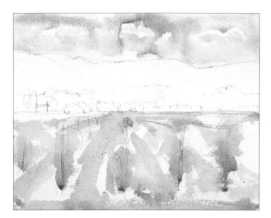

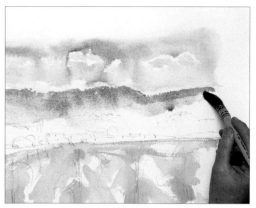

4 Using a medium mop brush, loosely paint sap green into the foreground to indicate the rows of vines. Leave to dry.

5 Mix a deep blue from ultramarine violet, cobalt blue and viridian and wash it over the hills. Put a few dots along the top edge to break up the harsh outline and imply trees.

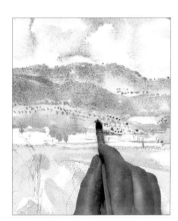

6 Mix a mid-toned green from viridian with a little cobalt blue. Using a medium mop brush, brush this mixture over the lower part of the hills. Mix a dark blue from cobalt blue, ultramarine violet and viridian. Using a large mop brush, darken the shadows on the distant hills. Use the same colour to stipple a few dots on the green hills to imply trees on the horizon.

**Tip**: It is often easier to assess colours if you turn your reference photo upside down. This allows you to concentrate on the tones without being distracted by the actual subject matter.

**Assessment time**
Once you are happy with the general lines and colours of the scene, you can start thinking about adding those all-important touches of detail and texture. Don't be tempted to do this too early: once you have painted the detail, it will be much harder to go back and make any tonal corrections to the background or the spaces between the rows of vines.

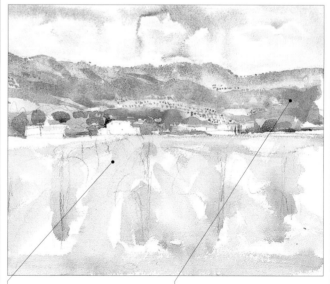

The perspective of the foreground has been established, leaving you free to add detail and texture.

The background is virtually complete, with darker shadows on the hills providing a sense of light and shade.

▶

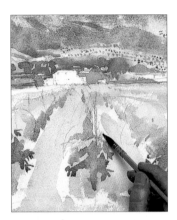

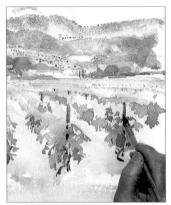

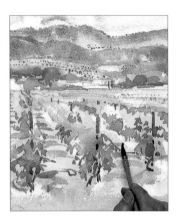

7 Mix a dark green from sap green, Payne's grey, and a little burnt umber. Using a large mop brush, wet the foreground with clean water, leaving gaps for the vines. Using a medium mop brush, brush the dark green mixture on to the damp areas and let it flow on the paper to define the general green masses of the vines and their leaves. Paint the dark shapes of the foreground vine leaves.

8 Continue painting the vine leaves, as in Step 7. Don't try to be too precise or the painting may easily start to look overworked: generalized shapes will suffice. Mix a warm but neutral grey from ultramarine violet and burnt umber and, using a fine round brush, paint in the stems of the vines and the posts that support them, taking care to make the posts smaller as they recede into the distance.

9 Mix a dark shadow colour from ultramarine violet and a little burnt umber and brush this mixture across the ground in between the rows of vines. Again, take care over the perspective and make the shadows narrower as the vines recede into the distance.

10 Mix a warm, reddish brown from light red and a touch of Naples yellow and use this to paint the buildings in the background. This warm colour causes the buildings to advance, even though they occupy only a small part of the picture area. Using a fine brush and the same dark green mixture that you used in Step 7, touch in some of the detail on the vines.

11 Using an almost dry brush held on its side, brush strokes of light red in between the rows of vines. This strengthens the foreground colour but still allows the texture of the paper to show through, implying the pebbly, dusty texture of the earth in which the vines are planted.

12 Using a fine brush, brush a little light red on the top of the roofs. This helps the roofs to stand out and also provides a visual link with the colour of the earth in the foreground. Add a little burnt umber to the light red mixture to darken it, and paint the window recesses and the shaded side of the buildings to make them look three-dimensional.

**French vineyard**

Fresh and airy, this painting is full of rich greens and warm earth colours, providing a welcome dose of Mediterranean sunshine. Note how most of the detail and texture are in the foreground, while the background consists largely of loose washes with a few little dots and stipples to imply the tree-covered mountains beyond. This contrast is a useful device in landscape painting when you want to establish a sense of scale and distance.

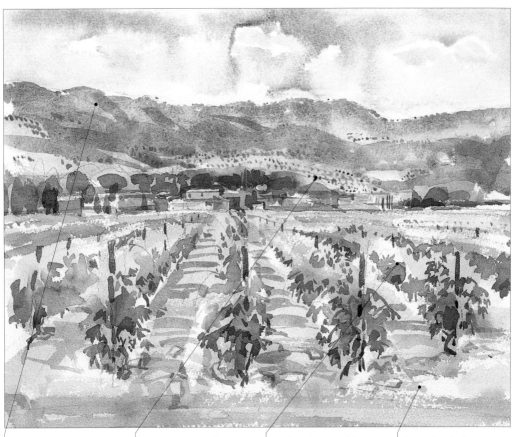

Cool colours in the background recede.

Simple dots and stipples are enough to give the impression of distant trees.

Note how the rows of vines slant inwards and converge towards the vanishing point.

Warm colours in the foreground advance.

# Craggy mountains

This project is a good exercise in aerial perspective. Although the scene itself is very simple, you must convey a sense of the distances involved in order for it to look convincing. Tonal contrast is one way of achieving this: remember that colours are generally paler towards the horizon, and so the mountains in the far distance look paler than those in the immediate foreground. Textural contrast is another way to give a sense of distance: details such as jagged rocks and clumps of snow need to be more pronounced in the foreground than in the background.

The use of warm and cool colours to convey a sense of light and shade is important, too. Cool colours, such as blue, appear to recede and so painting crevices in the rocks in a cool shade makes them look deeper and further away from the viewer. Warm colours, on the other hand,

appear to advance and seem closer to the viewer. These should be used for the areas of rock that jut upwards into the sunlight.

Although you want the painting to look realistic, don't worry too much about capturing the exact shapes of individual rocks: it is more important to convey an overall impression. Use short, jagged strokes that follow the general direction of the rock formations. This will help to convey the mountains' craggy texture.

## The original scene

These craggy peaks, stretching far into the distance, make a dramatic image in their own right. In the late spring, when this photograph was taken, the drama is enhanced by the billowing white clouds, set against a brilliant blue sky, and the last vestiges of snow clinging to the rocks.

## Materials
- *2B pencil*
- *Rough watercolour board*
- *Watercolour paints: ultramarine blue, burnt sienna, cobalt blue, phthalocyanine blue, alizarin crimson, raw umber*
- *Brushes: large round, old brush for masking*
- *Sponge*
- *Tissue paper*
- *Masking fluid*
- *Scalpel or craft (utility) knife*

> **Tip**: The sponge is used in this project to lift off paint colour applied to the sky area, and to apply paint. The surface of the sponge leaves a soft, textured effect.

Textural detail is most evident in the foreground; this also helps to create a sense of distance.

Note how the colours look paler in the distance, due to the effect of aerial perspective.

1 Using a 2B pencil, lightly sketch the scene, indicating the main gulleys and crevices and the bulk of the clouds in the sky. Keep your pencil lines loose and fluid: try to capture the essence of the scene and to feel the "rhythm" of the jagged rock formations.

2 Mix a pale, neutral grey from ultramarine blue and burnt sienna. Using a large round brush, wash this mixture over the foreground mountain.

3 Mix a bright blue from cobalt blue and a little phthalocyanine blue. Using a large round brush, wash it over the top of the sky. While this is still wet, dampen a small sponge in clean water, squeeze out the excess moisture, and dab it on the sky area to lift off some of the colour. This reveals white cloud shapes with softer edges than you could achieve using any other technique.

**Tip**: Each time you apply the sponge, turn it around in your hand to find a clean area, and rinse it regularly in clean water so that you don't accidentally dab colour back on to the paper.

▶

4 Mix a neutral purple from alizarin crimson, ultramarine blue and a little raw umber. Using a large round brush, dampen the dark undersides of the clouds and touch in the neutral purple mixture. While this is still damp, touch in a second application of the same mixture in places to build up the tone. If necessary, soften the edges and adjust the shapes of the dark areas by dabbing them with a piece of sponge or clean kitchen paper to lift off colour.

5 Study your reference photograph to see exactly where the little patches of snow lie on the foreground mountain. Using an old brush, apply masking fluid to these areas to protect them from subsequent applications of paint. Use thin lines of fluid for snow that clings to the ridges and block in larger areas with the side of the brush. Wash the brush in liquid detergent and warm water. Leave the masking fluid to dry completely before moving on to the next stage.

6 Mix a dark blue from cobalt blue and phthalocyanine blue and paint the distant hills between the two mountains. Dilute the mixture and brush it over the background mountain. Leave to dry. Mix a dark brown from burnt sienna with a little alizarin crimson and ultramarine blue, and wash this mixture over the background mountain. Add a little alizarin crimson and begin painting the foreground mountain.

7 Using a large round brush, continue to paint the foreground mountain. Use the same dark brown mixture that you used in Step 6 for the areas that catch the sun, and phthalocyanine blue for the areas that are in the shade. Paint with relatively short and slightly jagged vertical brushstrokes that echo the direction of the rock formations. This helps to convey the texture of the rocks.

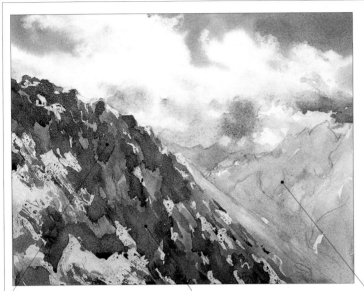

### Assessment time

Because of the careful use of warm and cool colours, the painting is already beginning to take on some form. Much of the rest of the painting will consist of building up the tones you have already applied to enhance the three-dimensional effect and the texture of the rocks. At this stage, it is important that you take the time to assess whether or not the areas of light and shade are correctly placed. Note, too, the contrast between the foreground and the background: the foreground is more textured and is darker in tone, and this helps to convey an impression of distance.

The rocks that jut out into the sunlight are painted in a warm brown so that they appear to advance.

The crevices are in deep shade and are painted in a cool blue so that they appear to recede.

The background mountain is painted in a flat colour, which helps to convey the impression that it is further away.

8 Mix a deep, purplish blue from alizarin crimson, phthalocyanine blue and raw umber. Brush this mixture along the top of the background peak, leaving some gaps so that the underlying brown colour shows through. Using the dark brown mixture used in Step 6, build up tone on the rest of the background mountain, applying several brushstrokes wet into wet to the darker areas.

9 Continue building up the tones on both mountains, using the same paint mixtures as before. Leave to dry. Using your fingertips, gently rub off the masking fluid to reveal the patches of white snow. (It is sometimes hard to see if you've rubbed off all the fluid, so run your fingers over the whole painting to check that you haven't missed any.) Dust or blow all dried fluid off the surface of the painting.

▶

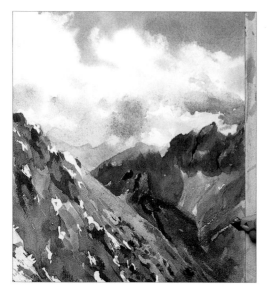

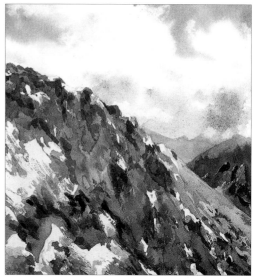

**10** Using the tip of a scalpel or craft (utility) knife and pulling the blade sideways, so as not to cut through the paper, scratch off thin lines of paint to reveal snow in gulleys on the background mountain.

**11** Apply tiny dots of colour around the edges of some of the unmasked areas to tone down the brightness a little. Continue the tonal build-up, making sure your brushstrokes follow the contours of the rocks.

**12** Dip a sponge in clean water, squeeze out any excess moisture and dampen the dark clouds. Dip the sponge in the neutral purple mixture used in Step 4 and dab it lightly on to the clouds to darken them and make them look a little more dramatic.

**13** The final stage of the painting is to assess the tonal values once more to make sure that the contrast between the light and dark areas is strong enough. If necessary, brush on more of the purplish blue mixture used in Step 8 to deepen the shadows.

**Craggy mountains**

This is a beautiful and dramatic example of how contrasting warm colours with cool colours can create a sense of three dimensions. Although the colour palette is restricted, the artist has managed to create an impressively wide range of tones.

Jagged brushstrokes that follow the direction of the rock formations create realistic-looking textures on the foreground mountain and the white of the paper shines through in places, giving life and sparkle to the image.

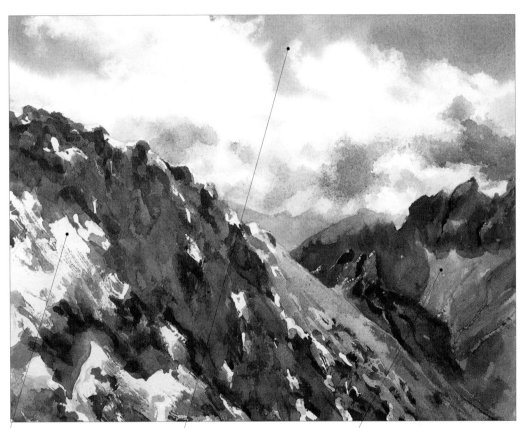

The white of the paper is used to good effect to imply patches of snow clinging to the rocks.

The soft-edged clouds and brilliant blue sky provide a perfect counter-balance to the harshness of the rocks below.

The background mountain is painted in flat washes, with far less textural detail than the foreground.

# Painting Still Lifes

Of all the subjects to draw and paint, still lifes are unique as all the elements are under your control – not only the objects being used, but also their position and the quality and direction of the light used to illuminate them. This gives you the chance to work at your leisure, with no pressure, and to experiment with composition, colour and technique.

Still-life subjects are found everywhere. The obvious ones include the numerous and ever-increasing varieties of fruit, vegetables and flowers available all year round. Kitchen and gardening equipment, children's toys, ceramics and glassware, patterned fabrics, found natural objects and the numerous objets d'art that litter most homes: the list is endless.

Traditionally, the objects used in a still life have some kind of association with each other, but you can also make interesting images by grouping together a range of objects that have little, or no, common ground.

There are also what are known as "found" still lifes, which are arrangements that you simply come across by chance. By definition, these are usually less contrived and more natural-looking than an arranged grouping. Found groupings might include fruit and vegetables falling out of a shopping basket, or a group of terracotta flower pots and garden tools in the corner of a shed or outbuilding.

Perhaps the most important point to consider with still lifes is the quality or type of light that you use to illuminate your subject. Although natural light is ideal, it can prove problematic. Arranging still-life groups directly in the sun can make for dramatic, strong images, but the sun will move and the light will constantly change. You can use lamps of various kinds to light your subject. It is important to remember that low-voltage bulbs can give an orange cast, so it is better to invest in a few daylight bulbs, as these will make colours look cleaner and brighter.

**Tips:** • Invest in a couple of anglepoise lamps and daylight bulbs, so that you can control the direction and quality of the light.
• Make a series of thumbnail sketches of the composition before you begin. Often, you will find that a better composition suggests itself.
• Take risks with your groupings and compositions in order to give your images an edge.
• Look out for "found" groupings that may give rise to an image. If you do not have painting materials to hand, capture the moment with a photograph.

**Tulips ▼**
Natural sunlight pours through a window and falls on a bunch of tulips. The intensity of the light is exaggerated by making the shadow on the wall much darker than it was in reality.

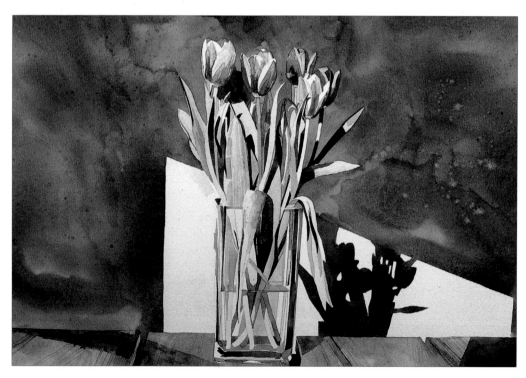

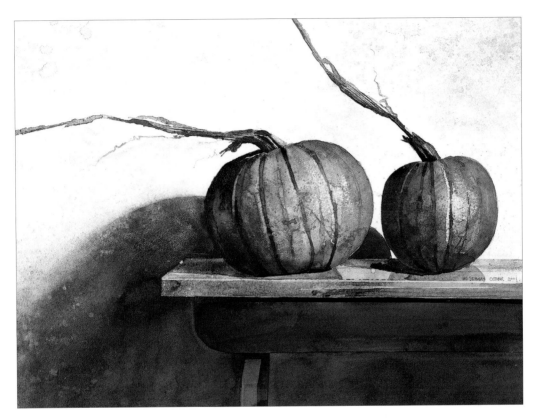

**Pumpkins** ▲
This painting was made on a heavy, rough paper that did not require stretching. Gum arabic was used in the mixes to increase the intensity and transparency of the paint. The paint was applied wet into wet and wet on dry, with areas of paint removed and distressed using sandpaper.

**Leeks** ▶
This is a contrived and carefully arranged still life. The leeks and knife are viewed from above, and an illusion of depth is achieved by painting the linear pattern on the cloth at a slight angle.

# Strawberries and cherries in a bowl

Still lifes don't have to be complicated, and with a few colourful fruit and a china bowl, you can set up a simple but very attractive study on a corner of your kitchen table. However, you do need to spend time thinking about your composition: with relatively few elements, the position of each one is critical.

When you have chosen your subject, move the fruit and bowl around until you get an arrangement that you are happy with. Look at the shadows and the spaces between the objects, as well as at the objects themselves: they are just as important in the overall composition.

Above all, this is an exercise in colour. Choose fruit that have some variation in colour, to provide visual interest. Also look for complementary colours – ones that are opposite each other on the colour wheel – such as red and green, or yellow and violet. Here, touches of green on the leaves and stems offset the vibrant reds of the fruit, while shadows on the yellow ochre background are painted in a complementary shade of violet.

Remember that even things that you know are a brilliant white, such as the doily on which the bowl stands, should rarely (if ever) be painted as such. Shadows and reflected light imbue them with a subtle but definite hue of another colour. Half close your eyes to help you assess what colours and tones to use, and keep any washes in these areas very pale to begin with. You can build them up later if necessary, but if you make them too strong there's no going back.

## Materials
- *2B pencil*
- *140lb (300gsm) NOT watercolour paper, pre-stretched*
- *Watercolour paints: yellow ochre, dioxazine violet, cobalt blue, Hooker's green, vermilion, cadmium orange, cadmium red, cerulean blue, cadmium yellow, Naples yellow, alizarin crimson, leaf green, olive green, phthalocyanine blue*
- *Brushes: medium chisel*
- *Ruling drawing pen*
- *Masking fluid*

## The set-up
Set up your still life on a plain white piece of paper, so that you can concentrate on the subject, and position a table lamp to one side to cast interesting shadows. Experiment by placing the fruit in different positions and at different angles: you need to create a balanced composition so that you don't end up with too large an area of empty background.

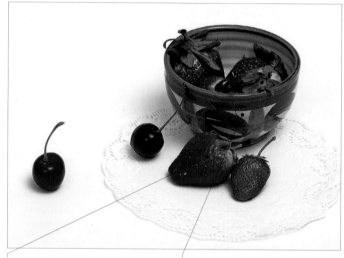

The strawberries shade gradually from deep red to a pale yellow.

The bowl is painted in strong colours that detract from the fruits.

**1** Using a 2B pencil, lightly sketch the fruit and the bowl and roughly indicate the cut-paper pattern on the doily.

2 Dip a ruling drawing pen in masking fluid and mask out the areas that will be left white in the final painting – the bright highlights on the fruit and the rim of the bowl and the pattern on the doily.

3 Finish off the masking. You must leave it to dry completely before you start to apply any paint, otherwise you run the risk of smudging it and destroying the crisp, clean lines that you want to keep.

4 The white background is very stark, so start by mixing yellow ochre with a little dioxazine violet to make a dull yellow as a background colour. Dampen the background and the patterned edge of the doily with clean water, taking care to brush around the cherry, and brush the mixture over this area, adding a little more violet to the mixture on the left-hand side. Brush a slightly darker violet under the edge of the doily to create a slight shadow. The background and shadow colours are virtually complementary colours, which work well together.

5 Mix a dull blue from cobalt blue and a little dioxazine violet. Using the tip of the brush, start to paint the blue of the pattern on the bowl. Continue to build up the pattern, using Hooker's green and a pale mixture of vermilion and a little dioxazine violet.

**Tip**: Make the colours on the bowl more subdued than they are in real life, so that they do not detract from the vibrant reds of the fruit.

▶

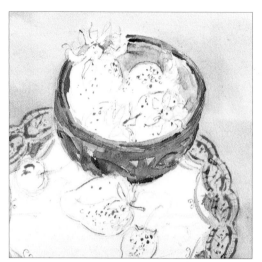

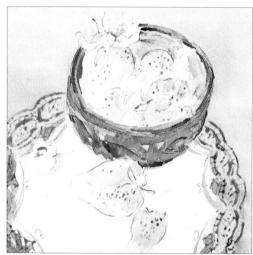

6 Mix a rich orange from cadmium orange and cadmium red and finish painting the pattern on the bowl. Mix a very pale blue from cobalt blue and cerulean blue and paint the inside of the bowl, taking care not to touch any of the fruit. Brush a little dioxazine violet into the most deeply shaded part of the inside of the bowl. Leave to dry.

7 You need to work quickly for the next two stages, which are painted wet into wet so that the colours merge on the paper. Mix a very pale yellow from cadmium yellow and a hint of Naples yellow. Wet the strawberries with clean water and carefully brush this yellow mixture on to the palest areas, taking care not to allow any paint to spill over on to the doily.

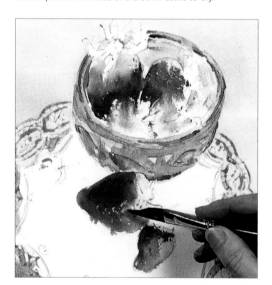

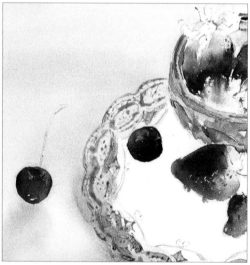

8 While this is still damp, mix cadmium red with a little cadmium orange and brush this mixture over the red parts of the strawberries. Mix vermilion with alizarin crimson and drop this mixture wet into wet on to the very darkest parts of the strawberries. (You may need several applications to build up the necessary density of tone.)

9 Paint the cherry on the background in vermilion. Apply another layer of vermilion while the first one is still wet, brushing a little cadmium yellow on to the right-hand side to give some variety of tone. Mix alizarin crimson with a hint of dioxazine violet and paint the cherry on the doily, which is a darker tone than the one on the background. Leave to dry.

**10** Brush clean water over the strawberry leaves. Paint the lightest leaf areas in cadmium yellow, the mid tones in leaf green, and the darkest tones in olive green, adding a little phthalocyanine blue to the olive green for the very shaded parts.

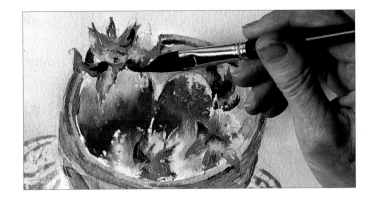

**Assessment time**

Paint the cherry stalks in olive green and darken the tone of the leaves overall, if necessary. The painting is very nearly complete, but you need to build up the shadows to make the still life look more realistic. Study your subject carefully to work out where the shadows fall and how dark they need to be in relation to the rest of the painting.

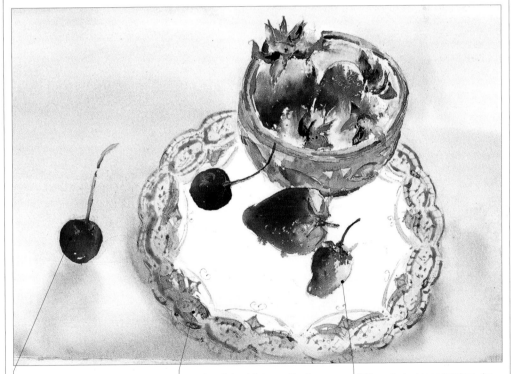

Subtle variations in tone across the surface of the fruit help to make them look lifelike.

Even though the doily is very thin, the lighting is so strong that it should cast a definite shadow.

With no shadows to anchor them, the cherries and strawberries look as if they are suspended in mid-air.

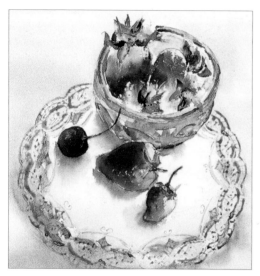

11 Brush clean water over the doily, carefully brushing around the fruit and bowl. Mix a very pale wash of cerulean blue and brush it over the doily; the paint will blur and spread softly, without leaving any harsh edges. While this wash is still damp, mix a very pale purple from dioxazine violet with a tiny amount of Hooker's green and paint the shadows under the fruit and bowl, wet into wet. Use the same paint mixture to brush in the shadow under the background cherry, this time wet on dry.

12 Although one is painted wet into wet and one wet on dry with harsher edges, the shadows under the two cherries look equally effective.

> **Tip:** Using a very pale wash of colour over the doily prevents it from looking too stark and bright, and helps to highlight the intricate patterning.

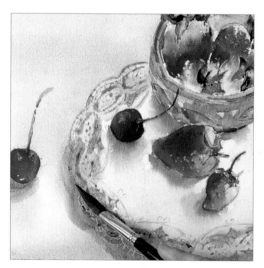

13 Deepen the shadow under the doily, using the same purple mixture of dioxazine violet and Hooker's green as used in Step 11. Leave to dry.

14 Using your fingertips, gently rub off the masking fluid, revealing the brilliant white of the doily and the highlights on the fruit and bowl.

## Strawberries and cherries in a bowl

This is a simple, yet carefully thought out, still life in which rich colours and textures abound. Note, in particular, the effective use of complementary colours. The artist has put together an attractive arrangement in which the shadows and the spaces between the objects play as important a role in the overall composition as the objects themselves.

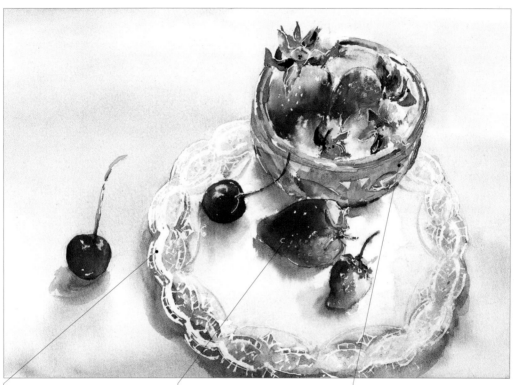

The intricate pattern and brilliant white of the doily are preserved through the careful application of masking fluid.

The reds are achieved by carefully building up a number of different tones – cadmium red, vermilion and alizarin crimson.

The colours of the bowl are deliberately subdued, so as not to detract from the richly coloured fruit.

# Still life with stainless steel

This kind of still life project is easy to set up at home. The trick is not to make the composition too complicated: a few colourful objects, strategically placed to exploit the way they are reflected in the metallic surfaces, will suffice.

Although this looks, at first glance, like a relatively simple still life, it requires very careful assessment of tone. Metal objects and other reflective surfaces take a lot of their colour from the objects that are reflected in them, so in this project you will need to look carefully at the reflections in order to assess what colours and tones you need to apply. However, the reflections tend to be a little more subdued in tone and less crisply defined than the objects being reflected. Bear this in mind while you are working and adjust your paint mixtures accordingly.

It is a common mistake to paint reflective surfaces too light, with the result that they lack substance. Remember to assess the tones of your painting at regular intervals and build up the tones gradually until the density is right.

Another aspect of tone that you need to consider here is how to make your subject look three-dimensional. To give form to a subject, you need to put darker tones on the shadowed side, but when you are dealing with curved or spherical shapes, like the stainless steel olive oil pourers in this project, the curves are so smooth that it can be hard to decide where the darker colours should begin. Work wet into wet for these areas, so that the colours merge naturally on the paper without any hard edges.

## The set-up

When you are setting up a still-life that contains shiny, reflective surfaces, make sure that the light source (which, indoors, is invariably some kind of lamp) does not reflect too prominently in the subject. The best way to do this is to place the light source to one side and at a reasonable distance from your subject.

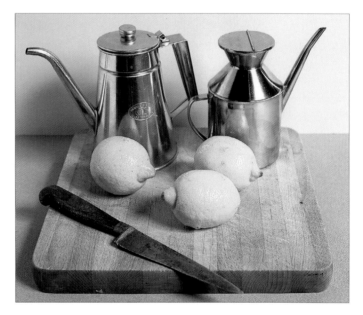

## Materials

- *2B pencil*
- *200lb (425gsm) NOT watercolour paper, pre-stretched*
- *Watercolour paints: cerulean blue, Payne's grey, cadmium lemon, ivory black, raw umber, burnt umber, lamp black, yellow ochre, burnt sienna, dioxazine purple, cadmium orange, alizarin crimson*
- *Brushes: fine round, medium round*
- *2B graphite stick*

1 Using a 2B pencil, lightly sketch the outline of your subject, making sure the shapes are accurate. You may find it easier to assess the shapes objectively if you turn your drawing upside down.

2 Mix pale washes of cerulean blue, Payne's grey, cadmium lemon and ivory black. Using a fine round brush, start to paint the lightest tones on the stainless-steel olive oil pourers, leaving any highlights as white paper. Judge which colour to use where by looking carefully at the reflections.

3 Paint the left-hand lemon and the reflected yellow highlights in the right-hand olive oil pourer in the same cadmium lemon wash used in Step 2. Leave some white highlights on both the lemon and the olive oil pourer. Note that the reflected yellows are duller in tone than those used to paint the actual lemon.

4 Paint the two right-hand lemons in the same pale cadmium lemon wash. Mix a mid-toned brown from raw umber with a touch of burnt umber and paint the handle of the knife. Paint the blade of the knife in a very dilute wash of lamp black, leaving a highlight near the handle. Leave to dry. Mix a pale brown from yellow ochre and a little burnt sienna and, using a medium round brush, paint the wooden chopping board.

**Assessment time**

The initial, lightest washes have now been laid down and the base colours of the whole still life established. You can now begin to elaborate on this, building up tones to the correct density and putting in the details. Work slowly, building up the tones gradually to avoid the risk of laying down a tone that is too dark.

The very brightest highlights have been left as white paper.

The reflections are muted in colour and worked wet into wet so that the colours blur a little.

5 Mix slightly darker versions of the greys and blues used in Step 2, adding a touch of dioxazine purple to the cerulean blue, and start to paint in the mid tones on the olive oil pourers, gradually defining the individual facets more clearly. Leave to dry.

6 Mix a mid-toned grey from Payne's grey and ivory black and darken the blade of the knife, leaving an area of lighter tone near the handle. Make sure you don't go outside the pencil lines: the outline of the knife must be crisply defined. Leave to dry.

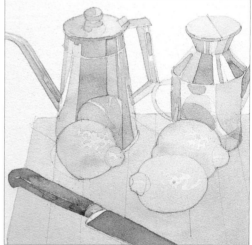

7 Add cadmium lemon to the mixture used to paint the chopping board in Step 4 and paint the reflections of the lemon in the pots. Begin to intensify the colour on the lemons themselves with a wash of cadmium lemon, working around the highlights. As you work down the lemons, gradually add cadmium lemon and then a hint of cerulean blue to the mixture, so that the colour is darker on the shadowed underside and the rounded shape of the fruit is clearer.

8 Touch a little more greenish yellow into the reflections of the lemons. Paint the handle of the knife again with the same mixture of raw umber and burnt umber used in Step 4, leaving a slight gap in the middle, where light hits the edge, to indicate the change of plane between the side and top of the handle. Leave to dry. All the mid tones of the painting have now been established.

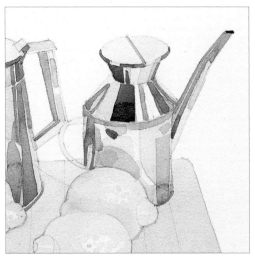

9 Mix slightly darker versions of the greys and blues used in Step 5 and continue reinforcing the tones on the olive oil pourers. As you darken these tones, the reflections (which are considerably lighter in colour) will begin to stand out even more clearly.

10 Strengthen the tones of the right-hand olive oil pourer in the same way, paying careful attention to the different facets of the two pourers. Add a touch of cadmium orange to paint the reflection of the chopping board.

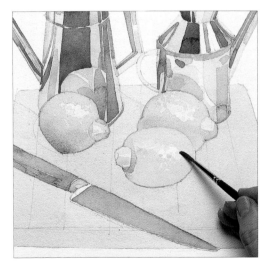

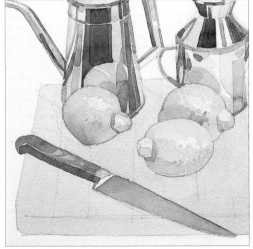

11 Using the same yellow mixtures as used in Step 7, build up the density of tone on the lemons. Again, remember to work carefully around the highlights that you left white in Step 3. Leave to dry.

12 Mix a dark brown from burnt umber and burnt sienna and, using a fine round brush, carefully paint the shaded side of the knife handle under the highlight line, making sure you retain the crisp, sharp lines. The knife immediately looks much more three-dimensional. Leave to dry. Using the same fine round brush, stipple a little of the greenish yellow mixture on to the dark undersides of the lemons to create the pitted surface texture of the fruit.

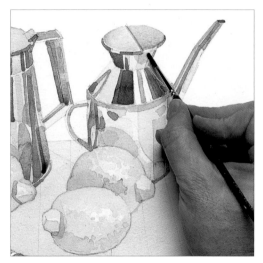

**13** In these final stages of the painting, put in the very darkest tones. Work across the painting as a whole, assessing the tones in relation to each other rather than concentrating on one specific area.

**14** Brush a little more of the greenish yellow mixture on to the underside of the foreground lemon. Leave to dry. Using the dark brown mixture of burnt umber and burnt sienna, and a medium round brush, paint the top of the chopping board. Leave to dry.

**15** Darken the burnt umber and burnt sienna mixture by adding a little more burnt sienna and a hint of alizarin crimson. Paint the front of the chopping board, which is in shadow, leaving a tiny highlight along the edge between the top and front of the board. Leave to dry. Paint alternate panels on the top of the board in a mixture of burnt umber and burnt sienna. Leave to dry.

**16** Add a little dioxazine purple to the dark brown mixture that you used to paint the front of the chopping board and paint the shadows behind the olive oil pourers and under the lemons and the knife. Leave to dry. Using a 2B graphite stick, draw vertical lines on the chopping board to indicate the grain of the wood.

**Still life with stainless steel**

This is a contemporary-looking still life with bold shapes and shadows. All the elements are contained within a triangle formed between the tip of the knife and the spouts of the olive oil pourers. Placing the knife on the diagonal also makes the composition more dynamic. Several layers of colour are applied to build up the tones to the right density.

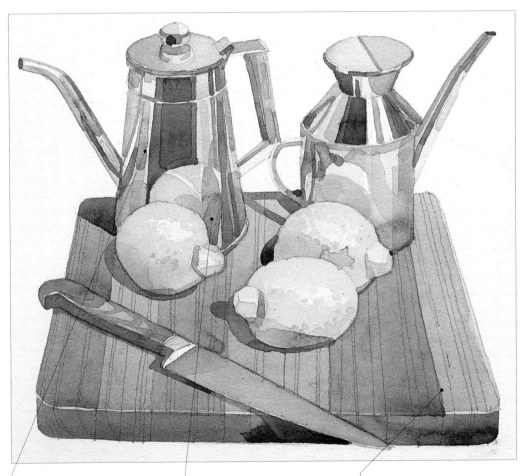

Variations in tone convey the shape of the olive oil pourers.

The reflections are slightly blurred and more subdued in tone that the objects being reflected.

Simple pencil lines effectively convey the grain of the wooden board without detracting from the main subjects.

# Eye of the tiger

People sometimes say that the eyes are the windows of the soul and, regardless of whether you are painting humans or animals, they certainly tell you a lot about the character and mood of your subject. All too often, eyes are drawn and painted as circles or ovals, which looks very unnatural. The eyeball is spherical even though, of course, only a small part of it is visible. This spherical shape is particularly obvious if you look at an eye from the side, but regardless of your viewpoint it helps to think of the eye as a three-dimensional form.

Subtle blends of colour are essential when it comes to painting the iris of the eye, while the "white" of the eye is often shadowed and not white at all. Finally, you must capture that all-important sparkle, which makes your subject look alive. Look at the position and shape of bright highlights in the eyes.

The artist chose a tiger's eye for this demonstration, because he also wanted to explore the markings on the surrounding fur, but the same principles apply to all subjects. An original painting of a tiger was used as reference material.

### Materials
- HB pencil
- Hot-pressed watercolour board or paper
- Watercolour paints: cadmium yellow, cadmium red, burnt sienna, Payne's grey, viridian, French ultramarine, Vandyke brown, ivory black
- Gouache paints: permanent white
- Brushes: fine round, ultra-fine round

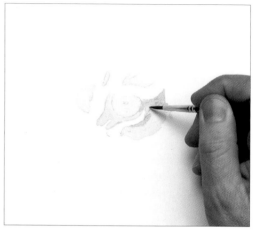

1 Using an HB pencil, lightly sketch the tiger's eye on smooth watercolour board or paper. Mix cadmium yellow with cadmium red for the gold of the eye and apply it carefully, using a fine round brush. Leave to dry. Mix burnt sienna with a little cadmium yellow and brush it over the tiger's fur, leaving the highlight area under the eye untouched. Paint the black facial markings around the eye in a dark mixture of Payne's grey. Leave to dry.

2 Mix a cool green from viridian and a little French ultramarine and, using a fine round brush, brush it over the top half of the iris, covering the pupil. Leave to dry. The basic colours and shapes have now been established. The next stage is to make the eye look three-dimensional by showing how the lids curve over the eyeball.

3 Using an ultra-fine round brush, paint the upper part of the iris in Payne's grey, gently feathering the colour down on to the green. This softens the transition in colour from one part of the eye to the next and looks much more natural than hard-edged, concentric circles of colour. Darken the upper rim of the eye with Payne's grey. Leave to dry.

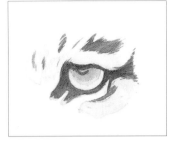

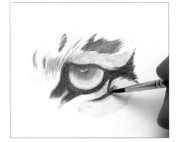

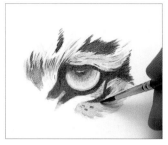

4 Darken the markings around the eye with a mixture of Vandyke brown and Payne's grey. Paint the pupil in the same colour.

5 While the pupil is still damp, feather the colour down on to the iris, so that there is a very subtle transition of colour. Mix French ultramarine with a touch of permanent white gouache and, using a fine round brush, brush in the shaded areas of the fur, making sure your brushstrokes follow the direction of the fur growth. Build up the dark markings around the eye with ivory black. Leave to dry.

6 Continue to build up the dark markings around the eye with ivory black. Darken the brown fur colour with burnt sienna and Vandyke brown, alternating between the two. Add tiny strokes of permanent white gouache on the eyeball and the lower eyelid to create highlights.

## Eye of the tiger

The dramatic colouring and fine detail make this a very attractive study. Subtle feathering of colour and the careful positioning of the highlights on both the eyeball and the lower lid combine to depict a rounded and very life-like eye. Tiny details like this can have as much impact as a full-scale painting and are a good way of practising difficult subjects.

Tiny touches of permanent white gouache on the pupil reflect the light, while subtle feathering softens the transition from one colour to the next.

Although the fur is white, it is in shade here and is painted in pale French ultramarine.

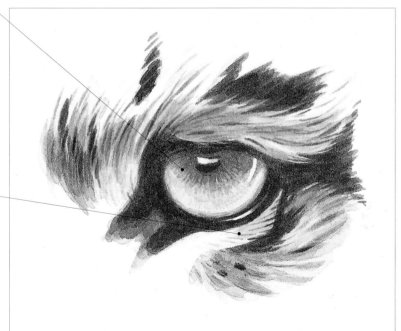

# Tabby cat

Cat fur is fascinating to paint and you will find a huge variety of markings, from tortoiseshell and tabby cats with their bold stripes to sleek, chocolate-point Siamese and long-haired Maine Coons. One of the keys to painting fur is being able to blend colours in a very subtle way, without harsh edges. Even pure white or black cats, with no obvious markings, have their own "patterns": because of reflected light and shadows, the fur of a pure white cat will exhibit clear differences in tone which you need to convey in your paintings.

Fur markings also reveal a lot about the shape of the animal. You need to look at an animal's fur in much the same way as a portrait painter looks at how fabrics drape over the body of a model: changes in tone and in the direction of the fur markings indicate the shape and contours of the body underneath. Always think about the basic anatomy of your subject, otherwise the painting will not look convincing. If you concentrate on the outline shape when you are painting a long-haired cat, for example, you could end up with something that looks like a ball of fluff with eyes, rather than a living animal. The cat in this project has relatively short hair, which makes it easier to see the underlying shape.

Cats seem to spend a lot of their time sleeping or simply sprawled out, soaking up the sunlight and, if you are lucky, you might have time to make a quick watercolour sketch. For "action" pictures – kittens batting their paws at a favourite toy or adult cats jumping from a wall or stalking a bird in the garden – you will almost certainly have to work from a photographic reference. You will be amazed at the number of ways cats can contort their bodies.

## Materials
- *HB pencil*
- *140lb (300gsm) rough watercolour paper, pre-stretched*
- *Watercolour paints: yellow ochre, raw umber, alizarin crimson, ultramarine blue, cadmium red, Prussian blue, burnt sienna*
- *Gouache paints: Chinese white*
- *Brushes: medium round, fine round*

## Reference photograph

This is a typical cat pose – the animal is relaxed and sprawled out, but at the same time very alert to whatever is happening around it. The markings on the fur are subtly coloured but attractive. The face is full of character, and this is what you need to concentrate on in your painting. If you can get the facial features to look right, you are well on the way to creating a successful portrait.

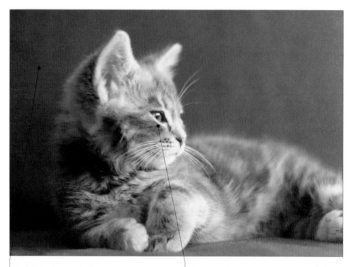

A plain background allows you to concentrate on the subject.

The eyes, the most important part of the portrait, are wide open and alert.

**1** Using an HB pencil sketch the cat, making sure you get the angle of the head right in relation to the rest of the body. Start with the facial features, sketching the triangle formed by the eyes and nose, then work outwards. This makes it easier to position the features in relation to each other. If you draw the outline of the head first, and then try to fit in the facial features, the chances are that you will make the head too small.

2 Mix a pale wash of a warm brown from yellow ochre and raw umber. Using a medium round brush, wash the mixture over the cat leaving the palest areas, such as the insides of the ears and the very light markings, untouched.

3 Add a little more raw umber to the mixture to make a darker brown and paint the darker areas on the back of the head and back.

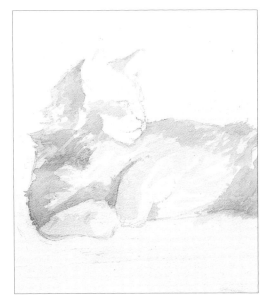

4 Continue applying the darker brown mixture, which gives the second tone. You are now beginning to establish a sense of form in the portrait.

5 Add a little alizarin crimson and ultramarine blue to the mixture to make a dark, neutral grey. Begin brushing in some of the darker areas around the head.

▶

6 Add more water to the mixture and paint the cat's back, which is less shaded. Start painting some of the markings on the hind quarters, using short, spiky brushstrokes along the top of the cat's back. This indicates that the fur does not lie completely flat.

7 Mix a warm brown from yellow ochre and raw umber and brush it loosely over the mid-toned areas. Mix a warm pink from alizarin crimson and a little yellow ochre and, using a fine round brush, paint the insides of the ears, the pads of the paws, and the tip of the nose.

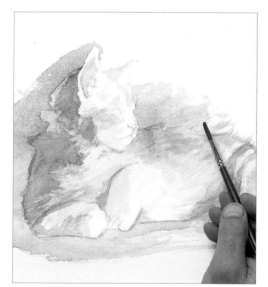

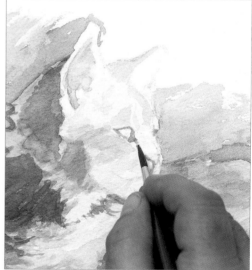

8 Mix a warm maroon colour from cadmium red, yellow ochre and alizarin crimson and paint the surface on which the cat is lying. Add ultramarine blue to darken the mixture and paint the background, carefully brushing around the cat.

9 Mix a purplish blue from ultramarine blue and cadmium red. Using a fine round brush, paint the dark fur on the side of the cat's head, the nostril, the area under the chin and the outline of the eye.

### Assessment time

Although the broad outline of the cat is there, along with some indication of the markings on the fur, the painting does not yet look convincing because the body looks flat rather than rounded. In addition, the cat's head is merging into the warm colour of the background, when it needs to stand out much more clearly.

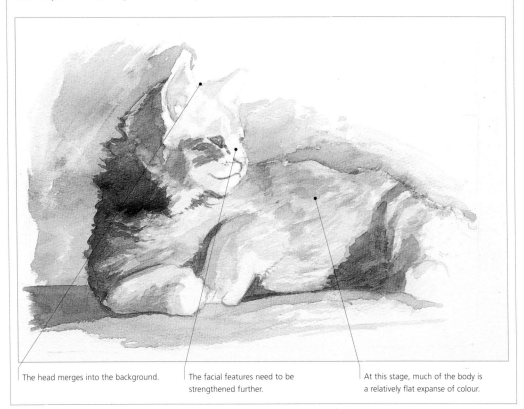

The head merges into the background.

The facial features need to be strengthened further.

At this stage, much of the body is a relatively flat expanse of colour.

10 Mix a greenish black from Prussian blue, burnt sienna and cadmium red and paint the pupil of the eye, leaving a white highlight. Brush more of the purplish-blue mixture used in Step 9 on to the shaded left-hand side of the cat and strengthen the shadow under the chin and on the back of the cat's head.

**Tip**: Pay careful attention to the highlight in the cat's eye. The shape and size of the white area must be accurate in order to look lifelike.

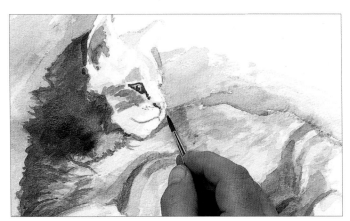

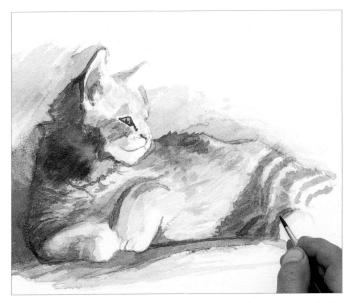

11 Using the same purplish-blue mixture, put in some of the stripes on the hind quarters and darken the tones on the back, paying careful attention to the direction of the brushstrokes so that the markings follow the contours of the body.

12 Using the same mixture, continue darkening the tones on the back to give a better sense of form.

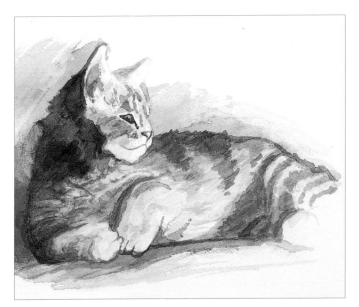

13 Adjust the tones where necessary. Now that you have put in lots of darks, you may need to tone down some of the bright areas that have been left unpainted by applying a very dilute wash of the first pale brown tone.

14 Darken the insides of the ears with alizarin crimson. Using a very fine brush and Chinese white gouache, paint the whiskers.

**Tabby cat**

This is a lively and engaging study of a favourite family pet. All portraits, whether they are of humans or animals, need to convey the character of the subject. The artist has achieved this here by placing the main focus of interest on the cat's face and its alert expression. The fur is softly painted, with careful blends of colour, but the markings are clearly depicted.

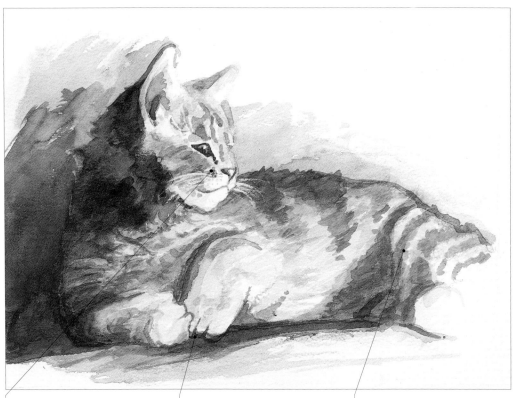

The facial features are crisply painted.

Deep shadow between the paws helps to create a sense of depth in the painting.

The markings change direction, following the contours of the body beneath.

# Otter

This delightful study of an otter, peering inquisitively out to sea, is an exercise in building up textures. You can put in as much or as little detail as you wish, but don't try to finish one small area completely before you move on to the next. Go over the whole painting once, putting in the first detailed brushmarks, and then repeat the process as necessary.

Remember to work on a smooth, hot-pressed watercolour paper or board when using masking film (frisket paper). If you use masking film on a rough-surfaced paper there is a risk that the film will not adhere to the surface properly, allowing paint to slip underneath and on to the area that you want to protect. Smooth paper also enables you to make the fine, crisp lines that are essential in a detailed study such as this.

## Materials
- *HB pencil*
- *Hot-pressed watercolour board or smooth paper*
- *Watercolour paints: ultramarine blue, cadmium yellow, burnt sienna, Vandyke brown, Payne's grey, cadmium red*
- *Gouache paints: permanent white*
- *Brushes: medium flat, medium round, fine round, very fine round*
- *Masking film (frisket paper)*
- *Scalpel or craft (utility) knife*
- *Tracing paper*

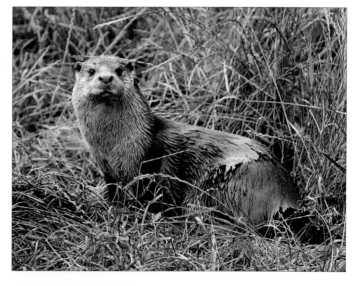

**Reference photographs**
Here the artist worked from two reference photographs – one for the otter's pose and fur detail, and one for the seaweed-covered rocks in the foreground. When you do this, you need to think carefully about the direction of the light. If you follow your references slavishly, you may find that sunlight appears to hit different areas of the picture at different angles, which will look very unnatural.

**Preliminary sketches**
Quick pencil sketches will help you to select the best composition, while a watercolour sketch is a good way of working out which colours to use.

1 Using an HB pencil, copy your reference sketch on to watercolour board or smooth paper. Place masking film over the picture area. Using a sharp scalpel or craft (utility) knife, cut around the otter and rocks. To avoid damaging your painting surface, trace your pencil sketch, then place the masking film over the tracing paper, cut it out, and reposition the film on the painting surface.

2 Carefully peel back the masking film from the top half of the painting. You may need use a scalpel or craft knife to lift up the edge. You can now work freely on the sky and background area, without worrying about paint accidentally spilling over on to the otter or foreground rocks – though it is worth rubbing over the stuck-down film with a soft cloth or piece of tissue paper to make sure it adheres firmly to the surface and that no paint can seep underneath.

3 Mix a pale blue wash from ultramarine blue with a hint of cadmium yellow. Using a medium flat brush, dampen the board above the masking film with clean water and then brush in vertical strokes of the pale blue mixture. While the first wash is still damp, brush more vertical blue strokes along the top of the paint and allow the paint to drift down, forming a kind of gradated wash. Leave to dry.

4 Carefully peel back the masking film from the bottom half of the painting, revealing the otter and rocks. Using a medium round brush, dampen the rocks with clean water and dot on the pale blue mixture used in Step 3.

▶

5 While the paint is still damp, use a fine round brush to dot in a darker mix of ultramarine blue and start building up tone on the rocks. Because you are working wet into wet, the colours will start to blur. Stipple a very pale cadmium yellow onto the rocks in places and leave to dry.

6 Mix a pale wash of burnt sienna and brush it over the otter's head and body. Brush over the chest area with the pale blue wash used in step 3. Leave to dry. Mix a darker brown wash from Vandyke brown and Payne's grey, and brush from shoulder to abdomen. Add a line around the back legs.

**Assessment time**
The base colours have now been established across the whole scene. Using the same colour (here, ultramarine blue) on both the background and the main subject creates a colour harmony that provides a visual link between the background and the foreground. You can now start to put in detail and build up the fur. In the later stages of this painting, you will want lots of crisp detail, so it's important to let each stage dry completely before you move on to the next – otherwise the paint will blur and spread.

The chest, which is in shadow, is painted in a cool, pale mixture of ultramarine blue.

This darker brown helps to show the direction in which the fur is growing.

This dark line around the otter's back legs starts to establish the rounded form of the body.

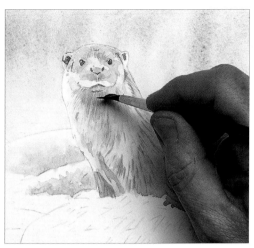

7 Mix a very dark brown from Vandyke brown and Payne's grey and, using a very fine round brush, put in the dark detail on the head – the inside of the ears, the eyes and the nose. Using the same colour, start to put in short brush marks that indicate the different directions in which the fur grows.

8 Mix a warm grey from Payne's grey and a little Vandyke brown. Using a fine round brush with the bristles splayed out in a fan shape, drybrush this mixture on to the otter's chest, taking care to follow the direction of the fur.

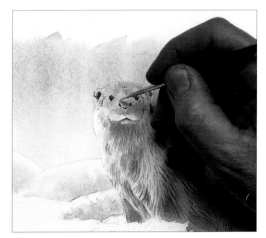

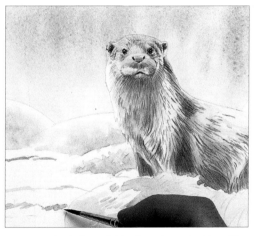

9 Continue building up tones and textures on the otter's chest and body. Paint the lightest areas on the otter's face with permanent white gouache. Mix a light, warm brown from burnt sienna and Vandyke brown and build up tones and textures on the otter's body. Darken the facial features.

10 Mix a bright but pale blue from ultramarine blue with a hint of cadmium yellow and, using a fine round brush, brush thin horizontal lines on to the rocks on the left-hand side of the painting. This blue shadow colour helps to establish some of the crevices and the uneven surface of the rocks.

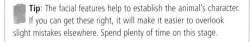

**Tip**: The facial features help to establish the animal's character. If you can get these right, it will make it easier to overlook slight mistakes elsewhere. Spend plenty of time on this stage.

▶

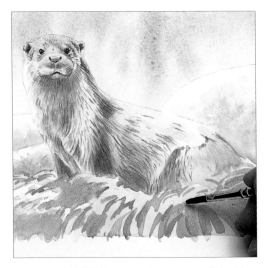

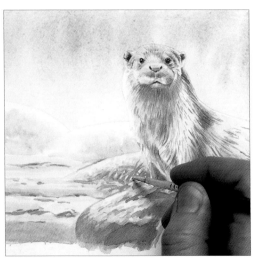

**11** Mix a dark, bluish grey from Payne's grey and Vandyke brown and, using a medium round brush, paint the strands of seaweed on the rocks on the right of painting with loose, broad brushstrokes of this mixture. Leave to dry.

**12** Brush a little ultramarine blue into the bottom left corner. Mix a warm brown from cadmium yellow and cadmium red and brush this mixture on to the rocks. Leave to dry. Paint lines of sea foam in permanent white gouache.

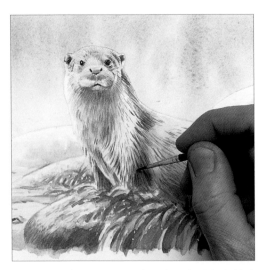

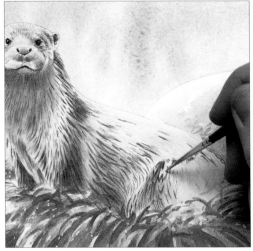

**13** Now add more texture to the rock on the right, behind the otter, by stippling on a dark mixture of ultramarine blue. Note that the top of the rock, which is hit by the sunlight, is very light while the base is much darker. Using the drybrush technique, continue to add tone and form to the body of the otter, using a warm mixture of burnt sienna and ultramarine blue. Build up tone and texture on the otter's chest in the same way, using a mid-toned mixture of ultramarine blue.

**14** Using a fine round brush and very short brushstrokes, paint white gouache to form the highlights along the top of the otter's back and on the body, where water is glistening on the fur. Use white gouache to paint the otter's whiskers on either side of the muzzle.

**Otter**

This is a fresh and lively painting that captures the animal's pose and character beautifully. The background colours of blues and greys are echoed in the shadow areas on the otter's fur, creating a colour harmony that gives the picture unity.

By including a lot of crisp detail on the otter itself and allowing the background colours of the sky and rocks to blur and merge on the paper, the artist has made the main subject stand out in sharp relief.

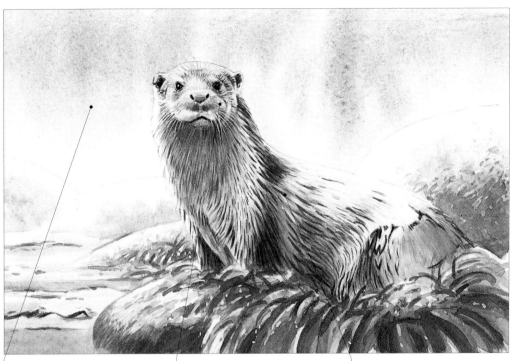

The background is painted in translucent, wet-into-wet washes that blur into indistinct shapes.

White gouache is used for very fine details such as the whiskers, which it would be very difficult to achieve simply by leaving the paper white.

The crisp fur detail on the otter is made up of several layers of tiny brushstrokes, worked wet on dry – a painstaking technique but one that is well worth the effort.

# Flamingo

This project offers you the opportunity to practise building up layers of colour and to use your brush in a very controlled way. You need to assess the tones quite carefully when you are painting a subject that is mostly just one colour. You may find that it helps to half close your eyes, as this makes it easier to work out where the lightest and darkest areas are.

It is often a good idea to keep the background soft and blurred by using wet-into-wet washes when you are painting a textured subject like this, as the details stand out more clearly and the subject is separated from its surroundings.

## Reference photograph

This shot was taken in a nature reserve as reference for the feather colours. Wildlife parks and nature reserves are good places to take photos of animals and birds that you might not be able to get close to in the wild.

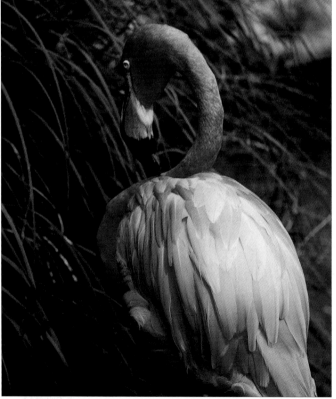

**Materials**
- HB pencil
- Hot-pressed watercolour board or smooth paper
- Watercolour paints: viridian, Payne's grey, cadmium red, ultramarine blue, ivory black, cadmium yellow
- Gouache paints: permanent white
- Brushes: large round, medium round, fine round, small flat, very fine
- Masking film (frisket paper)
- Scalpel or craft (utility) knife

**Preliminary sketches**

Try out several compositions to decide which one works best before you make your initial underdrawing.

1 Using an HB pencil, trace your reference sketch on to hot-pressed watercolour board or smooth paper. Place masking film (frisket paper) over the whole picture area. Using a sharp scalpel or craft (utility) knife, carefully cut around the outline of the flamingo and the oval shape formed by the curve of the bird's neck. Peel back the masking film from the background, leaving the flamingo covered.

2 Take a piece of tissue paper and gently rub it over the film to make sure it is stuck down firmly and smoothly. It is essential that the background wash can't slip under the mask and on to the flamingo's body.

3 Mix a pale, watery wash of viridian. Using a large round brush, brush it over the background in long diagonal strokes, stopping about halfway down the paper.

4 Mix a pale wash of Payne's grey. While the first wash is still damp, working from the bottom of the painting upwards, brush the Payne's grey over the background, stopping at the point where it overlaps the viridian a little.

▶

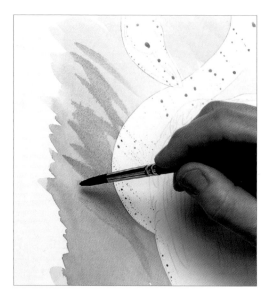

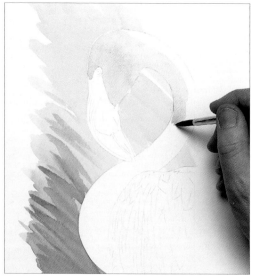

5 Using a medium round brush and holding the brush almost vertically, brush long strokes of Payne's grey over the damp wash to imply the foreground grasses. The paint will blur slightly, creating the effect of an out-of-focus background. Leave to dry.

6 Remove the masking film from the flamingo. Mix a pale, watery wash of cadmium red. Using a medium round brush with a fine point, carefully brush the mixture over the flamingo's head and neck, leaving the bill and a small highlight area on the top of the head unpainted. Make sure none of the paint spills over on to the background.

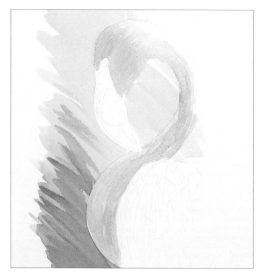

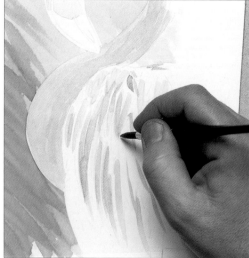

7 Strengthen the colour on the bird's head and neck by applying a second layer of cadmium red. Paint the pale pink wash on to the central part of the face.

8 Using the first wash of pale cadmium red, move on to the body, making broad strokes that follow the direction of the wing feathers. Leave the highlight areas unpainted. Add a wash of Payne's grey to the bill. Leave to dry.

## Assessment time

The overall base colours of the painting have been established and we are beginning to see a contrast between the blurred, wet-into-wet background and the sharper, wet-on-dry brushstrokes used on the bird, which will be reinforced as the painting progresses. Much of the rest of the painting will be devoted to building up tones and feather texture on the flamingo.

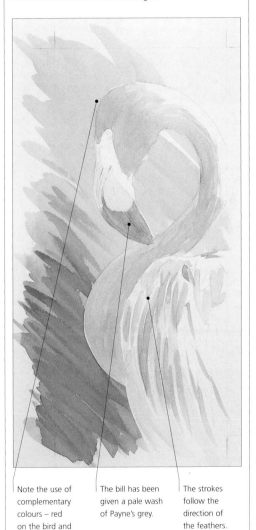

Note the use of complementary colours – red on the bird and green on the background.

The bill has been given a pale wash of Payne's grey.

The strokes follow the direction of the feathers.

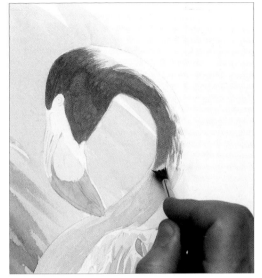

9 Mix a stronger wash of cadmium red and, using a very small, almost dry, round brush, start building up the colour on the head, making tiny, evenly spaced brushstrokes to create the feeling of individual feathers. Using a small flat brush with the bristles splayed out, start working down the neck, again making tiny brushstrokes.

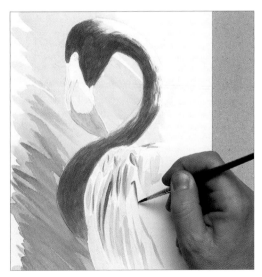

10 Continue painting the flamingo's neck, making sure that your strokes follow the direction in which the feathers grow. Using a fine round brush, paint over the main wing feathers again. Leave to dry.

▶

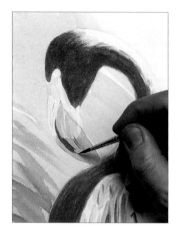

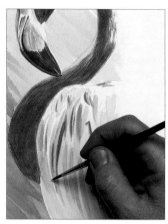

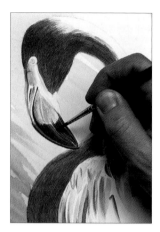

**11** Mix a very pale pink from pale cadmium red with a little permanent white gouache and, using a fine round brush, carefully paint the area around the eye. Mix a mid-toned wash of Payne's grey and, using a fine round brush, paint the detailing on the bird's bill. Leave to dry.

**12** Continue building up detail on the bill. Add a little ultramarine blue to the Payne's grey mixture and paint the shadow cast by the beak and the shadowed area on the outer edge of the bird's body. Leave to dry.

**13** Mix a wash of ivory black and paint the bill, leaving spaces between your brushstrokes in order to give some texture and show how light reflects off the shiny bill. Add a dot of pale cadmium yellow for the eye.

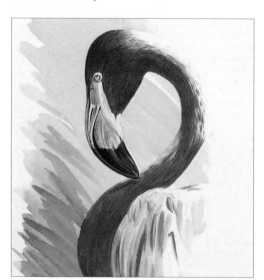

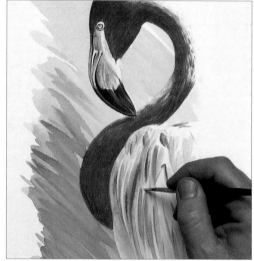

**14** Mix cadmium red with a little cadmium yellow and, using a very fine round brush, dot this mixture on to the bird's neck, just beyond the point where the initial cadmium red washes end, so that there isn't such a sharp transition from red to white. Use a fine round brush to add detail in ivory black to the eye.

**15** The body looks very pale compared to the head and neck so, using a fine round brush and cadmium red, continue to build up tone on the body with tiny brushstrokes that follow the direction of the feathers. Touch permanent white gouache into the white spaces on the bird's body, leaving white paper on the right-hand side so that the image appears to fade out on the lightest side.

## Flamingo

This is a beautiful example of the effectiveness of building up layers of the same colour to achieve the desired density of tone. The lovely soft texture is achieved through countless tiny brushstrokes that follow the direction of the feathers.

The composition is very effective, too. The tall, thin shape of the painting echoes the shape of the flamingo, and the viewer's eye is led in a sweeping curve from the bottom right-hand corner to the focal point – the bird's head.

Softly feathered brushstrokes soften the transition from red to white.

Paying careful attention to where the highlights fall has helped to make the bill look three-dimensional.

Note how gouache gives you much more control over the exact placement and size of highlights than simply leaving the paper unpainted, as you can paint over underlying colour with a very fine brush.

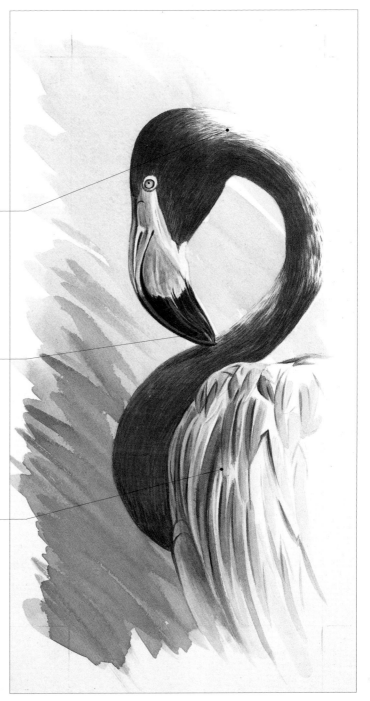

# Painting Buildings

We spend our lives living and working inside buildings, but often pay them scant regard for, as long as they serve the purpose for which they were constructed, our attentions are focused elsewhere.

Buildings not only reflect function and purpose, but also the people for whom they were built. Styles can vary greatly, depending on location and the prevailing weather conditions and climate. Often, buildings can be immediately identified as belonging to a certain place – think of the palazzos of Venice or the art deco skyscrapers of New York or Chicago. They also reflect the age in which they were built and may also often give clues to the surrounding landscape and geology, as many buildings are constructed using materials that are obtained locally.

Building materials vary enormously in colour and texture. Honey-coloured dressed stone, red brick, grey concrete, flint, weathered and painted wood, steel and glass, terracotta tiles, blue-grey slate, mud and straw: the wide range makes demands on any artist and will require the use of several different techniques to successfully represent them.

Inevitably, when you are drawing and painting buildings, you will need to use both aerial and linear perspective. The idea of having to use perspective alarms some people, but once you have mastered the basic principles, the rest is relatively straightforward. Simplicity is the key, and even highly complex buildings consist, when all the intricate architectural and decorative detail has been stripped away, of a few simple geometric shapes. Try to analyse your subject in these terms before you set pencil to paper.

Draw your building in the same way and sequence in which it was constructed. First, the basic structure, then the doors and windows. Only in the very final stages should you attempt to add any decorative embellishment.

Although you do not need to become an architectural authority, it does help if you have some knowledge, no matter how rudimentary, of how buildings are constructed. It is all too easy to draw or paint a building that does not appear solid and looks as if it will fall over at any minute. This is a common mistake, particularly for novice painters.

**Broadway, New York** ▼
This complex painting used both aerial and linear perspective. Linear perspective creates a sense of depth, leading the eye along the avenue and into the distance. Aerial perspective enhances the effect of distance, as the colour and the detail become less pronounced the further away they are.

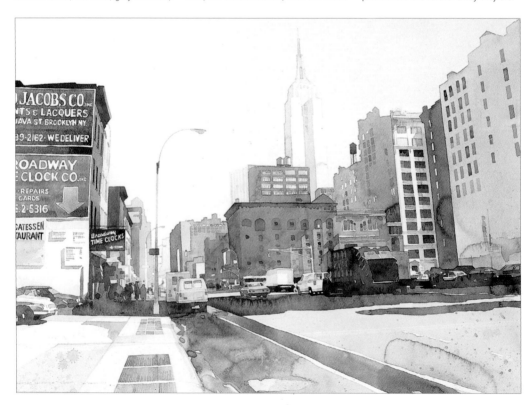

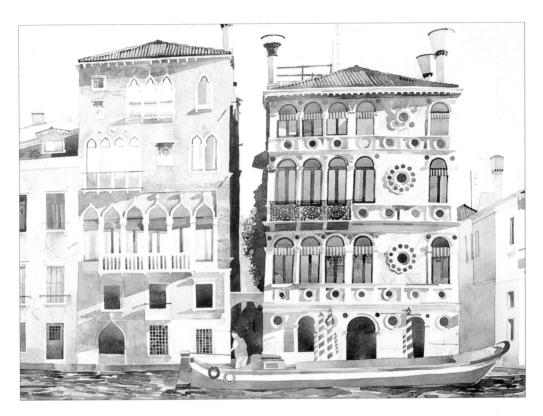

**Grand Canal, Venice** ▲
This painting of canalside buildings in Venice was made using wet-on-dry washes after a careful and detailed preliminary drawing.

> **Tips**: • Unless you are particularly confident, begin by making a light underdrawing to work out any problems regarding perspective and proportion.
> • Use both linear and aerial perspective. Both will help to create an illusion of depth, and the correct use of linear perspective will ensure that your building does not look as if it is about to fall over.
> • Pay attention to shadows: they contribute to the composition and will help to establish a sense of depth.
> • Use a range of watercolour techniques to capture the texture and character of the building and the materials used in its construction.

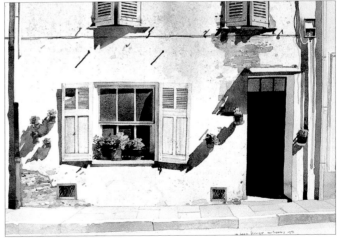

**Le Garde Freinet** ▲
This painting of a house in a small French village uses wet-on-dry and wet-into-wet techniques, along with careful spattering and drybrush work, to show the crumbling plaster and weathered paint on the pale blue shutters.

# Hillside town in line and wash

Line and wash is the perfect technique for this brightly coloured lakeside town, where you need fine detailing in the buildings and soft wet-into-wet washes in the surrounding landscape.

This project uses both waterproof and soluble inks, as they bring very different qualities to the image. Waterproof ink must be used in areas where you want the pen lines to remain permanent, such as the skyline and the wrought-iron balconies. Soluble ink, on the other hand, blurs and runs in unpredictable and exciting ways when you brush water or watercolour paint over it. Before you embark on any pen work, therefore, you need to think carefully about what kind of ink to use where.

In this scene, the tree-covered background is darker than the foreground. (Often in landscape paintings, you find that things in the background appear paler because of the effect of aerial perspective.) This helps to hold the image together, as it provides a natural frame around the focal point – the colourful buildings and their reflections.

## Materials
- HB pencil
- 120lb (220gsm) good-quality drawing paper
- Art pen loaded with waterproof sepia ink
- Art pen loaded with water-soluble sepia ink
- Watercolour paints: ultramarine blue, cobalt blue, sap green, yellow ochre, phthalocyanine green, cadmium orange, cadmium red, burnt sienna, cadmium yellow, alizarin crimson, deep violet
- Brushes: medium round

> **Tip**: If you are working from a reference photograph in which the light is very flat and bland, imagine how the light would fall on the scene on a bright sunny day. Where and how long would the shadows be? Make sure you keep your imaginary lighting consistent over the whole scene.

## The original scene
This photograph was taken on a very overcast day, simply as a reference shot for the architectural details. As a consequence of the weather, the colours are dull and the light is flat and uninteresting. In situations like this, feel free to improve on what you saw at the time by making the colours brighter in your painting.

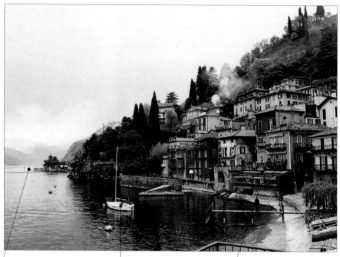

The composition pulls your eye to the edge of the picture, out into the centre of the lake.

The boat is a very stark white and detracts from the bright colours of the buildings.

The light is very flat: more contrast is needed to make the buildings look three-dimensional.

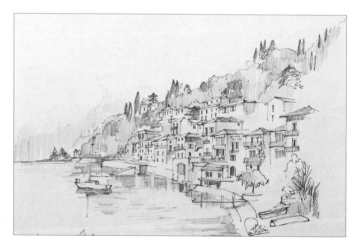

**Preliminary sketch**
Here the artist decided to crop in to make the composition tighter than it was in the original photograph. He also moved the boat further into the picture.

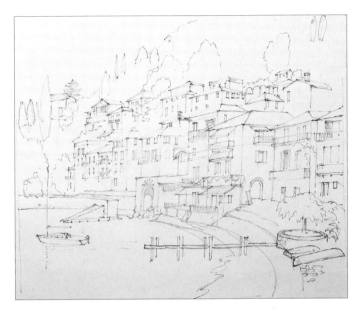

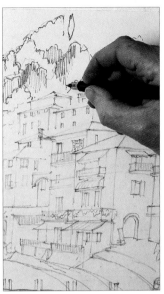

**1** Using an HB pencil lightly sketch your subject, taking plenty of time to measure the relative heights and angles of the buildings carefully and making sure that you keep all the many vertical lines truly vertical. You can work much more loosely for the background hillside and trees, which will form a much softer, impressionistic backdrop to the scene.

**2** Using waterproof sepia ink, put in the skyline. Using water-soluble sepia ink, put in the roofs and background trees, loosely hatching the trees to indicate the tones.

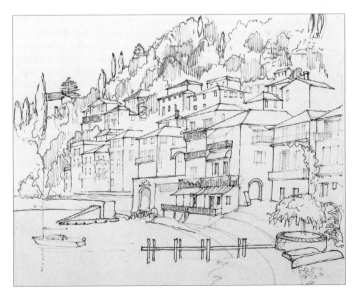

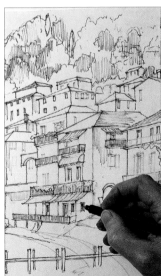

**3** Continue with the line work, hatching the darkest areas of the trees in water-soluble ink, which you want to blend with paint in the later stages, and drawing the railings on the balconies in waterproof ink, so that the lines are permanent.

**4** Using waterproof sepia ink, block in the windows on the shaded sides of the buildings.

▶

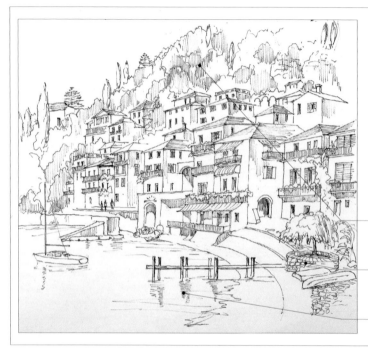

### Assessment time

The pen work is now complete and will underpin the whole of the painting. If you have planned it properly, the lines drawn in waterproof sepia ink will be permanent, while those drawn in water-soluble ink will blur and run when washed over with watercolour paint. You cannot predict exactly how the lines will run, but this unpredictability is part of the fun and will impart great liveliness and spontaneity to the finished work.

Hatching in water-soluble ink indicates the areas of light and dark on the trees.

Waterproof ink is used for all the lines that need to be retained in the final painting.

Loose scribbles indicate the ripples in the water.

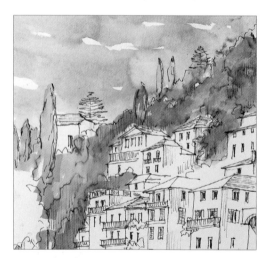

5 Mix a bright blue from ultramarine blue and cobalt blue watercolour paints. Using a medium round brush, wash this mixture over the sky, leaving some gaps for clouds. Mix a pale wash of sap green and brush it over the trees. Note how the soluble sepia ink blurs, giving the impression of the tree branches. Add a little yellow ochre to the mixture for the trees on the right-hand edge of the painting. Leave to dry.

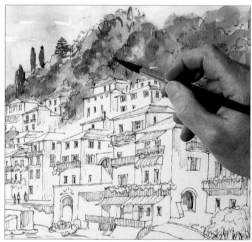

6 Mix a dark green from ultramarine blue and phthalocyanine green and paint the tall cypress trees that stand along the skyline. The vertical lines of the trees break up the horizon and add interest to the scene. Use the same dark green mixture to loosely brush in some dark foliage tones on the trees, taking care not to allow any of the paint to spill over on to the buildings below.

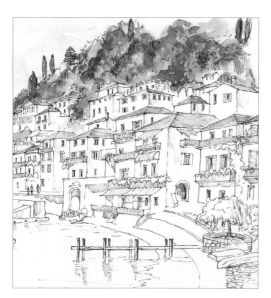

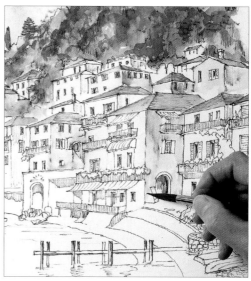

7 Mix a terracotta colour from cadmium orange, cadmium red and burnt sienna. Using the tip of the brush, paint the roofs, adding more burnt sienna for the shaded sides of the roofs. Note how the whole picture begins to take on more form and depth as soon as you put in some shading.

8 Use a slightly paler version of the mixture used for the roofs to paint the shaded sides of some of the buildings. Work carefully so that you retain the sharp vertical lines of the buildings. This is an important aspect of making the buildings look three-dimensional.

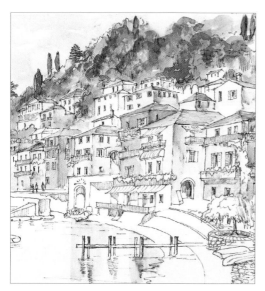

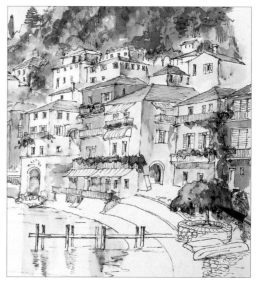

9 Mix a very pale wash of yellow ochre and brush it on to the front of some of the houses. Paint the shaded sides of the terracotta-coloured houses in a mixture of yellow ochre and burnt sienna.

10 Finish painting the façades of the buildings. Mix a light green from sap green and cadmium yellow and dot in the foliage on the balconies. While this is still damp, dot on dark phthalocyanine green to build up some tone and depth.

▶

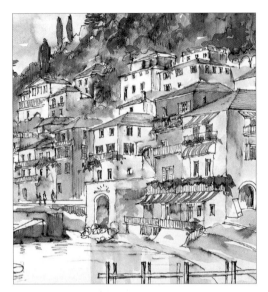

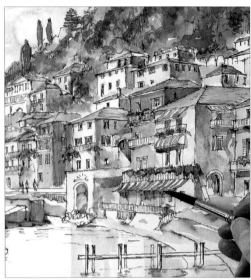

**11** Paint the striped awnings in dilute washes of alizarin crimson and cobalt blue (but don't try to make the stripes on the awnings too precise and even, or the work will start to look stilted). Paint the window shutters in cobalt blue and phthalocyanine green.

**12** Mix a pale but warm purple from ultramarine blue, deep violet and burnt sienna and paint the shadowed sides of the buildings and a narrow strip under the awnings. This reinforces the three-dimensional effect and separates the houses from each other and from the background.

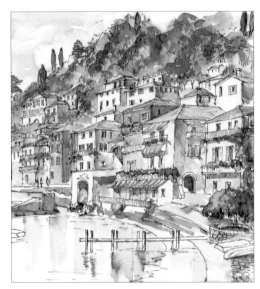

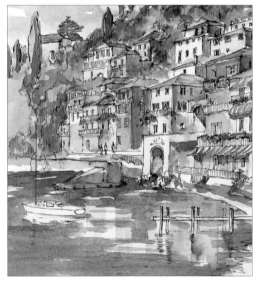

**13** Using the same colour, continue putting in the shadows on the houses and on the shoreline promenade and jetty. Paint the reflections in the water, using watered-down versions of the colours used on the buildings. Leave to dry.

**14** Mix a deep blue from ultramarine blue, cobalt blue and a little deep violet. Carefully brush this over the water area, working around the boat and the posts of the jetty and leaving some gaps for broken ripples and highlights.

## Hillside town in line and wash

With the addition of a few final details (the jetty, painted in a mixture of burnt sienna and ultramarine blue; the upturned boats in very pale washes of alizarin crimson and ultramarine blue, and the boat on the lake in alizarin crimson), the painting is complete. Precise pen work in both water-soluble and waterproof ink has combined with loose brushstrokes and wet-into-wet washes to create a lively rendering of this charming lakeside town.

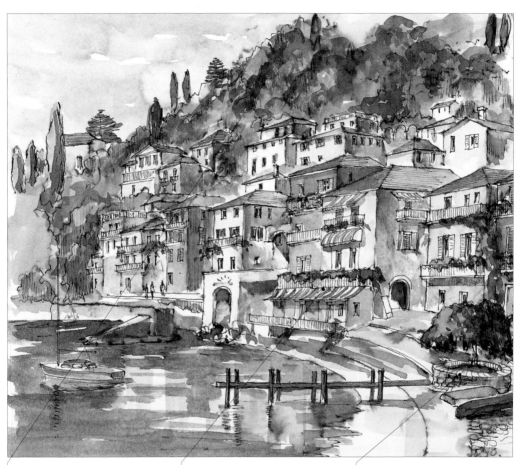

The blurred, wet-into-wet trees focus attention on the sharply defined buildings.

Loose strokes of colour are used to depict the awnings.

Precise pen lines set down in the very earliest stages remain in the finished work.

# Moroccan kasbah

The location for this striking and unusual project is the World Heritage site of Ait-Ben-Haddhou, in southern Morocco. It is a traditional-style village made up of several earthen fortresses, each one some 10 metres (30 feet) high.

With its straight-edged buildings and clean lines, the scene looks deceptively simple, but it demonstrates well how important it is to train yourself to assess tones. The earthen buildings are all very similar in colour (predominantly ochre and terracotta), so without strong contrasts of tone you will never succeed in making them look three-dimensional.

If you are painting on location, you may find that the light and, consequently, the direction and length of any shadows changes as you work. It is a good idea to make light pencil marks on your paper, just outside the margins of your painting, indicating the angle of the sun. This makes it easier to keep the lighting consistent when you are painting over a period of several hours.

## Materials
- *2B pencil*
- *140lb (300gsm) NOT watercolour paper, pre-stretched*
- *Watercolour paints: cerulean blue, yellow ochre, light red, vermilion, mauve, white, alizarin crimson, Hooker's green, Winsor yellow, Payne's grey, ultramarine blue, burnt umber*
- *Brushes: large wash, medium round, medium flat, fine filbert*

> **Tip**: Use a pencil to measure the relative heights of the buildings. Hold the pencil out in front of you and align the tip with part of your subject (say, the top of the tallest building), then run your thumb down the pencil until it aligns with the base of the building. You can transfer this measurement to your watercolour paper, again holding the pencil at arm's length. It is important to keep your arm straight and the pencil vertical, so that the pencil remains a constant distance from the subject.

## The original scene
The artist took this photograph around midday, when the sun was almost directly overhead. Consequently, the colours looked somewhat bleached out and there were no strong shadows to bring the scene to life. She decided to use a little artistic licence and enhance what she saw by intensifying the colours in order to make her painting more dramatic.

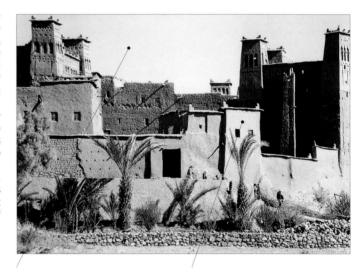

The sky looks pale and doesn't have the warmth that one associates with hot African countries.

Here, the mud-brick buildings look pale and bleached out; in the right light, however, they glow a warm orangey-red.

**1** Using a 2B pencil, lightly sketch the scene, taking careful note of the relative heights of the buildings and their angles in relation to one another.

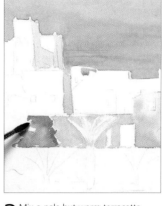

3 Mix a pale but warm terracotta colour from yellow ochre, light red and a tiny amount of vermilion. Using a medium round brush, wash this mixture over the buildings, working around the fronds of the foreground palm trees and adding a little more yellow ochre as you work across from right to left.

2 Using a large wash brush, dampen the sky area with clean water, brushing carefully around the outlines of the buildings to get a neat, clean edge. Mix a wash of cerulean blue. After about a minute, when the water has sunk in but the paper is still damp, quickly brush on the colour. (You may want to switch to a smaller brush to paint up to the edge of the buildings. Use the side of the brush and brush the paint upwards, to avoid accidentally getting any of the blue colour on the buildings.)

**Tip**: Vary the tone of the buildings. If they are too uniform in tone they will look newly built and mass produced.

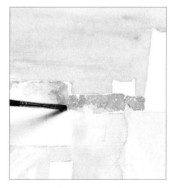

4 Add a little mauve to the mixture to make a deeper tone. Paint the wall at the base of the picture, painting around the trunks of the palm trees. Hold the brush at an angle as you do this and make jagged marks, as this helps to convey the texture of the trunks and shows that they are not straight-edged.

5 Continue working across the painting until you have put in all of the lightest tones of the buildings.

6 Mix a mid tone from yellow ochre and a tiny amount of mauve and, using a medium flat brush, stipple this mixture on to the buildings in the centre of the painting to give them some texture as well as tone. Add more mauve to the mixture for the darker left-hand side.

▶

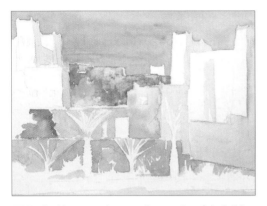

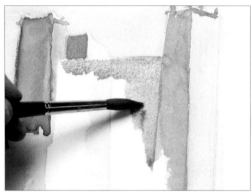

**7** Brush white watercolour over the top edge of the building in the centre. This reduces the intensity of the yellow and makes it look as if it has been bleached by the sun.

**8** Mix a dark terracotta from light red, yellow ochre and a touch of alizarin crimson and start painting the darkest tones – the sides of the buildings that are in deepest shade.

### Assessment time

The light, mid- and dark tones are now in place across the picture and, although the tones have not yet reached their final density, we are beginning to get a clear sense of which facets of the buildings are in bright sunlight and which are in shade. From this stage onwards, you need to continually assess the tonal values as you work, because even slight changes in one area will affect the balance of the painting as a whole. Take regular breaks, propping your painting up against a wall and looking at it from a distance to see how it is developing.

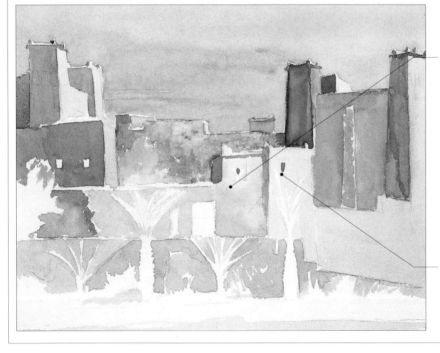

Stronger contrasts of tone are needed in order for the buildings to look truly three-dimensional.

Details such as the recessed windows and doors will help to bring the painting to life.

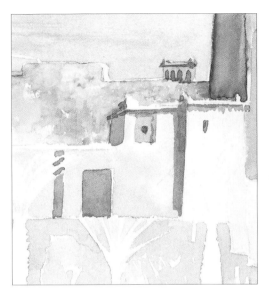

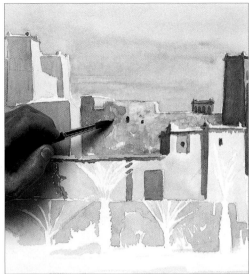

9 Mix a very dark terracotta colour from light red, yellow ochre and a touch of alizarin crimson, and begin putting in some of the fine details, such as the door in the exterior wall and some of the small windows. You are now beginning to establish a feeling of light and shade in the painting.

10 The right-hand buildings, which are in the deepest area of shade, look too light. Darken them as necessary by overlaying more washes of the colours used previously. Also darken the mid-toned wall in the centre of the picture and put some dark windows on the light side.

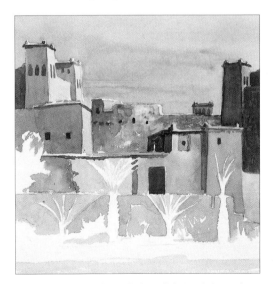

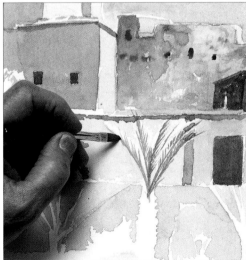

11 The lightest walls now look too light in relation to the rest of the painting, so darken them with another wash of the pale terracotta mixture used in Step 3. Build up the tone gradually. You can apply more washes if necessary, but if you make things too dark there is no going back.

12 Mix a yellowy green from Hooker's green and a little yellow ochre and, using a fine filbert brush, start putting in the green palm fronds in the foreground. Make short upward flicks with the brush, following the direction in which the palm fronds grow.

▶

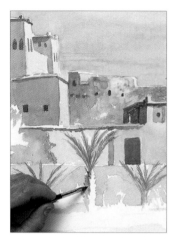

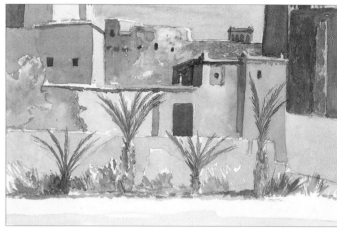

**13** Continue painting the palm fronds, adding a little Winsor yellow at the point where the fronds spring out from the trunk. Paint the shaded sides of the palm trunks in Payne's grey, using short, broken strokes to indicate the knobbly surface texture of the trunks.

**14** Lighten the grey by adding a little yellow ochre. Using the side of the brush, dab this mixture on to the left-hand side of the painting to indicate the scrubby texture of the bushes that grow in this area. Mix a very pale green from Payne's grey, yellow ochre and Hooker's green and dot in the side of the palm trunks that catches the light. Mix a grey-green from Payne's grey and Hooker's green and dot this mixture into the foreground shrubs. Mix a pale purple from alizarin crimson and ultramarine blue and paint the dry earth and the shadows around the base of the palm trees.

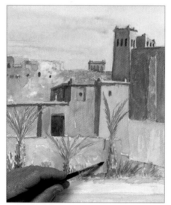

**15** Mix a pale wash of alizarin crimson and darken the wall in the foreground. Feel free to use some artistic licence in your choice of colours. Although the wall is, in reality, more terracotta than pink, you are trying to put colour into a subject that doesn't have much in order to create some drama and variety in your image. Adjust the tones over the painting as a whole if you feel that it is necessary.

**16** Mix a dark brown from light red and Payne's grey and put in the dark details, such as the windows. Drybrush a pale mixture of Hooker's green over the foreground to give it some tone. Mix a dark brown from burnt umber and Payne's grey and dab it on to the palm trunks to give them more tone and texture. Paint the shadows of the palm trees on the wall in a pale mixture of Payne's grey.

**17** Mix a dilute wash of white watercolour paint and brush it over the tops of the highest buildings. Because the paint is transparent the underlying colour shows through, creating the effect of strong sunlight shining on the buildings and bleaching out the colour. Don't worry if the white looks too strong when you first apply it to the paper as it will quickly sink in and look natural.

## Moroccan kasbah

The artist has managed to create a surprisingly wide range of tones in this painting, and this is one of the keys to its success, as the variety helps to convey not only the weathered textures of the mud bricks but also that all-important sense of light and shade. Rich, warm colours – far warmer than in the original reference photograph – help to evoke the feeling of being in a hot country. The foreground trees and bushes contrast well with the buildings in both colour and shape.

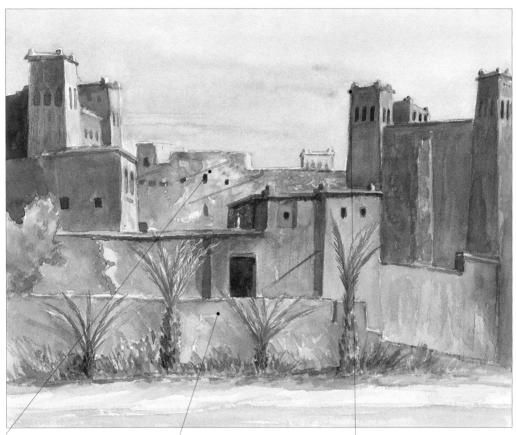

Transparent white watercolour paint allows some of the underlying colour to show through, and this creates the impression of sun-bleached brick.

In reality, this wall is the same colour as those behind. Painting it a warm pink brings it forward in the picture and helps to create an impression of distance.

Note the use of complementary colours – the orangey ochres and terracottas of the buildings against the rich cerulean blue of the sky.

# Arched window

Many people would have passed by this little window in favour of something with more obvious appeal, such as brightly painted shutters or a courtyard filled with colourful blooms. The beautiful proportions of this old window, however, with its worn stonework and row of empty terracotta pots, struck an instant chord with the artist. It is proof, if proof were needed, that you can find a subject to paint wherever you go.

Why not try this approach for yourself? Instead of looking for the picturesque, deliberately set out to find a subject that most people would consider to be unsuitable for a painting – the contents of a builder's skip, perhaps, or battered tin cans in the street. Even graffiti on a brick wall or a rusting padlock on a rickety old wooden gate can be turned into intriguing, semi-abstract studies.

From a pictorial point of view, one of the most fascinating things about old, worn subjects like this is that they have wonderfully subtle colours and textures, which makes them ideal candidates for the whole spectrum of watercolour textural techniques. Spattering, sponging, stippling and a whole range of additives can all be incorporated to good effect.

This project starts by using oil pastels as resists, revealing both the texture of the paper and underlying colours. Remember to press quite hard on the oil pastels, otherwise there won't be enough oil on the paper to resist the watercolour paint applied in subsequent stages.

## Materials
- *2B pencil*
- *140lb (300gsm) NOT watercolour paper, pre-stretched*
- *Soft oil pastels: light green, dark green, pale yellow, terracotta, bright orange, pink, light grey, mid-toned grey, olive green*
- *Watercolour paints: cerulean blue, dioxazine violet, Payne's grey, olive green, burnt sienna, cadmium orange, leaf green, phthalocyanine blue, cobalt blue*
- *Brushes: medium round, fine round*
- *Ruling drawing pen*
- *Masking fluid*

## Preliminary sketch
This scene contains relatively few colours and lots of dense shadows. The only way to make it look realistic is to work out in advance where the darkest and lightest tones are going to be, as the artist has done in this quick tonal sketch.

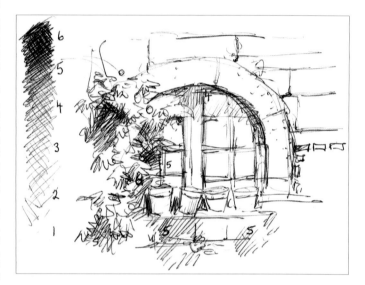

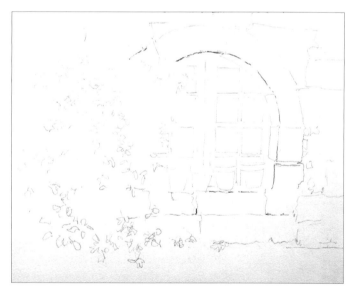

**1** Using a 2B pencil, lightly sketch the outline of the window with its row of terracotta flowerpots, the main blocks of stone that surround it, and the mass of plants growing on the left-hand side.

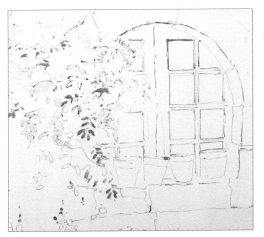

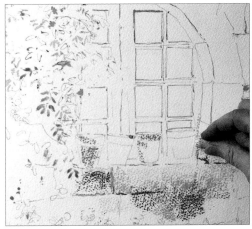

2 Dip a ruling drawing pen in masking fluid and mask the glazing bars on the window frame, the highlights on the rims of the terracotta flowerpots and the little yellow flowers on the bush on the left. Note the differing types of marks: thin straight lines for the highlights and short dots and dashes for the individual flower petals. Leave to dry.

3 Now start to put in colour and texture with soft oil pastels, pressing quite hard to ensure that enough oil is deposited on the paper to act as a resist when the watercolour paint is applied. Roughly dash in the leaf shapes, using light green for the tallest bush and a darker green for the one in the foreground. Drag pale yellow streaks across the stonework under the window. Put in some terracotta pastel on some of the bricks and the flowerpots. Draw the orange and pink flowers on the bush. Put in some light- and mid-toned grey on the worn stonework under the window.

**Assessment time**
With the addition of a few more pastel marks – more green on the leaves, orange on the terracotta pots, and a dark olive green in the spaces between the pots – the oil pastel stage is now complete. Oil resists water, so these colours will show through any subsequent watercolour washes. Because you are using a rough paper, some of the oil pastel lines will be broken and the texture of the paper will also be visible. Take time to check that you have included all the areas where you want texture.

Short dots and dashes convey the shapes of the leaves and flowers.

Long, broken strokes are used for the worn stonework.

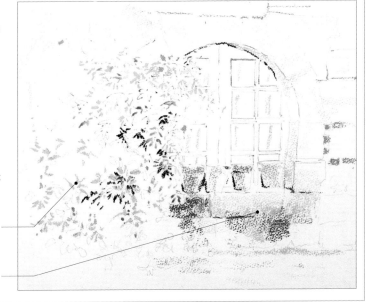

▶

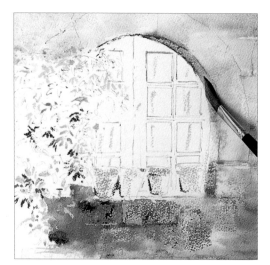

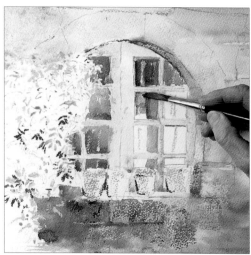

4 Now for the watercolour stages. Dampen the stonework with clean water. Mix a very pale greyish blue from cerulean blue and a little dioxazine violet watercolour paints and brush this mixture over the stonework, adding a little Payne's grey for the shadowed areas and a little more violet for the foreground. Brush very pale olive green over the shadowed stonework beneath the window ledge. Applied wet into wet, the colour blurs and looks like soft lichen.

5 Mix a very pale wash of cerulean blue and paint the white woodwork of the right-hand window frame. (Leaving the frame as white paper would look too stark in relation to the rest of the image.) Mix a warm brown from burnt sienna and dioxazine violet and carefully paint the window panes, leaving some gaps for highlights reflected in the glass.

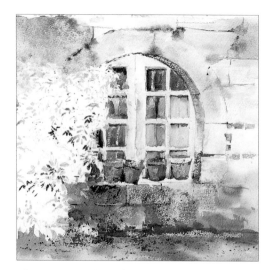

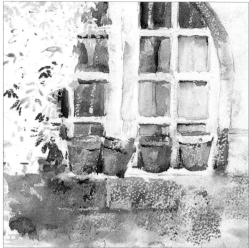

6 Mix an orangey brown from cadmium orange and dioxazine violet and paint the first terracotta flowerpot. Add Payne's grey to the mixture for the second pot in the row, which is in shadow, and burnt sienna for the third and fourth pots.

7 Note how the oil pastel marks that you applied in the early stages resist the watercolour paint, creating very realistic-looking but subtle texture in the stonework under the window and the flowerpots. The texture of the paper plays a part in this, too.

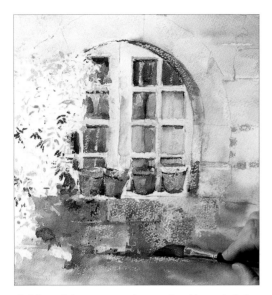

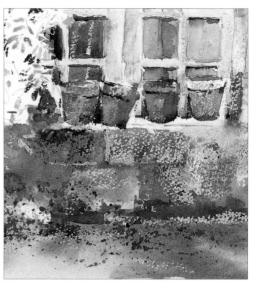

**8** Mix a pale but warm grey from cerulean blue and a little dioxazine violet and wash this mixture over the stonework under the window. While the wash is still damp, brush burnt sienna over the terracotta pastel of the bricks. Allow the paper to dry slightly, add dioxazine violet to the burnt sienna wash and paint the cracks in the stonework.

**9** Mix dioxazine violet with a little olive green and spatter this mixture lightly over the foreground to create some texture on the path and wall. These spatters of dark colour look like clumps of moss or small pebbles – both of which are in keeping with the somewhat derelict and dilapidated nature of the subject.

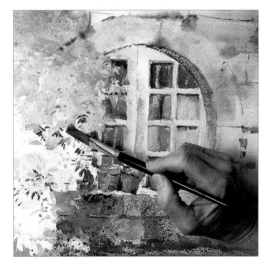

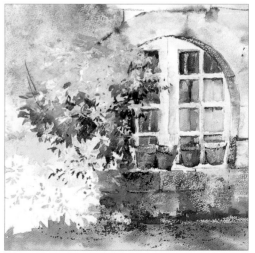

**10** Mix a fairly strong wash of leaf green (which is a bright, yellowy green) and brush it over the lightest areas on the tops of the bushes. Add cerulean blue to the mixture and use this colour to paint the mid-toned leaves, taking care not to obliterate all of the light green.

**11** Mix a dark green from olive green and phthalocyanine blue and dot in the darkest tones of the leaves on the background bush, making sure your brushstrokes follow the direction in which the leaves grow. You are now beginning to establish the form of the bushes.

▶

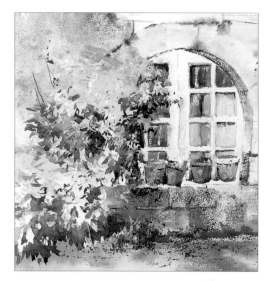

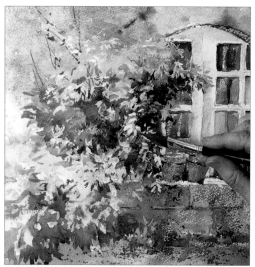

**12** Add cobalt blue to the dark green used in Step 11. Paint the spaces between the leaves of the foreground bush.

**13** Mix a very pale wash of cerulean blue and brush it over the white spaces to the left of the bushes, which look very stark in relation to the rest of the image. Mix a very dark green from burnt sienna, olive green and a little phthalocyanine blue. Stroke this mixture on to the very darkest leaves on the foreground bush, taking the colour across the front of the window to imply overhanging leaves and branches. Leave to dry.

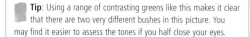

**Tip**: Using a range of contrasting greens like this makes it clear that there are two very different bushes in this picture. You may find it easier to assess the tones if you half close your eyes.

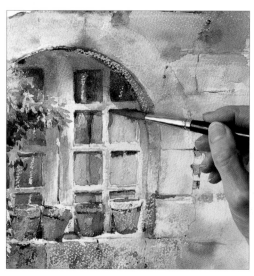

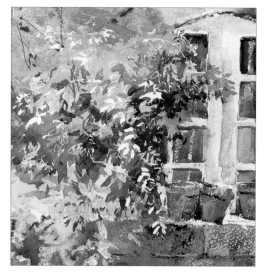

**14** Gently rub off the masking fluid. Mix a dark purple from cobalt blue, violet and a little burnt sienna and darken some of the shadows around the window.

**15** Mix a very pale wash of cerulean blue and tone down the starkness of some of the revealed whites.

### Arched window

This is a beautifully controlled study in texture, painted using a relatively subdued and limited palette – proof that simplicity is often the most effective option. The empty flowerpots are what really make the picture: they provide visual interest in the foreground to hold the viewer's attention and also imply a human presence in the scene.

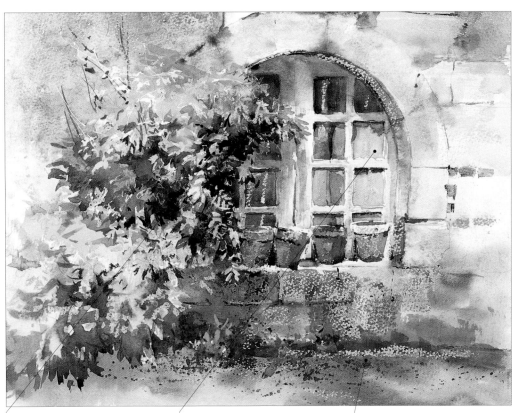

Using a range of greens both gives depth and indicates that there is more than one type of plant in this area.

Leaving tiny areas of window pane unpainted conveys the impression of light being reflected in the glass.

Two textural techniques, spattering and the use of resists, have been combined to good effect here.

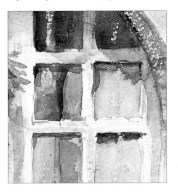

# Painting People

Portraits are often considered difficult to paint, although in reality they are no more complicated than any other subject. Part of the perceived difficulty in painting portraits comes from the need to capture a true likeness of the sitter, as somehow we expect portraits to be more lifelike, and less subject to the artist's personal interpretation, than other subjects. If you approach the subject and construct your image in the same way as any other, taking measurements and observing proportions, then that likeness should – and will – follow. Take time over your underdrawing as this is important, and observe where each facial feature is positioned in relation to the others.

A little knowledge of what the human skull is like will make it easier to position the facial features correctly. Although facial features will differ, certain measurements and proportions are approximately the same on most people.

However, a really good portrait should achieve far more than a physical likeness of the subject, it should also reveal something of the sitter's character. Hair, make-up and clothes are all important in capturing an individual's personality, and should be subject to the same scrutiny as the sitter's features.

The main watercolour techniques that you will find yourself using are wet into wet and wet on dry. Techniques that are

usually associated with making texture will, for obvious reasons, be used less often in portraiture, if at all, although drybrush can prove useful when painting hair. Watercolour is a good medium for portraits, but it requires a little forethought and planning. The traditional transparent watercolour technique of working light to dark is perfect for building up skin colours and tones, as new washes are applied over dry ones. Alternatively, flood paint colour into a wet area to create soft transitions, with one colour blending

seamlessly into another. Wet-on-dry work, which creates a sharp, hard-edged focus, should be restricted to painting the features on the sitter's face.

**The red shirt ▼**

The boy's mischievous and adventurous character is self-evident as he hangs from a tree branch with a considerable drop beneath. Carefully placed wet-on-dry washes were used over a drawing using very light wet-into-wet watercolour paints.

**Tips**: • Spend time plotting the facial features. If your measurements and assessment of proportion are correct, a good likeness should follow.
• Limit yourself to one or two techniques. Use wet-into-wet washes initially, and then create sharper focus by using wet-on-dry washes as the work progresses.
• Use gum arabic in your washes, or work on a support that has been heavily sized: this makes it easier to make corrections by washing off paint.
• If you are painting someone in their environment, work on the background and setting at the same time as the figure per se to avoid the portrait looking as if it has simply been pasted in.

### Lydia and Alice ▲

The initial work was made using wet-into-wet washes and the features were then sharpened using wet on dry. Gum arabic was used in many of the mixes. This has the effect not only of intensifying the colour but also of making the washes more transparent. Gum arabic also makes dry paint soluble if it is re-wet, so you can wash off dry paint and make any necessary corrections – this is a very useful facility when painting portraits.

### Sisters ▶

Working over a careful pencil drawing using wet-on-dry washes, an overall colour harmony was achieved by using a limited range of colours. Interestingly, the two girls were painted at different times. The poses were carefully chosen so that the figures could be combined on the support.

# Head-and-shoulders portrait

Painting a portrait from life for the first time can be a daunting prospect. Not only do you have the technical aspects to deal with, but you are working with a live model, who will almost certainly fidget and demand to see what you are doing. Before you embark on your first portrait session, practice drawing and painting from photographs to build up your skills and confidence.

You also have to consider your model's wellbeing. Make sure they are warm and comfortable and have adopted a pose that feels natural: they may have to hold the same pose for a long time. Ask them to fix their gaze on an object behind you

(a picture on the wall, perhaps) so that, if they do move, they can easily regain their original position.

Put a lot of care into your underdrawing. If you can get the facial features in the right place and know where the main areas of light and shade are going to be, then you are well on the way to success.

Finally, don't try to do too much. Details like clothing are relatively unimportant in a head-and-shoulders portrait. Instead, try to capture your subject's mood and personality by concentrating on the eyes and expression.

## Positioning the features

The sketches below are intended to provide some general guidelines to help position the facial features correctly. They are not infallible rules, however: everyone is different and you should train yourself to take objective measurements rather than relying on your preconceptions. Your viewpoint also makes a difference.

Resist the temptation to start by drawing an outline of the face. If you do this, the chances are that you will find you haven't allowed yourself enough space for the features. Start by working out the relative sizes and positions of the features and then worry about the overall outline.

It is always a good idea to put in faint pencil guidelines – a line down through the central axis of the face and lines across to mark the positions of the eyes, nose and mouth.

A large mass of hair can make things more complicated, as it is hard to work out exactly where the cranium ends and the hair begins. To begin with, try to work with a model whose hair sits close to the scalp or can be scraped back tight – or even a model with no hair at all.

### Head-on view
The left and right sides of the face are not totally symmetrical, but drawing a central guideline is a good starting point.

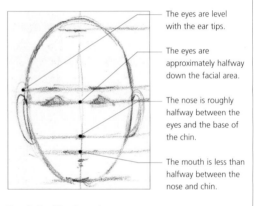

The eyes are level with the ear tips.

The eyes are approximately halfway down the facial area.

The nose is roughly halfway between the eyes and the base of the chin.

The mouth is less than halfway between the nose and chin.

### Head tilted forwards
When the head is titled forward, you can see more of the cranium and less of the facial features.

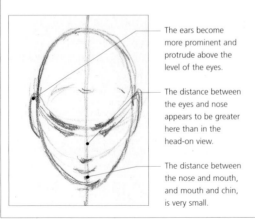

The ears become more prominent and protrude above the level of the eyes.

The distance between the eyes and nose appears to be greater here than in the head-on view.

The distance between the nose and mouth, and mouth and chin, is very small.

### Head tilted backwards
When the head is tilted backwards, you can see very little of the cranium.

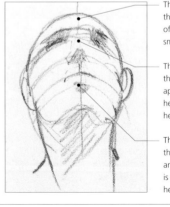

The distance between the eyes and the top of the cranium is very small from here.

The distance between the eyes and nose appears to be less here than in the head-on view.

The distance between the nose and mouth, and mouth and chin, is greater than in the head-on view.

## Materials

- *HB pencil*
- *140lb (300gsm) HP watercolour paper, pre-stretched*
- *Watercolour paints: light red, yellow ochre, alizarin crimson, sap green, sepia tone, neutral tint, ultramarine blue, ultramarine violet, cobalt blue, burnt umber, cadmium orange, cadmium red*
- *Brushes: large round, medium round, fine round*

## The pose

If you are new to portraiture, a simple pose, with the model looking directly at you, is probably the best way to begin. Place a strong light to one side of the model, as it will cast an obvious shadow and make it easier for you to assess areas of light and shade.

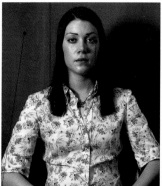

Select a plain background that does not draw attention away from your subject.

The eyes are the key to any portrait.

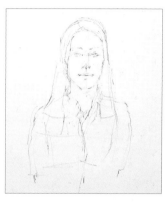

**1** Using an HB pencil lightly sketch your subject, putting in faint construction lines as a guide to help you check that the features are accurately positioned.

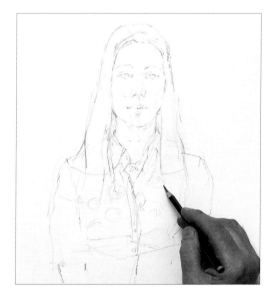

**2** Begin to put in some indication of the pattern in the model's blouse. You do not need to make it detailed.

> **Tip**: From time to time, look at your drawing in a mirror. This often makes it easier to assess if you have got the proportions and position of the features right. Also hold your drawing board at arm's length, with the drawing vertical, to check the perspective. When you work with the drawing board flat, the perspective sometimes becomes distorted.

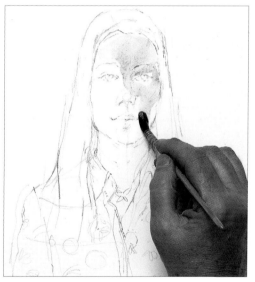

**3** Mix light red and yellow ochre to make the first warm but pale flesh tone. Using a medium round brush, wash this mixture over the face, neck and forearms, avoiding the eyes and leaving a few gaps for highlights. This is just the base colour for the flesh. It will look a little strange at this stage, but you will add more tones and colours later on.

▶

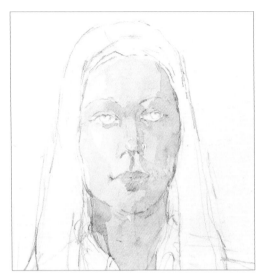

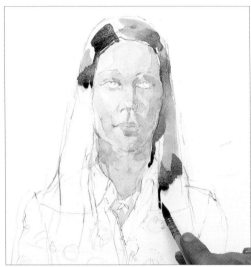

4 You have to work quickly at this stage to avoid the wash drying and forming hard edges. While the first wash is still damp, add more pigment and a little alizarin crimson to the first skin tone and paint the shadowed side of the face to give some modelling. Add more alizarin crimson to the mixture and paint the lips. Leave to dry.

5 Touch a little very dilute alizarin crimson on to the cheeks and some very pale sap green into the dark, shaded side of the face. Mix a warm, rich brown from sepia tone and neutral tint and start to paint the hair, leaving some highlight areas and the parting line on the top of the head completely free of paint.

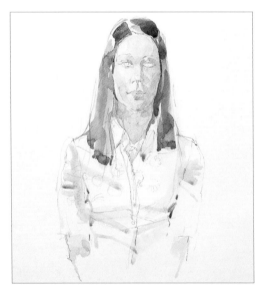

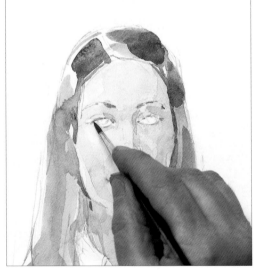

6 Mix a very pale blue from ultramarine blue and a hint of ultramarine violet. See where the fabric in the blouse creases, causing shadows. Using a fine round brush, paint these creases in the pale blue mixture.

7 Go back to the hair colour mixture used in Step 5 and put a second layer of colour on the darker areas of hair. Paint the eyebrows and carefully outline the eyes in the same dark brown mixture.

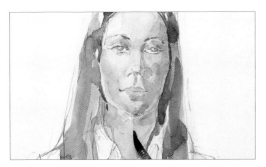

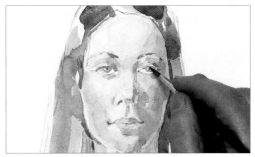

**8** Mix a very light green from yellow ochre with a little sap green and, using a fine round brush, paint the irises, leaving a white space for the highlight where light is reflected in the eye. Strengthen the shadows on the side of the face and neck with a pale mixture of light red and a little sap green.

**9** Use the same shadow colour to paint along the edge of the nose. This helps to separate the nose from the cheeks and make it look three-dimensional. Mix ultramarine violet with sepia tone and paint the pupils of the eyes, taking care not to go over on to the whites.

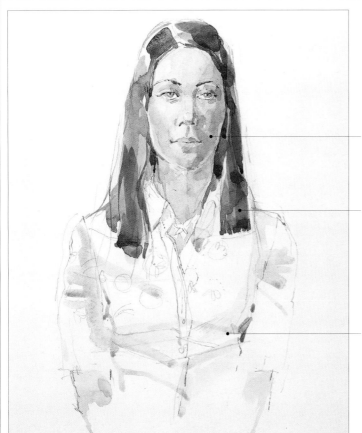

**Assessment time**
The portrait is nearing completion and it is time to stand back and decide what adjustments to make and what final details to add. Beware of overworking a portrait like this. The key to its success is its directness.

The model does not stand out clearly from the stark white background.

Successive washes of colour give the hair depth and sheen.

The creases and shadows in the blouse imply the contours of the body underneath the fabric.

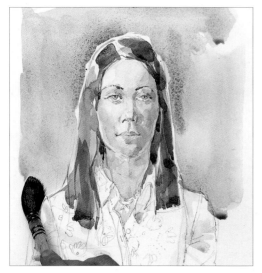

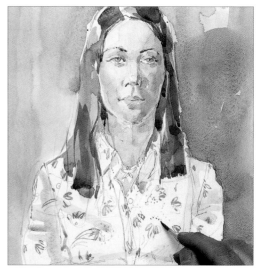

**10** Mix a dark green from sap green, cobalt blue and burnt umber. Using a large round brush, carefully wash this mixture over the background, taking care not to allow any of the paint to spill over on to the figure. (You may find it easier to switch to a smaller brush to cut in around the figure.)

**11** While the background wash is still damp, add a little more pigment to the green mixture and brush in the shadow of the girl's head. Mix an orangey-red from cadmium orange and cadmium red and, using a fine round brush, start putting in some of the detail on the girl's blouse.

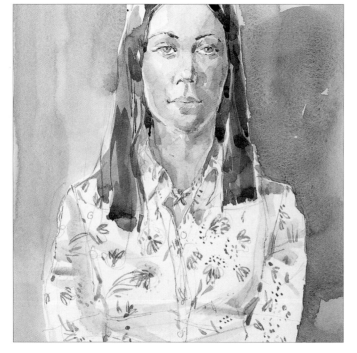

**12** Continue building up some indication of the pattern on the girl's blouse, using the orangey red mixture from Step 11, along with ultramarine blue and sap green.

**Tip:** Don't try to replicate the pattern exactly: it will take far too long and will change the emphasis of the painting from the girl's face to her clothing.

**Head-and-shoulders portrait**
This is a sensitive, yet loosely painted portrait that captures the model's features and mood perfectly. It succeeds largely because its main focus, and the most detailed brushwork, is on the girl's eyes and pensive expression. Careful attention to the shadow areas has helped to give shape to the face and separate the model from the plain-coloured background.

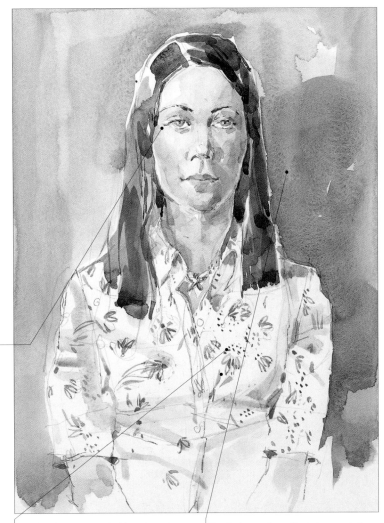

The detailed painting of the eyes and mouth helps to reveal the model's mood and character.

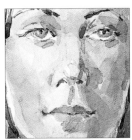

In reality, the pattern on the blouse is much more detailed than this, but a more accurate rendition would have drawn attention away from the girl's face.

The shadow on the wall helps to separate the model from the background and gives the image more depth.

# The swimmer

Although the subject of this project looks simple enough – a solitary figure swimming underwater, with relatively little discernible detail – the real interest lies in the play of light on the water and the way that shapes are slightly distorted, producing an image that tends towards abstraction. Your task is not only to capture the sleek form of the swimmer and to freeze a moment in time, but also to convey a sense of the dappled sunlight and the movement of the water.

As so often happens in painting, it helps to exaggerate certain elements in order to get across the mood that you want. Distorting the figure of the swimmer slightly in order to make it look more streamlined is one way to do this; making more of the dappled patches of sunlight on the water is another.

Adding a few drops of gum arabic to your paint mixes is a very useful technique when painting water, as it increases the gloss and transparency of watercolour paint. This, combined with the careful build-up of layers of colour, helps to make the water look as if it is shimmering in the sunlight.

## Materials
- *2B pencil*
- *200lb (425gsm) NOT watercolour paper, pre-stretched*
- *Watercolour paints: cadmium lemon, alizarin crimson, cerulean blue, cobalt turquoise, cadmium red, cadmium yellow, Payne's grey, ivory black, burnt sienna, burnt umber*
- *Brushes: large round, medium round, small round*
- *Gum arabic*
- *3B graphite stick*

### Reference photograph
Fascinated by the way the sunlight played on the water, the artist asked his daughter to dive repeatedly into this brightly tiled swimming pool, so that he could take reference photographs to work on at his leisure. When you are shooting a moving subject, it is hard to predict what you will actually capture on the film, so always take a lot more shots than you think you will need.

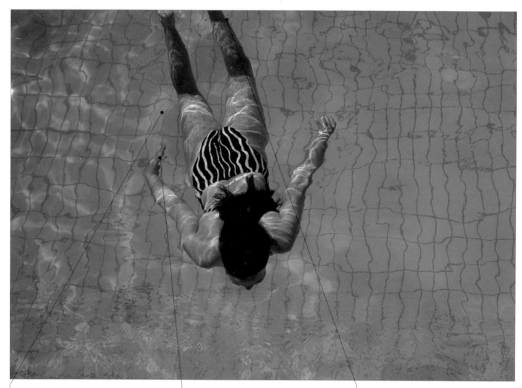

There is some dappled light on both the girl and the water, but this can be exaggerated in the painting to increase the feeling of sunlight.

Elongating the legs, arms and hands will increase the sense of movement.

Cutting off the legs at the top of the frame gives a more dynamic composition and allows the figure space into which to move.

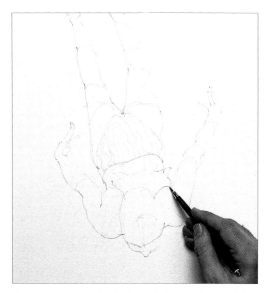

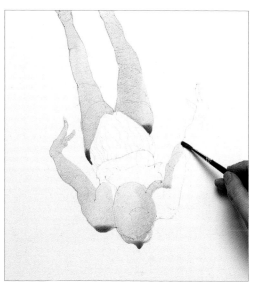

1 Using a 2B pencil, lightly sketch the figure. Note that it is slightly distorted because of the way the light is refracted through the water. In addition, the fingers and legs have been deliberately elongated a little to create a sense of the figure moving through the water at speed.

2 Mix a light pink wash from cadmium lemon and alizarin crimson, and a slightly redder version of the same mixture. Using a medium round brush, wash these colours over the whole of the body, alternating between the two mixtures to give some tonal variety. Leave to dry.

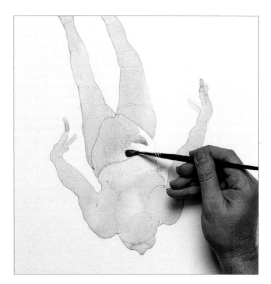

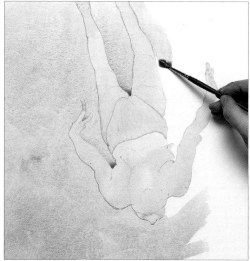

3 Mix a strong wash of cadmium lemon and add a little of the lighter pink wash used in Step 2. Using a medium round brush, paint the girl's bikini bottoms in this colour. Leave to dry.

4 Mix a large quantity of a pale blue wash from cerulean blue and a little cobalt turquoise. Wash this mixture over the whole of the background, taking care not to allow any of the paint to go over the figure. (You may need to switch to a smaller brush to "cut in" around the edges of the figure.)

▶

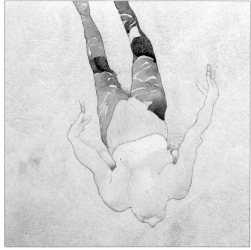

5 Mix three flesh tones from the following colours: alizarin crimson and cadmium lemon; alizarin crimson and a little cerulean blue; cadmium red and cadmium yellow. Dot a small amount of gum arabic into each mixture. Using a medium round brush and alternating between the three mixtures, start to paint over the girl's legs, leaving the base colour showing through in highlight areas. It doesn't matter too much which colour you use where, but try to reserve the darker mixtures for shadow areas.

6 Continue in this way until you have finished painting the legs. Leave to dry.

> **Tip**: Some of the washes may look very dark when you first apply them, but watercolour always dries to a slightly lighter tone. To be on the safe side, test your mixtures on a piece of scrap paper and leave to dry before applying them to the painting.

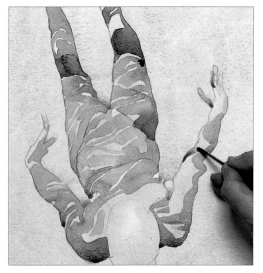

7 Mix a greenish yellow from cadmium lemon with a little Payne's grey. Using a small round brush, paint the ripples of light that run across the bikini bottoms.

8 Using a small round brush and the same flesh tones that you mixed in Step 5, paint the girl's arms and back, leaving some of the underlying wash showing through.

**Assessment time**
The underpainting is almost complete. The figure stands out well against the pale blue background of the water and is starting to take on a three-dimensional quality. The next stage is to redefine the form by using slightly darker mixtures and to start to put in some of the details.

Varying the flesh tones gives the figure form.

The base colour alone is visible in the most strongly lit areas.

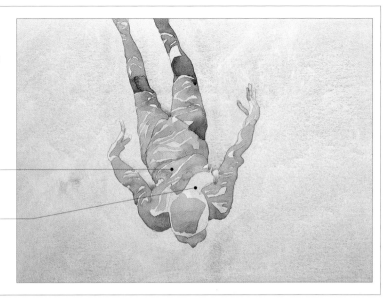

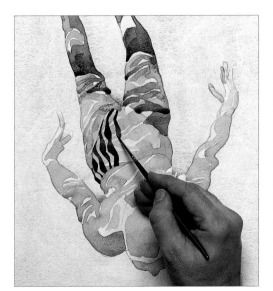

9 Mix slightly darker versions of the flesh tones used in Step 5 and work over the body again, in the same way as before. Mix a warm black from ivory black with a little Payne's grey and paint the stripes on the bikini bottoms. Note that the stripes are not straight lines. This is partly because the pattern is distorted by the way the light refracts from the water and partly because the fabric clings to the girl, helping to indicate the contours of her body.

10 Mix a rich, dark brown from burnt sienna and burnt umber and, using a medium round brush, paint the girl's hair. Leave some areas unpainted and apply a second layer of colour in others so that the hair is not a solid mass of the same tone of brown.

▶

**11** Mix a bright blue from cerulean blue and cobalt turquoise and, using a large round brush, begin to wash this mixture over the background. Leave some areas untouched in the top left-hand side, where sunlight dapples the water, and paint ripples in front of the girl's head to show how the water is displaced as she moves through it.

**12** Continue working around the figure with the same blue mixture until you have been over the whole of the background. As in Step 4, you may find that you need to switch to a smaller brush in order to paint right up to the edge of the figure, as you must take care not to allow any of the blue mixture to spill over on to the figure. Leave to dry.

**13** Mix a stronger version of the cerulean blue and cobalt turquoise mixture used in Step 11 and add a few drops of gum arabic. Paint over the background again, leaving a few spaces here and there to give the effect of dappled light. Leave to dry.

**14** Using a 3B graphite stick, draw the lines of the tiles on the base of the pool. Note that, because of the way the light is refracted and the effects of perspective, the lines are not straight. The lines in the distance slope inwards because this area of the painting is further away from the viewer.

## The swimmer

This is a graphic depiction of a swimmer slicing through water, the impression of speed reinforced by a deliberate distortion of her figure and the energetic ripples in front of her head. There is a wonderful feeling of light and warmth in this painting, achieved through the careful build-up of layers of colour.

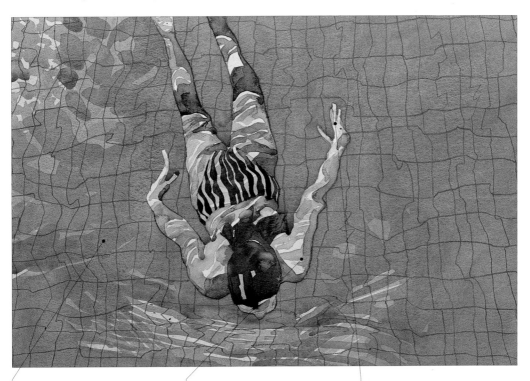

Because of the effects of perspective, the lines of the tiles slope inwards.

The effect of dappled sunlight is created by applying only one or two layers of colour to certain areas.

The swimmer's hands, arms and legs are slightly elongated, which helps to give the impression of movement.

# Seated figure in interior

Painting someone in a setting gives you the opportunity to say much more about them than you can in a straightforward head-and-shoulders portrait. For example, you might choose to include things that reveal something about your subject's interests – a keen musician with a guitar, perhaps, or an antiques collector surrounded by some of his or her most treasured possessions – or their work. In a domestic setting, the décor of the room itself is very often a reflection of your subject's tastes and personality.

The most important thing is not to allow the surroundings to dominate. The focus of the painting must remain on the person. This usually means that you have to deliberately subdue some of the detail around your subject, either by using muted or cool colours for the surroundings, so that your subject becomes more prominent, or, if the setting is very cluttered, by leaving some things out of your painting altogether.

**Materials**
- *3B pencil*
- *Rough watercolour board*
- *Watercolour paints: raw umber, alizarin crimson, cobalt blue, lemon yellow, phthalocyanine blue*
- *Brushes: medium flat, Chinese, fine round, old brush for masking*
- *Masking fluid*
- *Craft (utility) knife or scalpel*
- *Sponge*

**Reference photographs**
Here the artist used two photographs as reference – one for the seated, semi-silhouetted figure and one for the shaft of light that falls on the table top. Both photographs are dark and it is difficult to see much detail, but they show enough to set the general scene and give you scope to use your imagination. Instead of slavishly copying every last detail, you are free to invent certain aspects of the scene, or to embellish existing ones.

The highlight on the figure's hair is very atmospheric.

The shaft of bright sunlight illuminates part of the table top while almost everything else is in deep shade.

1 Using a 3B pencil, lightly sketch your subject, making sure you get the tilt of her head and the angles of the table, papers and books right.

2 Mix a warm, pinky orange from raw umber and alizarin crimson. Using a medium flat brush, wash it over the background, avoiding the highlight areas on the window. Add more alizarin crimson to the mixture for the warmest areas, such as the girl's shirt and the left-hand side of the curtain, and more raw umber for the cooler areas, such as the wall behind the girl and the glazing bars on the window. Leave to dry.

**3** Mix a very pale green from cobalt blue and lemon yellow and, using a Chinese brush, paint the lightest foliage shades outside the window, remembering to leave some white areas for the very bright sky beyond.

**Tip:** To enhance the impression of light coming through the window, take care not to paint foliage right up to the edge of the window frame.

### Assessment time

Mix a very pale blue from cobalt blue and a touch of raw umber and put in the cooler tones inside the room – the left-hand side, which the shaft of sunlight coming through the window doesn't reach, and the shadows under the table. Leave to dry.

You have now established the warm and cool areas of the painting, which you will build on in all the subsequent stages. Because of her position within the frame (roughly in the first third), the girl is the main focus of interest in the painting, even though she is largely in shadow. Keep this at the forefront of your mind as you begin to put in the detail and as you continually assess the compositional balance while painting.

This area is left unpainted, as it receives the most direct sunlight.

The warm colour of the girl's shirt helps to bring her forwards in the painting.

The shadow areas are the coolest in tone. They recede.

4 Mix a warm brown from alizarin crimson and raw umber and paint the girl's hair. Mix a rich red from alizarin crimson, cobalt blue and a little raw umber and, using a Chinese brush, paint the curtain. Apply several vertical brushstrokes to the curtain, wet into wet, to build up the tone and give the impression that it hangs in folds.

5 Using the same red mixture, paint the shoulders and back of the girl's shirt. Add more raw umber to the mixture and paint the shadow area between the wall and the mirror, immediately behind the girl. Mix a warm blue from phthalocyanine blue and a little alizarin crimson, and paint the dark area beneath the table using loose brushstrokes.

6 Using an old brush, "draw" the shapes of leaves in the bottom left-hand corner in masking fluid. Leave to dry. Mix a rich, dark brown from raw umber and a little alizarin crimson and, using a fine round brush, paint the darkest areas of the girl's hair.

7 Add a little raw umber to the mixture for the lighter areas of hair around the face. Build up the shadow areas in the foreground of the scene, overlaying colours as before. Darken the girl's shirt in selected areas with the alizarin crimson, cobalt blue and raw umber mixture.

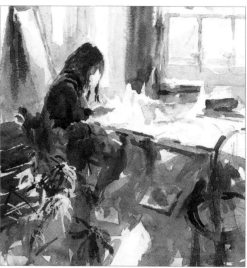

**8** Mix a mid-toned green from phthalocyanine blue and lemon yellow and, using a fine round brush, dot this mixture into the foliage that can be seen through the right-hand side of the window. Mix a very pale purplish blue from pthalocyanine blue and a little alizarin crimson and darken the glazing bars of the window.

**9** Paint the area under the window in a warm mixture of alizarin crimson and phthalocyanine blue. Mix a dark, olive green from raw umber and phthalocyanine blue and, making loose calligraphic strokes, paint the fronds of the foreground plant. Brush a very dilute version of the same mixture on to the lower part of the mirror. Build up the background tones.

**10** Mix a muted green from phthalocyanine blue and lemon yellow. Brush it over the background behind the girl. Because the green is relatively cool, it helps to separate the girl from the background. It also provides a visual link between this area and the foliage on the right.

**11** Paint a few vertical strokes on the curtain in a dark mixture of alizarin crimson and phthalocyanine blue. This helps to make the highlight on top of the pile of books stand out more clearly. Mix a warm brown from raw umber and phthalocyanine blue and paint under the window.

**12** Rub off the masking fluid from the bottom left-hand corner. Continue building up the tones overall, using the same paint mixtures as before and loose, random brushstrokes to maintain a feeling of spontaneity.

▶

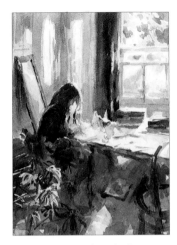

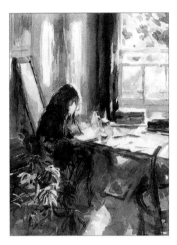

**13** Mix a very pale wash of raw umber and lightly brush it on to some of the exposed areas in the bottom left-hand corner. Build up more dark tones in the foreground, using the same mixtures as before.

**14** Using a craft (utility) knife or scalpel, carefully scratch off some of the highlights on the bottle on the table. Paint the wall behind the girl in a pale, olivey green mixture of raw umber and phthalocyanine blue.

**15** Brush a little very pale cobalt blue into the sky area so that this area does not look too stark and draw attention away from the main subject.

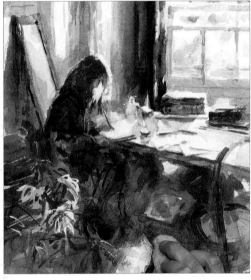

**16** Continue building up tones by overlaying colours. Use very loose brushstrokes and change direction continually, as this helps to convey a feeling of the dappled light that comes through the window.

**17** Using a 3B pencil, define the edges of the papers on the table. Mix a very pale wash of phthalocyanine blue and, using a fine round brush, carefully brush in shadows under the papers on the table to give them more definition. Dip a sponge in a blue-biased mixture of phthalocyanine blue and alizarin crimson and gently press it around the highlight area on the floor to suggest the texture of the carpet.

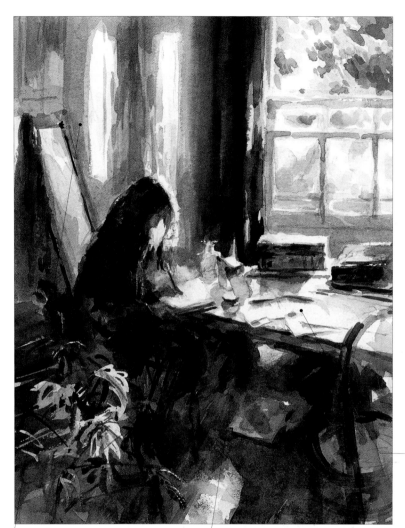

**Seated figure in interior**
There is a wonderful sense of light and shade in this painting, and the loose brushstrokes give a feeling of great freshness and spontaneity. The scene is beautifully balanced, both in terms of its distribution of colours and in the way that dark and light areas are counterposed.

Sunlight pours through the window, illuminating the books and papers. Much of this area is left unpainted.

Pale, cool colours on the wall help to differentiate the girl from the background.

The foreground is loosely painted with overlayed colours, creating a feeling of spontaneity.

# Indian market scene

Full of hustle and bustle, often packed with colourful displays of fruit, vegetables and other goods, street markets are a wonderful source of inspiration for artists – but with so much going on, it is often very difficult to work in situ. And even if you do manage to find a quiet spot to set up your easel, the chances are that you will soon find yourself surrounded by a crowd of curious onlookers, which can be somewhat intimidating.

This is one situation where it is useful to take reference photos, as you can work quickly and unobtrusively, and gather a whole wealth of material to paint from at a later date. Start with distant views and gradually move in closer to your chosen subject – and don't forget about things like advertisements, hand-written signs and unusual produce, all of which can add a lot of atmospheric local detail to your paintings.

If you want to take photographs of people, it is always best to ask their permission, although this does bring with it the risk that your subjects will start playing up to the camera. If this happens, take a few "posed" shots first and then, when they have turned back to their business, take a few more. Another good tip is to set your camera on its widest setting and point it slightly to one side of the person you are photographing. You will appear to be looking somewhere else, but the camera's field of view will be wide enough to include them in the frame, too. Above all, don't stint on the number of shots you take: film is inexpensive and if you've got a digital camera, there are no processing costs at all.

## Materials
- 4B pencil
- 90lb (185gsm) rough watercolour paper, pre-stretched
- Watercolour paints: indigo, alizarin crimson, raw umber, cobalt turquoise, cadmium red, Hooker's green, cadmium yellow, burnt umber, cobalt blue
- Gouache paints: Bengal rose, permanent white
- Brushes: Chinese, fine round
- Household candle

### Reference photographs
Here the artist used two photographs. The one on the right shows the corner of the stall and the stallholder selling his wares, and the one below shows the two ladies shopping and rows of colourful bowls of powdered dyes. In her compositional sketch, the artist angled the bowls to provide a more gentle lead-in to the picture.

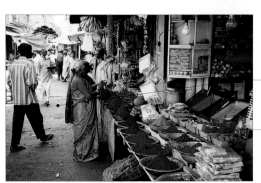

The stallholder is just visible. He will be more prominent in the painting.

There is nothing of interest in this area.

A more gentle lead-in will be provided if the bowls start in the bottom right corner of the image.

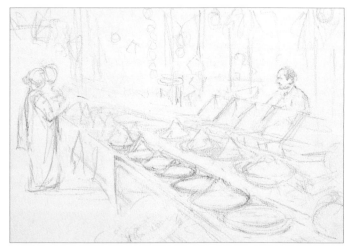

**1** Using a 4B pencil, sketch the subject, taking care to get the perspective right. Note how the bowls of powder get smaller and closer together as they recede into the distance.

 **Tip:** To make it easier to get the shapes of the bowls of powder right, think of them as simple geometric shapes – ovals with rough triangular shapes on top.

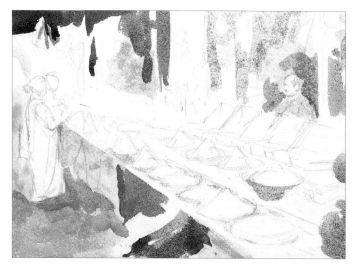

**2** Mix a warm, greyish blue from indigo, alizarin crimson and a little raw umber and start putting in the cool background colours. Paint the area of deepest shade under the table, adding more raw umber to the mixture for the pavement area. This neutral background will help to unify the painting. With so many vibrant colours in the scene, the overall impact could easily be overwhelming.

**3** Add more alizarin crimson to the mixture to make a darker, brown colour and brush in the shadows under the bowls and the wooden vertical supports of the shelves in the background. Use a paler version of the mixture to paint the stallholder's shirt and a darker one to paint the background of the more distant stall and the area immediately behind the stallholder's head. Filling in the negative spaces in this way makes it easier to see what it is happening in such a complicated scene.

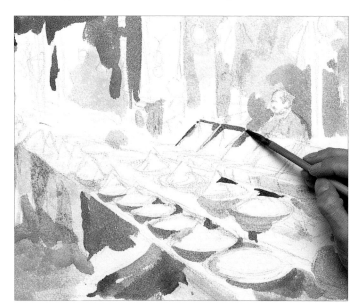

**4** Mix a warm shadow colour from indigo with a tiny amount of alizarin crimson and paint the shadows under the steel bowls, taking care to leave highlights on the rims. Use the same mixture to paint lines in between the oblong dishes of powder in the background.

**5** Using an ordinary household candle, stroke candle wax over the lightbulbs. Press firmly so that enough of the wax adheres to the paper. The wax will act as a resist. The white paper will show through in places, while other areas will take on the surrounding colour, as if that colour is reflected in the glass of the bulb.

▶

**Assessment time**

Using the same basic mixtures as before, continue putting in some background colours and the shadows under the bowls. The basis of the background is now complete, both tonally and compositionally.

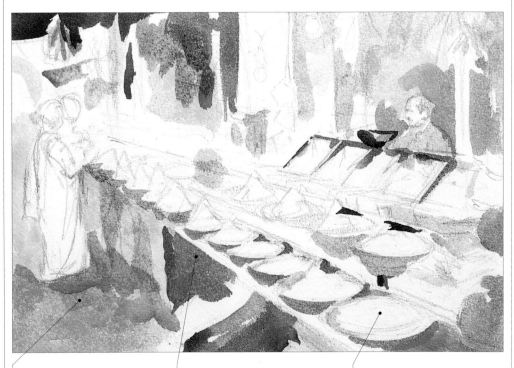

Blocking in the negative spaces makes it easier to see what is happening in the rest of the scene.

We "read" this shaded area as being on a different plane to the stall top, which is in bright sunlight.

Although the bowls are empty at this stage, their shapes and shadows are clearly established.

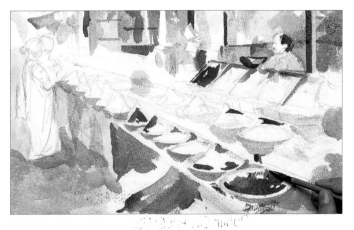

6 Mix a warm, purplish black from alizarin crimson and indigo and paint the stallholder's hair. Mix cadmium red with alizarin crimson and paint the wooden support on the right-hand edge of the foreground stall. Drybrush a little of the same colour on to the stall top, where powder has been spilt, and start putting the same colour into the bowls of powder. Paint cobalt turquoise on the walls at the far end.

**Tip**: While you have one colour mix on your palette, see where else you can use it in the painting.

**7** Mix a wash of Hooker's green and paint the green plastic that covers the basket on the ground and the mounds of green powder. Mix a warm orange from cadmium red and cadmium yellow and dot the mixture into the background immediately behind the stallholder to indicate the packages on sale. (A hint of the basic shape and colour is sufficient.) Add a little burnt umber to the orange mixture and paint the stallholder's face.

**8** Paint the women's skin tones in the same orangey-brown mixture. Mix a strong purple from Bengal rose gouache and cobalt blue watercolour and paint the sari worn by the woman in the foreground, leaving a few highlight areas untouched.

**9** Using the same mixture and a fine round brush, paint the creases in the sari, adding more cobalt blue to the mixture for the very darkest creases. By darkening the tones in this way, you will begin to imply the folds in the fabric. Mix a dark purple from Bengal rose, alizarin crimson and a little indigo and dot in the pattern on the sari. Mix Bengal rose with a tiny amount of cobalt blue and paint the mounds of very bright pink powder.

**10** Continue painting the powders, mixing cadmium red with Bengal rose for the red powders and using cobalt blue for the blue ones. Don't worry too much about the shapes of the mounds at this stage. This will become clearer as you build up the tones later on.

**11** Build up the tones on the powders, using the same mixtures as before. Using a 4B pencil, draw the lines of the plastic-wrapped packages on the corner of the stall. Mix a pale wash of cobalt turquoise and brush over the lines, using a fine round brush.

▶

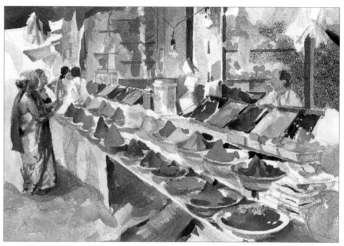

**12** Mix a dark purple colour from Bengal rose, alizarin crimson and a little indigo. Using a fine round brush, accentuate the creases in the sari fabric in the same colour.

**13** Using a mixture of alizarin crimson and indigo, paint around the stallholder. Darkening the background in this way helps to make him stand out from his surroundings. Use the same alizarin crimson and indigo mixture to strengthen the shadows on the right-hand side of the stall.

**14** By this stage, all you need to do is refine some of the details. Mix a rich, brownish black from alizarin crimson, indigo and cadmium red and darken the stallholder's hair. Darken his skin tones with a more dilute version of the same mixture. Paint the stripes on the colourful woven basket in Bengal rose gouache and darken the tones on the wooden posts of the stall.

**15** Tone down the brightness of the paper, where necessary, with very pale washes of the background colours. Paint the highlights on the lightbulbs in permanent white gouache.

## Indian market scene

Here, the artist has created a lively interpretation of a busy market, packed with colourful sights and people going about their daily business. The composition is much more satisfactory than that of the original reference photographs.

The line of bowls leads diagonally through the image to the two women, while the stallholder is positioned near enough to the intersection of the thirds to provide a secondary focus of interest for the painting.

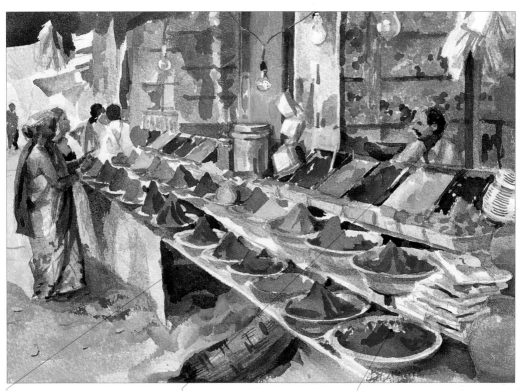

The contrast between light and dark areas establishes the different planes of the image.

The stallholder's direct gaze encourages us to follow his line of sight across the scene to the two women.

The indentations in the mounds of powder are skilfully conveyed by applying more layers of colour to the darker, shaded areas.

# Glossary

**Additive**
A substance added to paint to alter characteristics such as the paint's drying time and viscosity. Gum arabic is a commonly used additive in watercolour painting.

**Body colour**
Opaque paint, such as gouache, which can obliterate underlying paint colour on the paper.

**Colour**
**Complementary:** colours that lie opposite one another on the colour wheel.
**Primary:** a colour that cannot be produced by mixing other colours, but can only be manufactured. Red, yellow and blue are the three primary colours.
**Secondary:** a colour produced by mixing equal amounts of two primary colours.
**Tertiary:** a colour produced by mixing equal amounts of a primary colour and the secondary colour next to it on the colour wheel.

**Composition**
The way in which the elements of a drawing or painting are arranged within the picture space. The composition does not need to be true to real life.

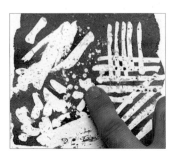

**Closed composition:** one in which the eye is held deliberately within the picture area.
**Open composition:** one that implies that the subject or scene continues beyond the confines of the picture area.

**Drybrush**
The technique of dragging an almost dry brush, loaded with very little paint, across the surface of the paper to make textured marks.

**Format**
The shape of a painting. The most usual formats are landscape (a painting that is wider than it is tall) and portrait (a painting that is taller than it is wide), but panoramic (long and thin) and square formats are also common.

**Gouache** *see also* Body colour.

**Ground**
The prepared surface on which an artist works. *See also* Support.

**Highlight**
The point on an object where light strikes a reflective surface. In watercolour painting, highlights are often left as white paper.

**Hue**
A colour in its pure state, unmixed with any other.

**Line and wash**
The technique of combining watercolour washes with pen-and-ink work.

**Mask**
Any substance that is applied

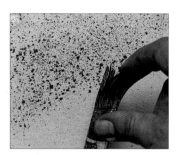

to paper to prevent paint from reaching specific areas. Unlike resists, masks can be removed when no longer required. There are three materials used for masking – masking tape, masking fluid and masking film – although, depending on the techniques you are using and the effect you want to create, you can simply cover up the relevant part of the painting by placing a piece of paper over it.

**Overlaying**
The technique of applying layers of watercolour paint over washes that have already dried in order to build up colour to the desired strength.

**Palette**
(1) In watercolour painting, a ceramic or plastic container in which paint colours are mixed.
(2) The range of colours used by an artist.

**Pan**
A small, rectangular container in which watercolour paint is sold.

**Paper**
The commonly used support for watercolour paintings.
**HP (hot-pressed):** The smoothest type of watercolour paper. HP paper is particularly good for fine brushwork.

**NOT:** This shortened name stands for "not hot-pressed". It is a slightly textured paper.

**Rough:** The most textured type of watercolour paper.

**Tinted:** Although watercolour paper is normally white, tinted watercolour paper is available in a small range of pale colours.

**Weight:** The weight of a paper is normally given in pounds per ream (a ream being 500 sheets) or grams per square metre. The heavier the watercolour paper, the more water it can absorb. Papers under 140lb (300gsm) need to be stretched before use to prevent them buckling when water is applied.

### Perspective

A system whereby artists can create the illusion of three-dimensional space on the two-dimensional surface of the paper.

**Aerial perspective:** the way the atmosphere, combined with distance, influences the appearance of things. This is also known as atmospheric perspective.

**Linear perspective:** linear perspective exploits the fact that objects appear to be smaller the further away they are from the viewer. The system is based on the fact that all parallel lines, when extended from a receding surface, meet at a point in space known as the vanishing point. When such lines are plotted accurately on the paper, the relative sizes of objects will appear correct in the painting.

### Resist

A substance that prevents one medium from touching the paper beneath it. Wax (in the form of candle wax or wax crayons) is the resist most commonly used in watercolour painting; it works on the principle that wax repels water.

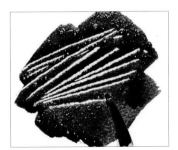

### Sgraffito

The technique of scratching off paint to reveal either an underlying paint colour or the white of the paper. The word comes from the Italian verb *graffiare*, which means "to scratch".

### Shade

A colour that has been darkened by the addition of black or a little of its complementary colour.

### Spattering

The technique of flicking paint on to the paper to create texture.

### Sponging

The technique of applying colour to the paper with a sponge, rather than with a brush, in order to create a textured appearance.

### Stippling

The technique of applying dots of colour to the paper, using just the tip of the brush.

### Support

The surface on which a painting is made (normally paper in watercolour painting).

### Tint

A colour that has been lightened. In pure watercolour, a colour is lightened by by adding water to the paint.

### Tone

The relative lightness or darkness of a colour.

### Underdrawing

A drawing made as a guide to where to apply the paint.

### Wash

A thin layer of transparent paint that usually covers a large area of the painting.

**Flat wash:** an evenly laid wash that exhibits no variation in tone.

**Gradated wash:** a wash that gradually changes in intensity from dark to light or (less commonly) vice versa.

**Variegated wash:** a wash that changes from one paint colour to another.

### Wet into wet

The technique of applying paint on to wet paper or on top of an earlier wash that is still damp.

### Wet on dry

The technique of applying paint to dry paper or on top of an earlier wash that has dried completely.

# Suppliers

## Manufacturers

If you are unable to find what you want in your local art shop, the leading manufacturers of paints, papers and brushes should be able to supply you with details of stockists in your area.

Daler-Rowney UK Ltd
PO Box 10
Bracknell
Berkshire RG12 8ST
United Kingdom
Tel: (01344) 424621
Website: www.daler-rowney.com

Winsor & Newton
Whitefriars Avenue
Wealdstone
Harrow
Middlesex HA3 5RH
United Kingdom
Tel: (020) 8427 4343
Website: www.winsornewton.com

H. Schmincke & Co.
Otto-Hahn-Strasse 2
D-40699 Erkrath
Germany
Tel: (0211) 2509-0
Fax: (0211) 2509-461
Website: www.schmincke.de

## Stockists

UNITED KINGDOM
ABS Brushes
Wetley Abbey, Wetley Rocks
Staffordshire ST9 0AS
Tel: (01782) 551551
Fax: (01782) 551661
Email: abs.brushes@btinternet.com
Website: www.absbrushes.com
(Brushes only)

Art Express
Freepost NEA8739
Leeds LS1 1YY
Freephone: (0800) 731 4185
Fax: (0113) 243 6074
Website: www.artexpress.co.uk
(Postal address for overseas customers:
Index House, 70 Burley Road,
Leeds LS3 1JX, UK)

Dodgson Fine Arts Ltd
t/a Studio Arts
50 North Road
Lancaster LA1 1LT
Tel : (01524) 68014
Fax: (01524) 68013
Email: enquiries@studioarts.co.uk
Website: www.studioarts.co.uk
or www.studioartshop.com

Falkiner Fine Papers
76 Southampton Row
London  WC1B 4AR
Tel: (020) 7831 1151
Fax: (020) 7430 1248
Email: falkiner@ic24.net

Hobbycraft
Hobbycraft specialize in arts and crafts materials and own 19 stores around the UK. For details of stores near you, phone freephone (0800) 027 2387 or check out the yellow pages or the company's website.
Website: www.hobbycraft.co.uk

Buy on-line from:
Jacksons Art Supplies
PO Box 29568
London N1 4WT
Tel: (0870) 241 1849
Fax: (020) 7354 3641
Email: sales@jacksonart.com
Website: www.jacksonart.com

SAA Home Shopping
PO Box 50
Newark
Notts NG23 5GY
Freephone: (0800) 980 1123
Tel: (01949) 844050 (overseas customers)
Email: homeshopping@saa.co.uk
Website: www.saa.co.uk

Stuart Stevenson
68 Clerkenwell Road
London EC1M 5QA
Tel: (020) 7253 1693

Turnham Arts & Crafts
2 Bedford Park Corner
Turnham Green Terrace
London W4 1LS
Tel: (020) 8995 2872
Fax: (020) 8995 2873

UNITED STATES
Many of the following companies operate retail outlets across the US. For details of stores in your area, check out the yellow pages or the relevant website.

Art & Frame of Sarasota
1055 South Tamiami Trail
Sarasota
FL 34236
Tel: (941) 366-2301
Toll Free: (800) 393-4278
Fax: 941-366-1352
Email: orders@in2art.com
Website: www.in2art.com

Dick Blick Art Materials
PO Box 1267
Galesburg
IL 61402-1267
Tel: (800) 828-4548
Fax: (800) 621-8293
Website: www.dickblick.com
(More than 30 stores in 12 states.)

Hobby Lobby
Website: www.hobbylobby.com
(More than 300 stores in 27 states.)

Michaels Stores
Michaels.com
8000 Bent Branch Dr.

Irving, TX 75063
Tel: (1-800) 642-4235
Website: www.michaels.com
(More than 750 stores in 48 states.)

Mister Art
913 Willard Street
Houston, TX 77006
Tel (toll-free): (866) 672-7811
Fax: (713) 332-0222
Website: www.misterart.com.

The Easel Studio
Tel (toll-free): (800) 916-2278
Fax (309) 273-0362
E-mail: bobbielarue@yahoo.com
Website: www.easelstudio.com

CANADA
Artists in Canada
803 Brightsand Terrace
Saskatoon
Saskatchewan
S7J 4X9
Website: www.artistsincanada.com

D. L. Stevenson & Son Ltd
1420 Warden Avenue
Scarborough
Ontario
M1R 5A3.
Tel: (416) 755-7795
E-mail (Canada): colourco@interlog.com
E-mail (US): customer service@
    artpaintonline.com

Buy customized paper and canvas
stretchers from:
Upper Canada Stretchers Inc.
1750 16th Avenue East
Box 565 Owen Sound
Ontario
N4K 5R4
Tel: (1-800) 561-4944
Fax: (519) 371-7328
Email: donato@ucsart.com
Website: www.ucsart.com

The Paint Spot
Tel: (800) 363 0546
Website: www.paintspot.ca

Colours Artist Supplies
414 Graham Avenue
Winnipeg
Manitoba R3C 0L8
Tel: (204) 956-5364,
Fax: (204) 943-6989
Email: colours@mb.sympatico.ca
(6 stores across western Canada)

AUSTRALIA
Art Materials
Website: www.artmaterials.com.au

Dick Blick Art Materials
Customer Service: (800) 723-2787
Product Info: (800) 933-2542
International: (309) 343-6181
E-mail: info@dickblick.com
Website: www.dickblick.com

Madison Art Shop
Tel: (800) 961-1570
Website: www.MadisonArtShop.com

MasterGraphics Inc.
810 West Badger Road
Madison
WI 53713
Tel: (608) 256-4884
Toll Free: (800) 873-7238
Fax: (608) 210-2810
E-mail: mastergraphics@masterg.com
Website: www.masterg.com

North Shore Art Supplies
10 George Street
Hornsby
New South Wales
Tel: (02) 9476 0202
Fax: (02) 9476 0203

Oxford Art Supplies Pty Ltd
CITY
221–223 Oxford Street
Darlinghurst
NSW 2010
Tel: (02) 9360 4066
Fax: (02) 9360 3461
Email: orders@oxfordart.com.au
Website: www.oxfordart.com.au
or www.janetsart.com.au

Oxford Art Supplies and Books
    Pty Ltd
Chatswood
145 Victoria Ave
Chatswood
NSW 2067.
Tel: (02) 9417 8572
Fax: (02) 9417 7617

NEW ZEALAND
Draw Art Supplies Ltd.
PO Box 24022
5 Mahunga Drive
Mangere Bridge
Auckland
Tel: (09) 636 4989
Fax: (09) 636 5162
Free Fax: (0800) 506 406
E-mail: enq@draw-art.co.nz
Website: www.draw-art.co.nz

Fine Art Supplies
PO Box 58 018,
38 Neil Park Dr.
Greenmount
Auckland
New Zealand
Tel: (64-9) 274 8896
Fax: (64-9) 274 1091
Website: www.fineart supplies.co.nz

# Index

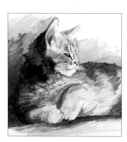

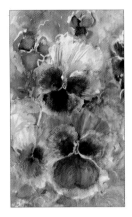

# Acknowledgements

The publishers and authors are grateful to **Daler-Rowney UK** and **Turnham Arts and Crafts** for their generous loan of materials for the photography.

In addition, special thanks must go to the following watercolour artists for their step-by-step demonstrations:

t = top, b = bottom, l = left, r = right, c = centre.

Ray Balkwill: pages 128–133; Diana Constance: pages 40–41; 212–217; Joe Francis Dowden: pages 110–115; 122–127; Paul Dyson: pages 45, 184–185; 192–197; 198–203;

Abigail Edgar: pages 136–139; 164–169; 238–243; 244–249; Wendy Jelbert: pages 116–121; 140–143; 150–153; 154–159; 172–177; 218–223; Melvyn Petterson: pages 58–59; 61–63; 64–67; 68–71; 75(b)–77; 80–83; 104–107; 186–191; Paul Robinson: pages 206–211; Ian Sidaway: pages 24–25; 28; 32–3; 44; 46–47; 50–51; 52 (tl, tr, cl, cr); 54 (tl, tr); 56 (tl, tr); 60; 72–73; 74–5 (t); 78–79; 178–183; 232–237; Albany Wiseman: pages 26–27; 29; 42–43; 52–53; 54–55; 56–57; 100–103; 144–147; 160–161; 226–231.

Copyright paintings and photographs are reproduced in this book by kind permission of the following:

t = top, b = bottom, l = left, r = right, c = centre.

Paul Dyson: pages 20, 90, 91 (t); Trudy Friend: pages 21 (t); 99 (b); 135 (b); Jonathon Hibberd: page 144 (t); Sarah Hoggett: pages 58 (bl); 61 (tl); 64 (b); Wendy Jelbert: pages 22 (b); 91 (br); 99 (t); 99 (t); 108; 109 (b); 135 (t); 148; Ian Sidaway: pages 91 (bl); 92–93; 94–95; 98; 109 (t); 134; 149; George Taylor: 28 (b); 100 (t).